THE INSPIRED LANDSCAPE

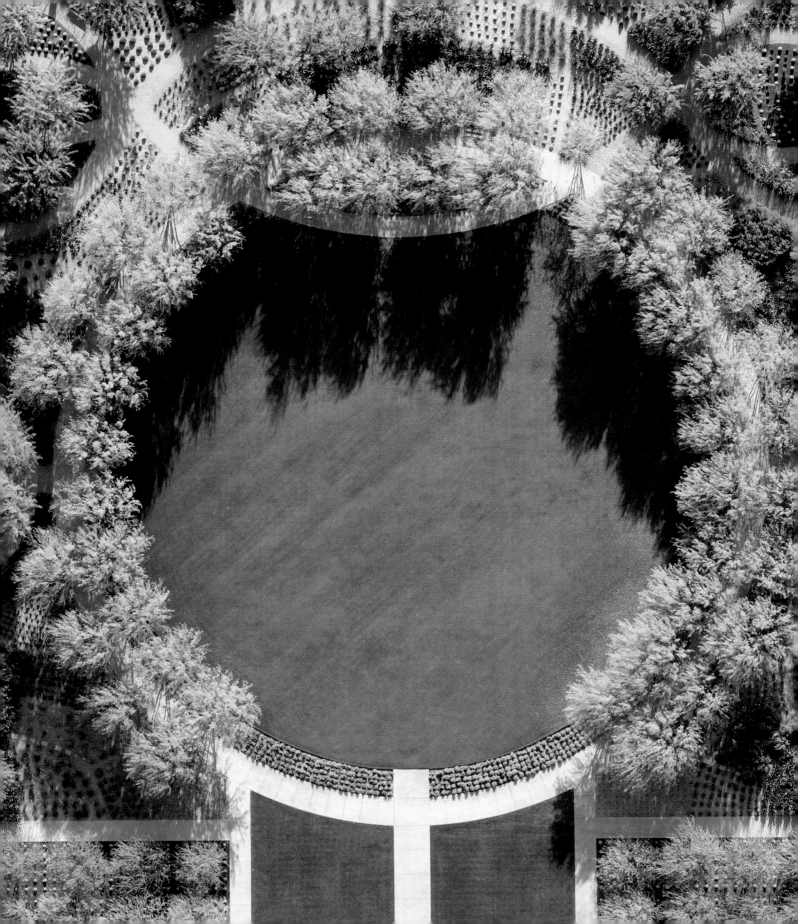

THE INSPIRED LANDSCAPE

Twenty-one leading
landscape architects
explore the
creative process

Susan Cohen

Foreword by
Peter Walker

Timber Press
Portland, Oregon

Frontispiece: Sunnylands Center and Gardens, Rancho Mirage, California. James Burnett landscape architect

Dedication: Southwest Concourse at the University of Massachusetts, Amherst. Stephen Stimson landscape architect

Photo and illustration credits appear on pages 257–261.

The Haseltine Building
133 S.W. Second Avenue, Suite 450
Portland, Oregon 97204-3527
timberpress.com

Printed in China
Text design by Alie Kouzoukian
Cover design by Patrick Barber

Library of Congress Cataloging-in-Publication Data

Cohen, Susan, 1941– author.
 The inspired landscape: twenty-one leading landscape architects explore the creative process/Susan Cohen; foreword by Peter Walker.—First edition.
 pages cm
 Includes index.
 ISBN 978-1-60469-439-0
 1. Landscape architects. 2. Landscape architects—Pictorial works. 3. Landscape architecture.
4. Landscape architecture—Pictorial works. I.Title. II.Title: Twenty-one leading landscape architects explore the creative process.
 SB469.37.C64 2015
 712.092—dc23 2015008581

A catalog record for this book is also available from the British Library.

*For landscape architects—whose
works, grounded in the practical,
are elevated by their imaginations*

CONTENTS

FOREWORD

BY PETER WALKER

In this new collection of the work of twenty-one well-known landscape architects, Susan Cohen uses the lens of specific projects not only to review a series of remarkable works of landscape architecture, but also to glimpse the personal nature of their individual designs and to provide a fuller understanding of the processes and context of these works. Reading through these chapters, one experiences a rich and varied record of creative approaches as well as the wide range of project types that make up the field at the turn of the new century. The reader is taken inside the design process to gain insight into a variety of built landscape forms.

Included here are a diversity of modern landscapes, including botanical gardens, university grounds, conference centers, a cancer care center, parks both large and small, industrial heritage renewal, reclaimed urban waterfronts, a Japanese shrine, a garden for the American Academy in Rome, and a social venue in Marfa, Texas. Represented also are several gardens built on top of structures and a country home with extensive acreage. This is not, however, a catalogue or survey. Rather, it is a series of investigations into the inspiration and process of individual designers, case studies of clients and collaborators, situations, and programs.

Modern landscape architecture is perhaps the most varied and difficult field of design because it is made up of concepts both engineered and biologic. It demands the use of both fixed and living material, requiring not only the production of elegantly scaled landforms, walls, and paving, but also the recycling of water and, of course, the projection of living plants from their infancy to old age. All of this is done to produce spaces where society can play, work, recreate, and find visual enjoyment.

This book is a wonderful resource for designers, gardeners, and students and for anyone seeking insight into, and inspiration from, today's landscape design.

FINDING THE MUSE

AN INTRODUCTION

Through training and experience, landscape architects have the ability to recognize the possibilities of a given site as well as its constraints. They know how the sun will move across the sky and where the shadows will fall, how the wind will blow, which plants will grow well, where the best views might be, and where people are most likely to walk or gather. They know how to analyze the existing soil and how to accommodate both natural conditions and the surrounding built environment. Most importantly, they understand how to meet the needs of people who will use the space.

However, like musicians, painters, poets, and sculptors, the best landscape architects are also artists. They use their skills, their imaginations, and the materials of their craft to create something new, works that move and change through time. And like all artists, they must begin with an idea; they must invoke their muses to create a singular landscape that is also a work of art.

This book explores and illustrates the sources of these ideas in the work of twenty-one outstanding landscape architects in their successful projects in the United States, Canada, England, Scotland, Germany, France, Italy, Israel, China, and Japan. Although there are threads that link some of their thoughts and methods, each created landscape is unique, and all the landscape architects have a story to tell about how the spark of a design idea—inspiration—came to them.

It is no surprise that the inspirations and influences for their projects are as varied as the landscape architects who made them and the sites on which they worked. And yet many projects here resonate with each other.

For instance, Signe Nielsen's Fulton Landing, a small urban park in Brooklyn, New York, is very different from Gary Hilderbrand's residential property in Guilford, Connecticut. But both landscape architects turned to the historical uses of their waterfront sites, drawing inspiration from the shoreline activities of centuries past. Nielsen's influences include the decorative patterns of Native Americans who once lived here, Walt Whitman's famous poem "Crossing Brooklyn Ferry," about the Fulton Ferry that departed from this location, and the magnificent Brooklyn Bridge adjacent to the site. Hilderbrand was struck by the extensive stone debris that littered his clients' property, remnants of the extensive old granite quarry that had provided the stone for the base of the Statue of Liberty in the nineteenth century. Instead of carting away tons of this abandoned stone, as many of the neighbors had done, Hilderbrand used it throughout the property in ways both practical and artful. In doing so, he felt he honored the work of the hundreds of experienced stonemasons, most of them immigrants from Europe, who had toiled here a hundred years earlier.

By coincidence, two landscape architects were similarly inspired by a natural desert phenomenon: the streambeds that carry intermittent floodwaters in times of heavy rain. Desert wadis, as they are called in the Middle East, sparked Shlomo Aronson's design for a gathering place at Ben-Gurion University in Israel's Negev Desert. His evocative stone wadi at Kreitman Plaza, which runs continuously with burbling water, shares kinship with a winding garden creek that collects rainwater in Christine Ten Eyck's Capri Lounge garden in Marfa, Texas, where such desert washes are called arroyos.

For others, a single work of art provided the spark of invention. While sketching design concepts for the Native Plant Garden at the New York Botanical Garden, Sheila Brady took time out to visit a museum and found, in a wood sculpture by Martin Puryear, her inspiration for the abstract shape of a large pond, the new garden's central feature. Similarly, Cornelia Oberlander, who has admired the pioneering work of the nineteenth-century photographer Karl Blossfeldt since her childhood days in Germany, found the vision for the form of a green roof in Vancouver in his photograph of a gently undulating orchid leaf. For the Sunnylands Center and Gardens, James Burnett was encouraged by Vincent Van Gogh's painting *A Wheatfield with Cypresses* to use drought-tolerant plants in large sweeps, creating an unexpectedly lush landscape in the southern California desert.

All landscape architects study garden history as part of their training, and most are inveterate visitors to gardens old and new. So it is not surprising that they reach back to gardens of the past for ideas. Tom Stuart-Smith, invited by the owner of an English country estate to make a walled garden on a sloping piece of land not far from the manor house, created an imaginative terraced composition that references the famous seventeenth-century Villa Lante in Italy. While in Rome at the American Academy, Laurie Olin made countless visits to both ancient and Renaissance-period Italian gardens, which he studied, sketched, and photographed. He used several ideas and details from these gardens in his landscape redesign at the academy. For his roof at the Museum of Modern Art in New York, Ken Smith cited as inspiration two gardens created in 1958: the patently synthetic garden in the film *Mon Oncle* and Isamu Noguchi's rooftop Peace Garden at the UNESCO headquarters in Paris. For Shunmyo Masuno, a landscape architect and Zen Buddhist priest, remembered landscapes are part of a centuries-old tradition of garden making in Japan.

Some landscape architects find their muse in the site itself. In looking for the "memories of the land," landscape architect Ryoko Ueyama was thrilled to discover that her 4-acre site for a park north of Tokyo was located directly on the axis between two mountains, one of which is the iconic Mount Fuji. Calling this coincidence a "divine pronouncement," she emphasized this line in her design with a diagonal pattern of stripes that runs the length of the park. In Duisburg, Germany, Peter Latz was struck by the huge abandoned concrete and iron structures on his post-industrial site and found imaginative and useful ways to incorporate them into his plan for a new public park.

Others find flashes of inspiration from childhood memories. For Kongjian Yu, the remembered landscape is his family's rice fields in rural China and the paths through which, as a boy, he led the village water buffalo to graze. Across the world, Stephen Stimson grew up on a dairy farm in Massachusetts. His strong bond with a five-generation agricultural past led him to use stone walls, orchard-like plantings of trees, and benches bracketed by heavy metal fastenings that recall farm implements in his project at the University of Massachusetts. Kim Wilkie's childhood in Iraq and Malaysia gave him an obsession with ziggurats and old Mesopotamian sites, as well as a fascination with all things sacred and mystical. These early interests inspired his Orpheus landform at Boughton House in Northamptonshire, England.

Great landscape architects, like their counterparts in other arts, seem able to draw inspiration from diverse sources: a place, a poem, a painting, a remembered garden, a path taken in childhood, or the shape of a leaf. Judging from the work presented here, the ancient muses of invention are still among us, providing spirited inspiration to landscape architects practicing today.

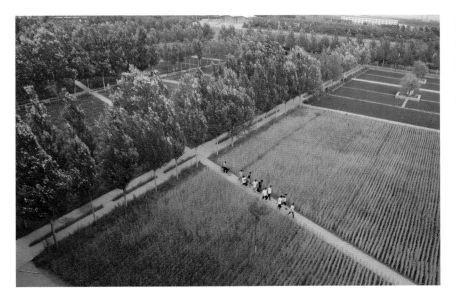

Informed by his farming childhood, Kongjian Yu created a working rice field landscape for the newly built campus of Shenyang Jianzhu University. He based his design on a rectilinear grid, reflecting the ancient layout plans of Chinese cities, and then added a diagonal path through the pattern.

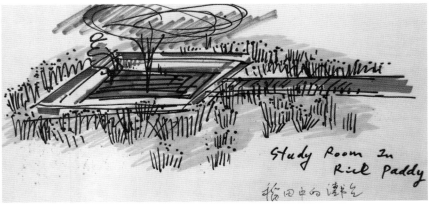

Study Room In Rice Paddy

稻田中的讲台

Yu's sketch shows his early concept for the shaded places to sit within the fields of rice.

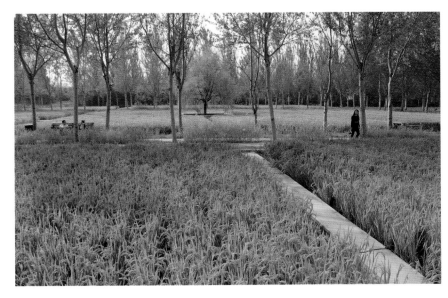

This rice field landscape adds beauty, harmony, and social spaces to the campus. In addition, a substantial crop of rice is harvested each year.

SHLOMO ARONSON

**KREITMAN PLAZA
AT BEN-GURION UNIVERSITY OF THE NEGEV
BEERSHEBA, ISRAEL
OPENED IN 1994**

Inspired by the surrounding Negev Desert, Shlomo Aronson sought to create a desert environment that would also be a paradise.

The winding form of Aronson's stream echoes those he had seen in the desert. The groves of trees, including palms, give the plaza the atmosphere of an oasis.

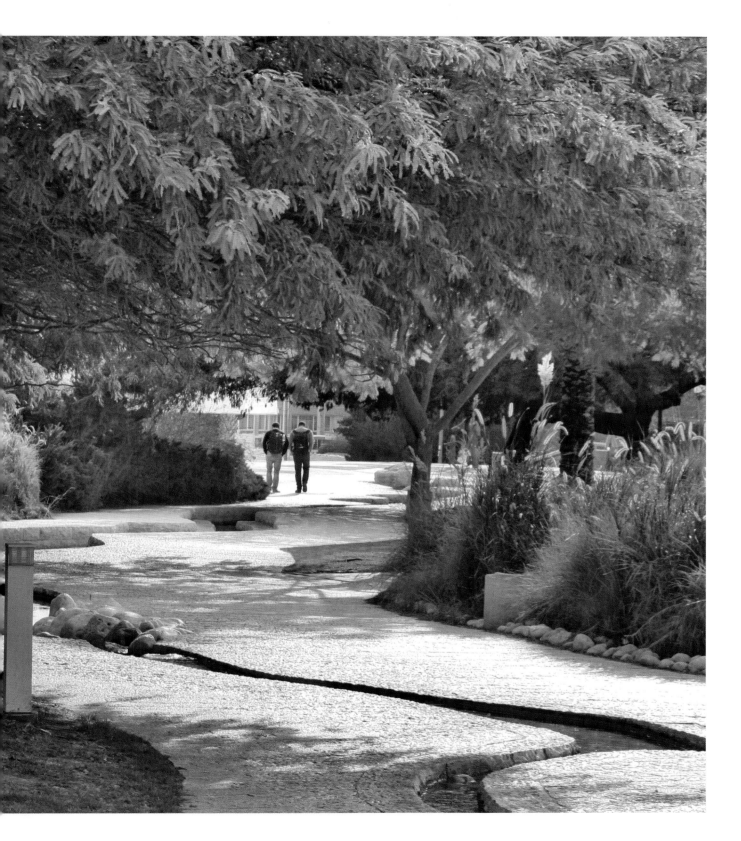

Shlomo Aronson's principal inspiration for Kreitman Plaza at Ben-Gurion University was the surrounding Negev Desert, and the most compelling element in his design is his poetic and magical abstraction of a wadi, the carrier of the desert's transient water. *Wadi* is an Arabic term that can refer either to a valley or to the channel cut by the ephemeral desert streams that fill with a rush of water during times of rain.

Wadis exist throughout Israel, and several can be seen from the road as one heads south from Jerusalem to Beersheba. Gradually, the rich agricultural fields created by Israel's advanced irrigation systems give way to ridged and mottled earth in various shades of tan: from light beige to burnt sienna. Closer to Beersheba, near Bedouin family compounds, camels are silhouetted against the sky on the tops of small hills, the color of their coats matching the color of the land. Visible here and there are small ditches in the landscape, with vegetation that is a sign of occasional water.

The town of Beersheba itself has been populated for thousands of years because of the reliable water source that flows down from the Hebron Hills in winter. Since ancient times, this water has been stored in cisterns underground. The Nahal Beersheba, the area's main river, is a wadi that floods in the winter season, and two other wadis flow through the city.

David Ben-Gurion, Israel's first prime minister, insisted that the new university be built in the Negev Desert. Considered the founding father of Israel, Ben-Gurion envisioned that the barren Negev could bloom, literally, and that a university in the quiet historic town of Beersheba would be of great benefit to the area. "In Israel," according to Ben-Gurion, "in order to be a realist, you have to believe in miracles."

Convinced that the country would be well served by investing resources in this southern desert, Ben-Gurion set an example by moving to a kibbutz in the Negev Desert when he retired from political life in 1970. By then, the brand-new University of the Negev had opened; it was renamed Ben-Gurion University of the Negev after his death in 1973.

Two decades later, landscape architect Shlomo Aronson was invited to reimagine a major pedestrian entrance and to create a gathering place for the university community of approximately 20,000 students. Named for its English donors, the Kreitman family, the new plaza opened in 1994 and has been the heart of the campus ever since, a crossroads for students and faculty moving from place to place and a quiet shaded space to rest between classes and activities. On a warm spring day a week before the Passover holiday, groups of students were sitting, chatting, and studying. Solitary students were lounging with books, and many students were crossing the campus or entering and leaving the nearby student union.

Aronson, a native Israeli who earned landscape architecture degrees from the University of California, Berkeley, and then Harvard, recalled his first thoughts for this site: to create a desert environment that would also be a paradise. From the beginning, it was important to him that the design would age well and, therefore, that the best, most enduring materials be employed. Given the climate, shade was an imperative if the plaza, which had been previously open to the sky, was going to be used.

He also envisioned a scheme that juxtaposed the rational world—the realm of university teachings and classical architecture—with the raw nature of the desert that lay just outside Beersheba and the campus precinct. This balance was his key to the project.

To exemplify the rational, classical tradition, Aronson's firm designed the arcade that surrounds the plaza's wild oasis, offering an almost continuous shaded walkway around the site. Within the arcade, simple stone benches offer many places to sit. The columns of the arcade are clad in stone, and the canopy is made of glass-fiber-reinforced concrete. From under this canopy, one sees small round openings of translucent glass that provide a visual connection to the blue of the sky. Square lattice acts as a kind of frieze below the roof and provides additional shade from the sun.

Aronson's arcade recalls the ordered repetition of columns in Islamic architecture, but here each group of columns supports a pyramidal roof, rather than a dome. In Jewish tradition, this architectural form relates to gateways, as is appropriate at Ben-Gurion University. This form was also used in Jerusalem's much-praised Supreme Court building, which opened two years before Kreitman Plaza. Designed by architects Ram Karmi and Ada Karmi-Melamede, the Supreme Court building

The winding wadi and the generous plantings near the arcade are the heart of Kreitman Plaza.

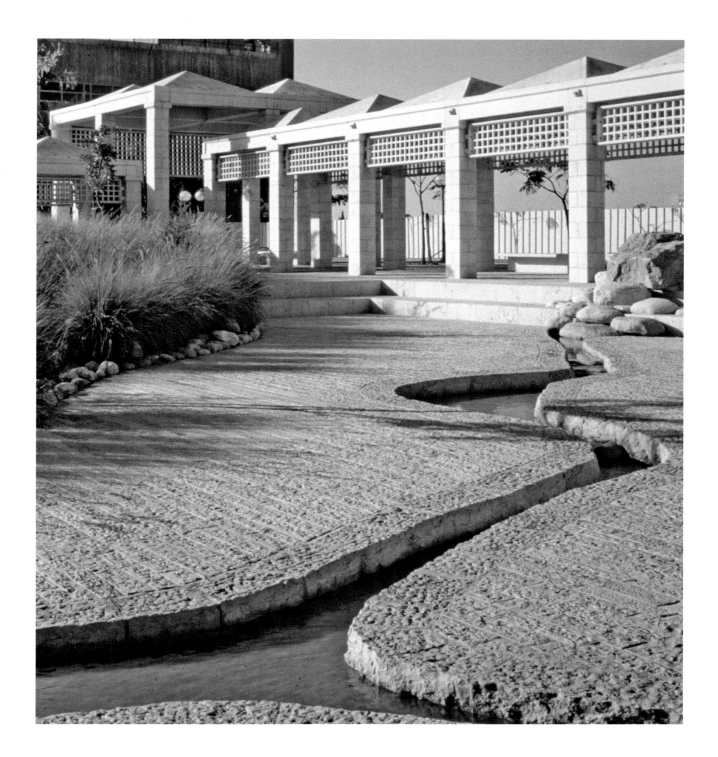

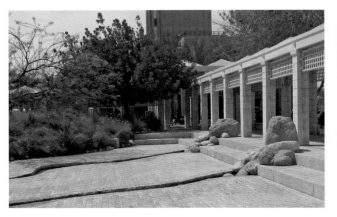
Small boulders create the two sources of the desert stream.

Aronson's wadi widens and narrows as it flows through the plaza.

contains an interior courtyard topped by a pyramidal roof that is copper-clad on its exterior. This space serves as a gateway to both the adjacent library and the courtrooms. As in Aronson's Kreitman Plaza arcade, tiny round windows in the roof bring light into the space from above. A clear precedent for both of these structures is the Tomb of Zechariah in Jerusalem, a carved stone edifice dating from the first century, in which the pyramid form is used as a roof.

Within the frame of the arcade, Aronson's wadi runs diagonally for about 250 feet through the plaza, and two water sources—low piles of stones—create a Y-shaped composition. The stream is narrow in most places, and students and faculty step over it easily. It seems that all those on campus have made this stream part of their personal choreography. Watching the movements of people navigate the wadi brings to mind the American landscape architect Lawrence Halprin and his wife, Anna, the dancer and choreographer, who were an important part of Aronson's life when he was a student at Berkeley in the 1960s. Halprin's investigations into the way people move through urban spaces influenced Aronson greatly. Halprin was Aronson's mentor and also his employer in California. Later, the two worked together in Israel on the Haas Promenade overlooking Jerusalem.

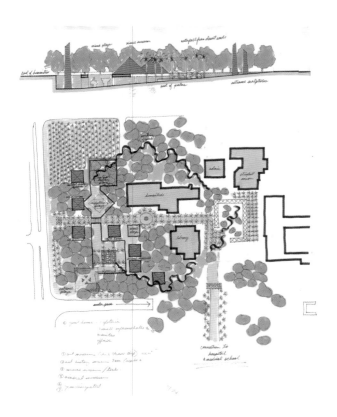
An early scheme proposed a more extensive system of desert streams. The elevation in this concept sketch shows the distinctive rooflines of the arcade.

SHLOMO ARONSON

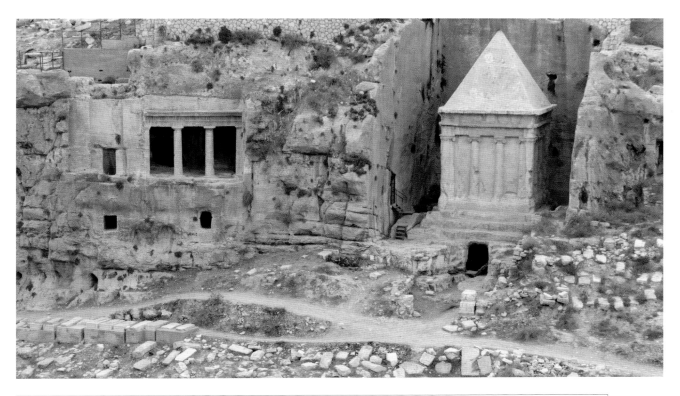

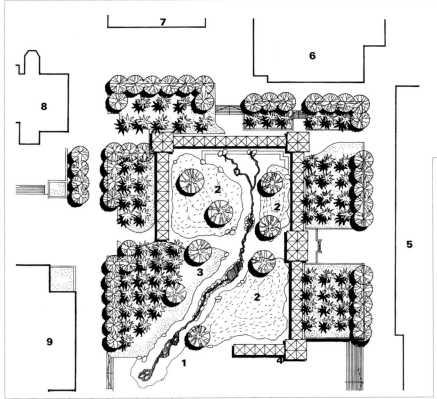

1	Desert creek
2	Desert planting
3	Lawn
4	Pergola
5	Main lecture building
6	Student union
7	Administration
8	Social science
9	Library

The distinctive roof of the Tomb of Zechariah is a precedent for Aronson's arcade architecture as well as for Jerusalem's Supreme Court building.

The final Kreitman Plaza plan shows the wadi, the planted mounds, and the trees that shade the lawn.

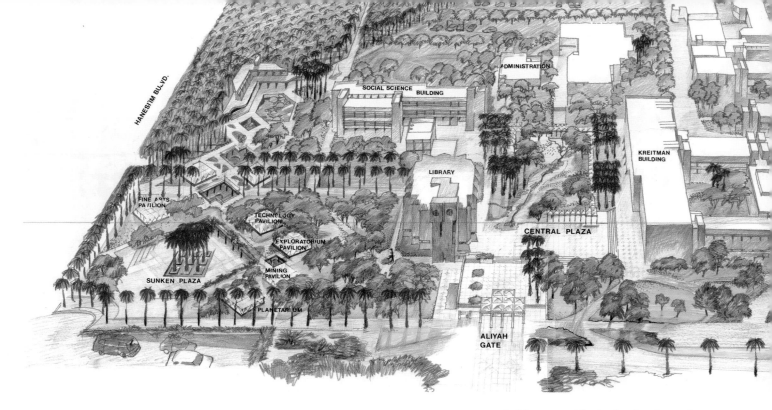

In this axonometric plan the plaza is seen in its larger context of the university.

Aronson's constructed stream, visible from the steps near the university's street entrance, invites one to walk on limestone-paved paths on either side of the flowing water and then to be surprised and delighted by the unexpected: the seductive sounds of water falling over carefully placed stones. This quiet background song animates the plaza and adds to the peace, comfort, and life of the place. The entire length of the stream is enhanced by both the music of the water and the light that dances over the partially submerged stones in the stream.

Near the stream, the lush planting of the plaza reiterates the oasis theme and evokes desert grasses, while an untamed mix of flowering shrubs and perennials add scent and visual delight. Groups of date palms are arranged in the grid pattern seen in agricultural plantations throughout Israel, and they provide much-needed shade. Although the extensive lawn under these palms recalls neither the desert nor the cultivation of date palms, this element was provided by Aronson to invite the students to use the space. As expected, they do.

A student sitting on a stone step between the plantings and the stream asked me why I was taking so many photographs of the plaza. When told of my interest in landscape design, he volunteered that he liked this place very much. "You know," he said, indicating with a wave of his hand both the stone-lined stream and the lush plantings, "This is a very difficult thing to do in the desert."

Aronson, too, is proud of Kreitman Plaza, and he is especially proud and happy that in twenty-five years there has been no damage and no graffiti here. Then he puts it more simply. In his soft voice, inflected with his native Hebrew, he said, "It's my favorite."

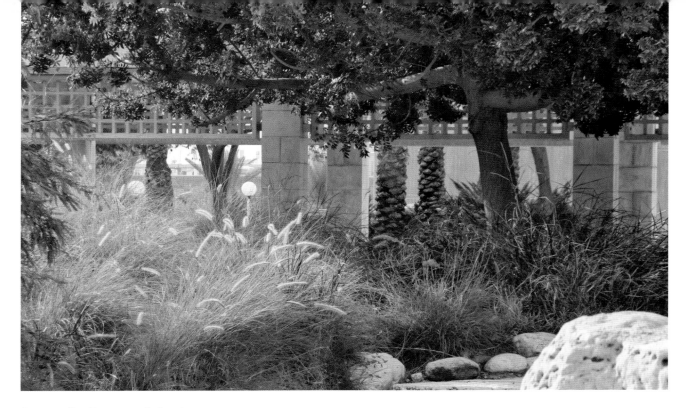

Grasses soften the man-made desert
landscape areas near the arcade.

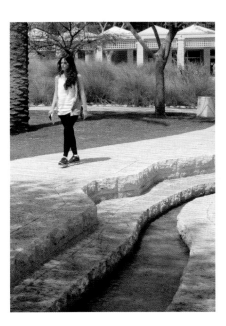

A student travels the path along
the desert stream.

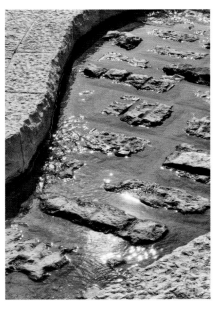

The water flows over irregular
stones at the bottom of the wadi,
making soft sounds.

SHEILA BRADY

**THE NATIVE PLANT GARDEN
AT THE NEW YORK BOTANICAL GARDEN
BRONX, NEW YORK
OPENED IN 2013**

The sculptures of Martin Puryear suggested the form of the central pond, and Joan Mitchell's paintings inspired the pattern of meadow plants in Sheila Brady's designs for a new native plant garden.

An aerial view of the Native Plant Garden at the New York Botanical Garden shows the pond's distinctive shape, the waterfalls, the boardwalk paths, and some of the 100,000 newly installed plants.

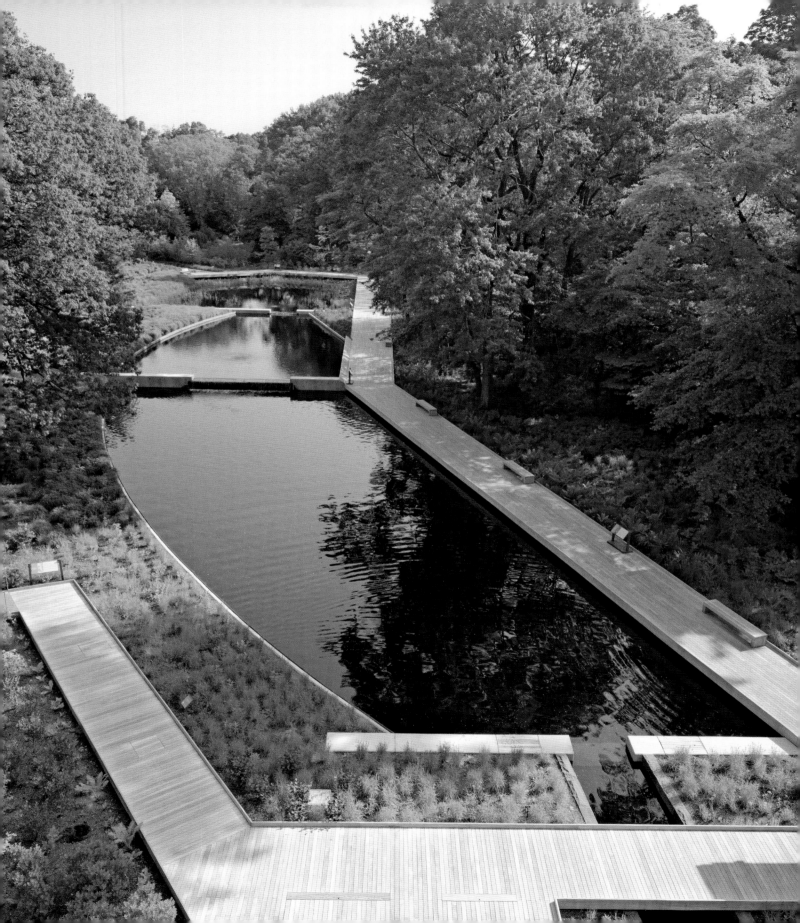

Trained in art before becoming a landscape architect, Sheila Brady is an inveterate museum goer, so it is not surprising that she found inspiration for the Native Plant Garden at the New York Botanical Garden in the works of two of her favorite artists, sculptor Martin Puryear and painter Joan Mitchell. A work by Puryear provided the specific landscape form, and Mitchell's paintings suggested a new way to pattern the plants within the garden.

One morning while working at her home near Washington, D.C., Brady was struggling to find the appropriate shape for the Native Plant Garden's central feature, a large pond. After hours of work and many discarded sketches, she decided to take a break and headed for the National Gallery of Art, where she knew a show of Puryear's work had recently opened. The exhibition, organized by the Museum of Modern Art in New York, included more than forty pieces, a major career retrospective for the much-honored artist.

Brady had long admired Puryear's beautiful craftsmanship, his attention to joinery, and the simplicity and evocative power of his works in wood. As she moved through the large exhibition spaces at the National Gallery, she found herself drawn to one work in particular, *Bask*, an early Puryear piece from 1976, part of the Guggenheim Museum's collection. She stood in front of it for a long, long time.

With renewed energy, Brady returned home, pulled out her roll of white trace, and picked up one of her favorite blue Prismacolor pencils. In her mind was the image of *Bask*, a low, 12-foot-long floor piece, made of black-stained pine. She was intrigued with its shape: softly curving on one side and flat on the other. She started to draw, thinking this form might be right for one of the two planned waterfalls. Soon, however, she realized that she was, in her words, "forcing it," something that her art school years had taught her never worked. Brady let go of that idea and all at once saw that the beautiful abstract form of Puryear's sculpture could suggest the shape for the entire pond.

As she drew, she realized that this form not only fit the site well, but also solved her design problem beautifully: the straight line of one side of the piece was suitable for the long length of a proposed boardwalk promenade, while the opposing soft curve was appropriate for the waterside edge of the wet meadow on other side of the pond. This abstract shape also met one of the program's goals for this project: that it should be contemporary in design.

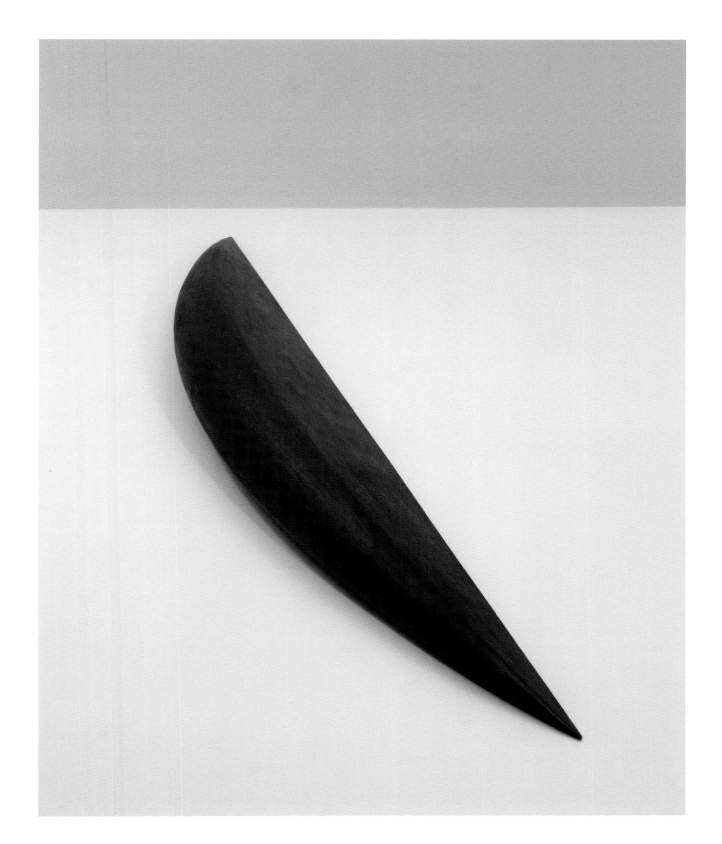

Brady made a quick sketch of her idea based on the Puryear sculpture.

Finding the form for the pond was one of the last pieces in a complicated puzzle. Brady and her team, in collaboration with the New York Botanical Garden's staff, already had determined much of the plan for the 3.5-acre garden. Two structures—a roofed entry pavilion and a classroom—had been proposed, and they were to be designed by Hugh Hardy in the architectural vocabulary of his visitor center buildings, not far away. The microclimates had been identified, and the locations for the multiple plant communities had been chosen, with habitats for more than 100,000 native plants. The pedestrian paths had been drawn.

The final plan shows the evolution of the pond design.

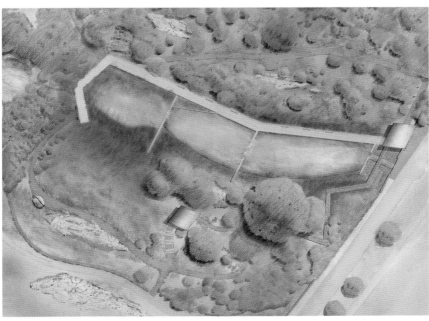

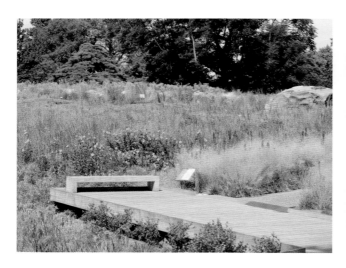

The path runs through the meadow, not around it.

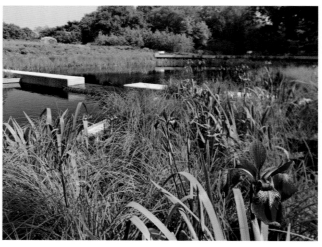

The garden's plant palette includes wetland species, such as this native iris.

Near the two waterfalls, a visitor enjoys the morning light on a summer day.

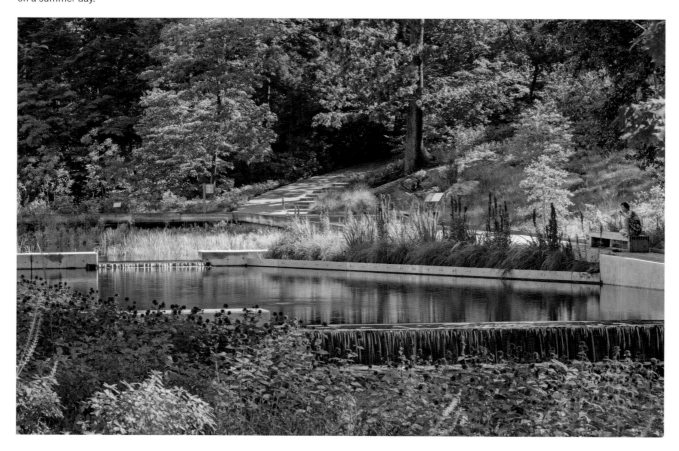

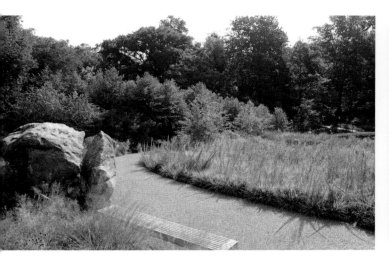

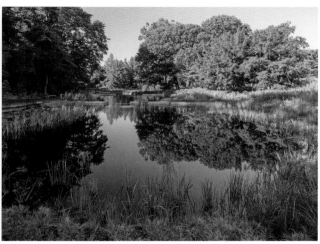

Brady planned the pedestrian path through the meadow to skirt Split Rock, a distinctive existing feature of the site.

The pond's wetland area is in the foreground, and the meadow is to the right.

This was to be a garden that provided the experience of being within large sweeps of native plants, not outside looking in. The space also was planned so that visitors, even if they explored an upland path through the edge of the forest, would at all times be aware that they were circumnavigating a body of water at the heart of the garden, almost in the manner of a Japanese stroll garden. The paths had been laid out to bring viewers close to many dramatic rocks on the site.

By the time Brady found her design for the pond, its general location had been selected near the center of the site, where an existing stream ran and where the water table was highest. The pond was to be completely sustainable, which meant that a half acre of water needed to be cleansed naturally, without the use of chemicals. A wetland was created with carex, juncus, acoris, and sarracenia to aid this process, and the final design included two waterfalls as part of the engineering of the complex system. Brady collaborated with fountain designers to make certain the system functioned well, that maintenance was minimal, and that all hardware was invisible. Most of the engineered system is underground and out of sight.

The form of the built pond is contemporary in design, but still very much at home in its naturalistic setting. The waterfalls add movement to the water's surface, while the pond's reflections of sky and trees give added dimension and life to the garden.

The pond is the heart of the garden, but the nearly 3 acres of native plants, arranged in drifts on varied topography, are the reason for this garden to exist. Flowering trees and shrubs were added within the forest area, and generous plantings of spring ephemerals, including hundreds of white trillium and blue *Mertensia virginica*, provide a charming display. When they are gone, soft sedges and ferns carpet the woodland floor.

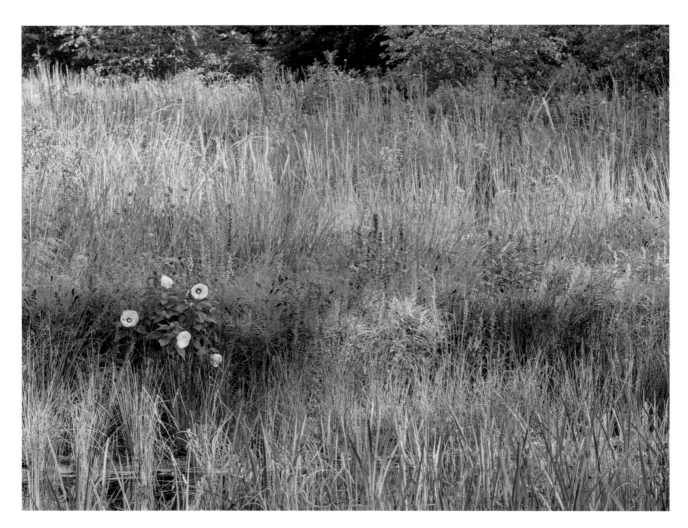

Blooms on grasses and perennials enliven the meadow in late summer.

An extensive meadow was created in an open sloping area. Walking along the path, Brady admired how the plants have grown together into a rich tapestry of perennials and grasses, and she pointed to some of her late-summer favorites: rudbeckia, aster, liatris, solidago, and little bluestem prairie grass.

In designing this planting scheme, Brady knew she did not want big, chunky masses of plants in the meadow. Instead, she had a more romantic vision, one inspired by the work of another of her favorite artists, Joan Mitchell, an American abstract expressionist painter who spent most of her career in France. While visiting Paris in her twenties, Brady came upon Mitchell's paintings in a local gallery and has loved her work ever since. Most of Mitchell's large works are abstracted landscapes that are known for vigorous gestures that are hers alone. Mitchell noted, "I paint from remembered landscapes that I carry with me."

32

Joan Mitchell's 1983 painting *La Grande Vallée XIV (for a little while)* inspired Sheila Brady in her meadow planting.

The layout of the meadow plants, including *Ratibida pinnata, Monarda fistulosa*, and *Liatris pycnostachya*, reflects Joan Mitchell's distinctive use of color.

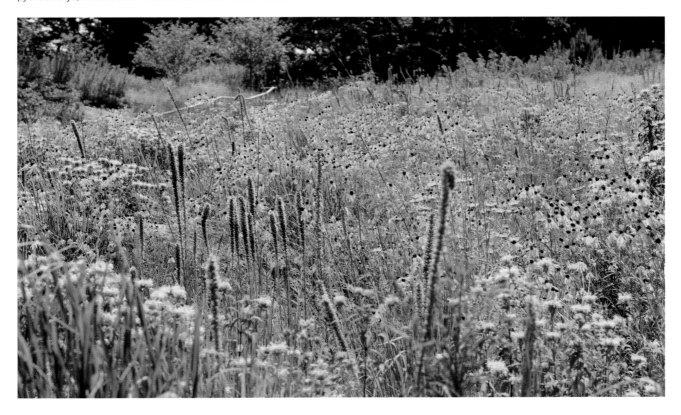

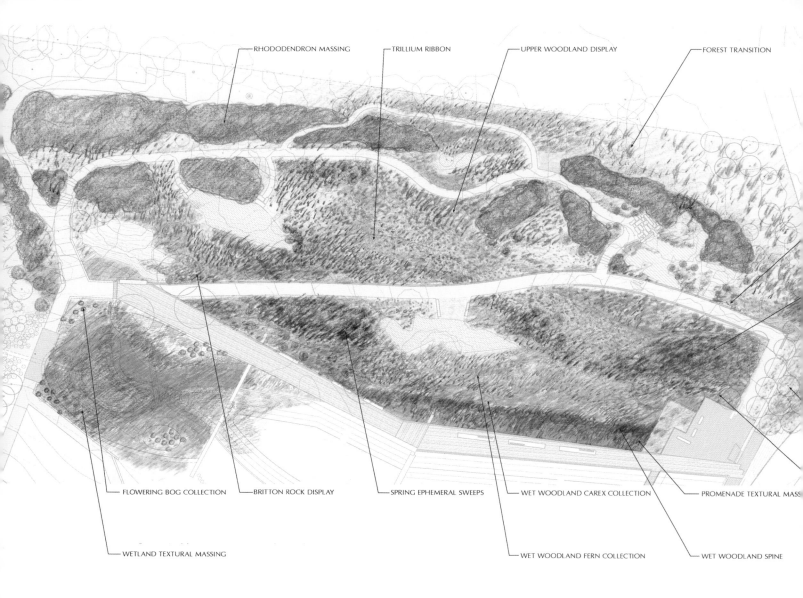

RHODODENDRON MASSING TRILLIUM RIBBON UPPER WOODLAND DISPLAY FOREST TRANSITION

FLOWERING BOG COLLECTION BRITTON ROCK DISPLAY SPRING EPHEMERAL SWEEPS WET WOODLAND CAREX COLLECTION PROMENADE TEXTURAL MASS

WETLAND TEXTURAL MASSING

WET WOODLAND FERN COLLECTION WET WOODLAND SPINE

Sheila Brady's design development plan for the woodland and wetland areas adjacent to the constructed pond (bottom) responds to the many existing mature trees on the site. Her woodland paths traverse the slope among a forest of trees.

Brady's treatment of plant materials, especially in the meadow, pays homage to Mitchell's paintings. Mitchell used color not in large shapes, but dispersed throughout the canvas in distinct strokes made with brushes or rags. Similarly, Brady's plants are interspersed with each other in repetitive patterns throughout the large meadow.

Brady acknowledges her debt to Mitchell. Indeed, her colorful layout sketches for the meadow plantings somewhat resemble a Joan Mitchell painting. "We all have inspirations that run around in our heads," Brady said. "Joan Mitchell and Martin Puryear are in my mind forever."

— SPRING EPHEMERAL COLLECTIONS

— SPRING EPHEMERAL SWEEPS

— ENTRY GROVE

— ENTRY PERENNIAL MASSING

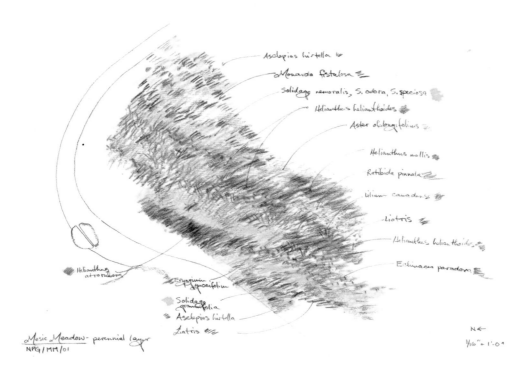

Brady's layout plan of the flowering plants in the meadow was suggested by Mitchell's work.

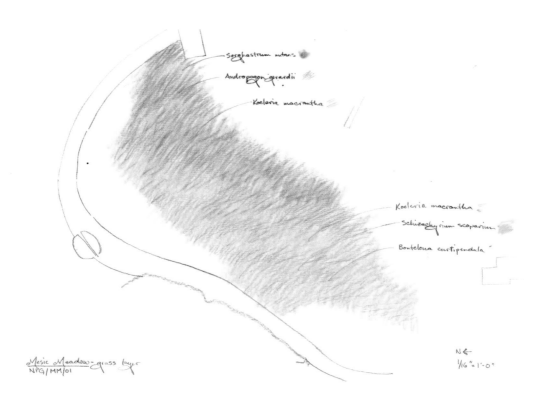

The pattern of the meadow's grasses is shown in this plan.

JAMES BURNETT

**SUNNYLANDS CENTER AND GARDENS
RANCHO MIRAGE, CALIFORNIA
COMPLETED IN 2012**

Van Gogh's painting of a Provençal landscape gave James Burnett his vision for the contemporary landscape at Sunnylands Center and Gardens.

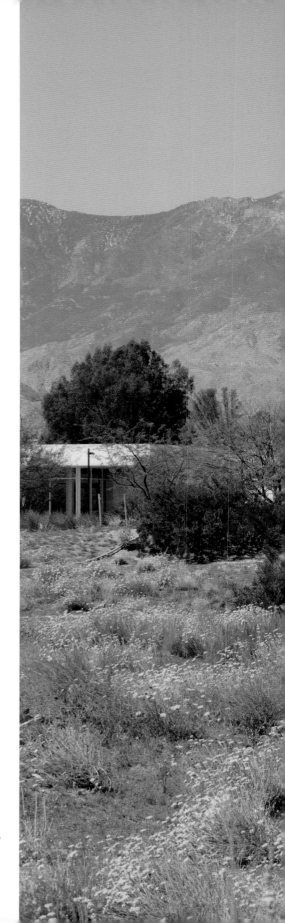

Burnett evoked elements of one of Van Gogh's most famous paintings, *A Wheatfield with Cypresses*, as can be seen in the sweeps of yellow plants in the meadow. The similar mountain backdrops in Saint-Rémy, France, and California's Coachella Valley enhance this association.

Van Gogh's *A Wheatfield with Cypresses* inspired the work of James Burnett at Sunnylands in southern California.

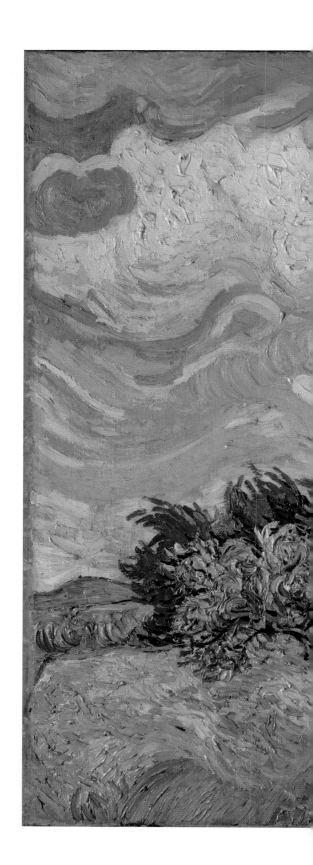

n 2006, James Burnett was commissioned by the Annenberg Foundation Trust at Sunnylands to work with architect Fred Fisher on the design of a new visitor center. At around this time, Burnett toured the Annenberg estate house, where an exhibition of reproductions of all the works acquired by the Metropolitan Museum of Art in New York through the generosity of the Annenberg Foundation was installed. Burnett, who paints for his own pleasure, was attracted to the landscape works of the Impressionist and Post-Impressionist painters, mostly painted *en plein air*. One work especially captured his attention and drew him in: Vincent Van Gogh's *A Wheatfield with Cypresses*, painted by the Dutch artist in Saint-Rémy, France, in the summer of 1889.

Although far away from southern California, this nineteenth-century agricultural field in southern France provided Burnett with his vision for designing the contemporary landscape at Sunnylands. In Van Gogh's painting, a horizontal swath of ripe wheat, golden in the sunshine, stretches across the canvas and contrasts with the dark green upright cypresses, the lighter green olive trees, and the surrounding green and gold of other fields. Red poppies dot the foreground, and a mountain range lies beyond the fields under a wild multi-hued sky.

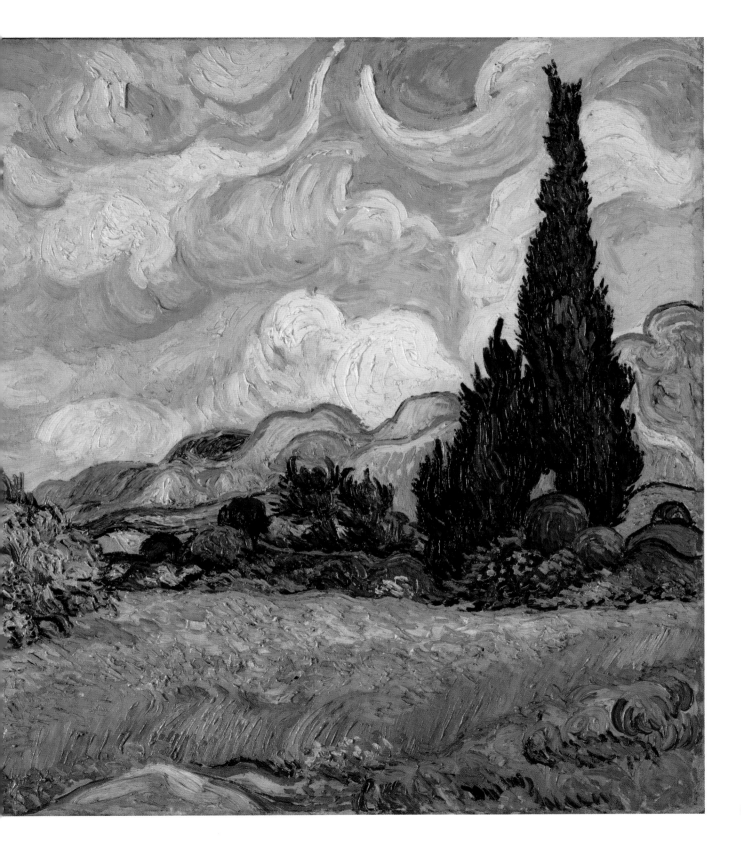

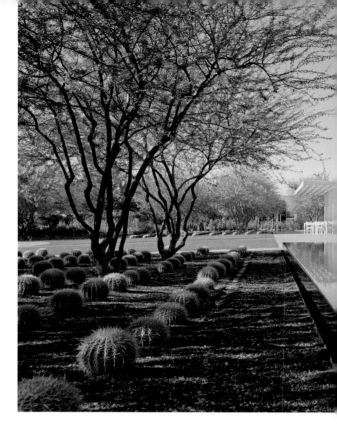

The aptly named Sunnylands Center and Gardens, the former winter estate of Walter and Leonore Annenberg, is located in Rancho Mirage, a city in southern California's Coachella Valley. The hot and arid climate, with an average of almost 350 days of sunshine each year, has made this area attractive as a winter resort and golfing destination.

More than a dozen golf courses now exist in and around Rancho Mirage. One of these, a nine-hole private course, is part of the Annenbergs' former winter home, which they established in 1966. This course and the rolling lawns surrounding the estate served as the initial landscape vision for the planned visitor center on adjacent undeveloped land. The visitor center, as envisioned, would interpret and celebrate the Annenbergs' cultural and educational contributions and the legacy of the historic estate, where for decades foreign royalty and heads of state met with American presidents for diplomacy as well as golf.

When James Burnett was engaged, his first assumption was that the landscape design of the visitor center would be linked visually to the estate. He imagined that the 40-foot-high tamarisk hedge separating the two parts of the property would be removed and a landscape of green lawns, small hills, and plentiful trees might continue around the new visitor center, unifying the complex.

It soon became clear, however, that another vision was required. As Burnett learned, the once-plentiful local aquifers were drying up, the mountain snowmelt was not longer reliable, and the Coachella Valley Water District was setting stricter limits on water use. Clearly, it was inappropriate in the twenty-first century to create a landscape so completely dependent on artificial irrigation. And without irrigation, according to Burnett, "The site was all just sand."

For a sustainable design solution, Burnett looked to the extensive native flora of the Sonoran Desert to the south. He put together a rich, but highly edited, selection of plants that would survive in the local conditions, and he presented his concept to the foundation. Initially, according to Burnett, Leonore Annenberg, Ambassador Annenberg's widow, was skeptical of this approach. Though she liked many of the plants in his presentation, she was accustomed to the green lawn and trees surrounding her estate, and she worried that the new landscape on the other side of the tamarisk hedge would be "just rock mulch and a few cactuses." In response to Burnett's planting suggestions, Mrs. Annenberg said she did not want to see a single grain of sand around the visitor center.

It was the swaths of golden vegetation in Van Gogh's *A Wheatfield with Cypresses*, as well as the punctuation of the trees and those red field poppies, that gave Burnett his design inspiration. He would use the desert plants in generous sweeping bands of texture, form, and color, and his palette, like Van Gogh's, would emphasize yellow. Burnett knew that Mrs. Annenberg was a big fan of yellow. The trick was to make desert plants read as a verdant landscape. Mrs. Annenberg agreed that if he could do that and make it beautiful, then he had her full approval.

JAMES BURNETT

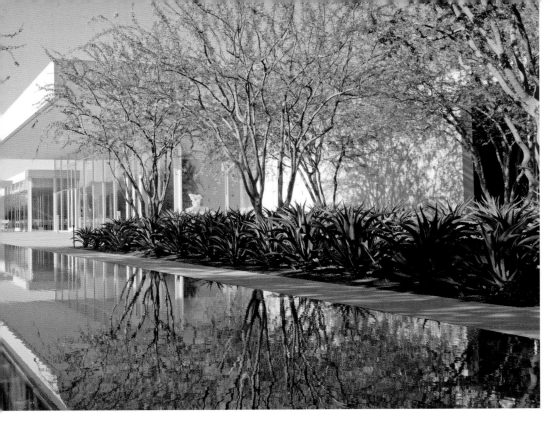

At the new visitor center in Sunnylands, Burnett's two long rectangular fountains provide a water view and splashing sounds to those using the dining terrace.

In Burnett's sketch, the flowing lines of plantings in the entrance area contrast with the more formal geometry in the garden behind the visitor center. The open area in front of the building is his meadow.

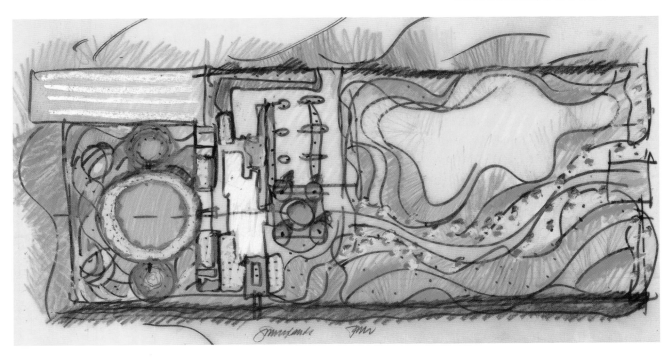

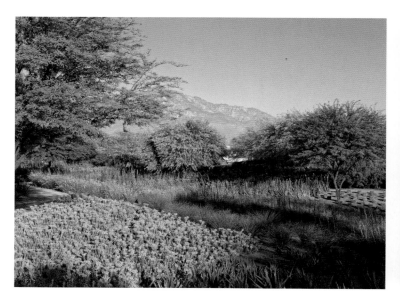

The long sweeps of plants and the mountains in the background recall Van Gogh's painting, as do the touches of red plantings.

The yellow blooms of palo verde trees are echoed in the color of the kniphofia below.

During the first stage of siting the new building and designing the approach, Burnett and architect Fred Fisher agreed that the building should be set back from the busy road, and Burnett designed a flowing entry drive, so that the visitor center building is seen only at the last moment, as a surprise. This winding drive is flanked by a Sonoran Desert version of Van Gogh's fertile French landscape. In choosing plant material, Burnett was assisted by horticulturist Mary Irish, an expert on Sonoran Desert vegetation. They worked together to select choice and hardy plants, and they choose carefully, as each species would to be used in vast quantities.

Burnett's sketch plan shows the scale of each band of planting. There are thousands of plants here, in generous sweeps: masses of agave, aloe, hesperaloe, barrel cactus, and kniphofia. Burnett knew that when they all grew together, the mulch would not be visible at all. He is pleased when visitors are overheard to say that they didn't know a desert garden could look like this, and he is proud that his designed landscape uses only 20 percent of the property's allowable water.

The curving geometry of the visitor center entry drive is transformed behind the building to a more formal pattern, dominated by a central circle of lawn that reflects both classical geometry and the doodling of the designer. "I just picked up a pencil and started to draw," said Burnett, whose affinity for classical proportions is clear. The large disk of lawn—the only lawn area on this property—is used for events and gatherings, and its form is a counterbalance to the rectilinear lines of the building. Circling the lawn, a wide walkway is dramatically overhung with palo verde trees, named for their distinctive green bark. Their striking yellow blooms recall the dominant golden yellow color of Van Gogh's wheat field.

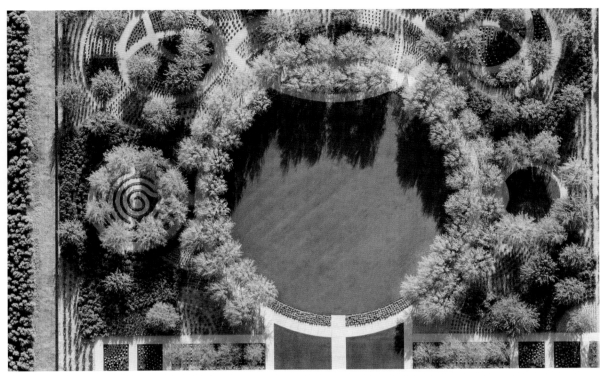

The generous circle of lawn is seen in this aerial photograph, along with the smaller spaces Burnett created to encourage visitors to explore the garden. The labyrinth is at the left.

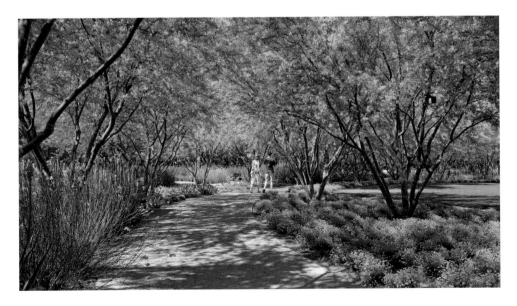

Visitors stroll under the palo verde trees that ring the central lawn.

The garden's labyrinth is meant to relax visitors, not challenge them. Burnett imagined this centuries-old pattern as a calming activity for those attending high-powered meetings at Sunnylands.

Throughout the garden, benches provide places to stop and appreciate the dramatic use of desert plants such as the *Aloe vera* on the left and the red-blooming *Hesperaloe parviflora* on the right.

But Burnett also wanted to invite visitors into the garden to wander, to explore the varied planted areas, and to find the labyrinth and walk that path as well. Along the walkways, he provided several convenient places to sit, and each bench is placed so visitors can appreciate the garden's lush desert plantings. As in Van Gogh's painting, the view includes a range of mountains in the background.

When he speaks of this garden, Burnett talks about the large masses of plant materials and compares them to the broad brush strokes of the painters he so admires: "I wanted to make a garden that I would want to paint one day." His landscape at Sunnylands Center and Gardens, inspired by Van Gogh, in turn encouraged the landscape architect and his painting instructor, Duncan Martin, to spend a day there, creating their own paintings of the landscape. Like Van Gogh and his contemporaries, they painted out of doors. But while Van Gogh's *A Wheatfield with Cypresses* is ensconced at the Metropolitan Museum of Art in New York, Martin's painting, a gift from his teacher, is now in James Burnett's collection.

The meadow of native plants is a habitat for local wildlife, including jackrabbits and rattlesnakes.

James Burnett painted the palo verde trees and barrel cactuses at Sunnylands.

James Burnett admired Duncan Martin's work and asked for painting lessons. Martin's painting of the Sunnylands gardens was made on the same day as Burnett's painting.

GILLES CLÉMENT

GARDEN AT THE MUSÉE DU QUAI BRANLY
PARIS, FRANCE
OPENED IN 2006

Gilles Clément modeled the museum garden on a savannah ecosystem that would have resonated with many of the peoples represented in the Musée du quai Branly.

Visitors walk along curving paths and under the building's overhang to reach the entrance of the Musée du quai Branly. Clément's plantings were carefully chosen and located to suggest a wilder nature.

A lush garden with several sitting areas occupies the space between the museum building and the tall glass wall along the sidewalk.

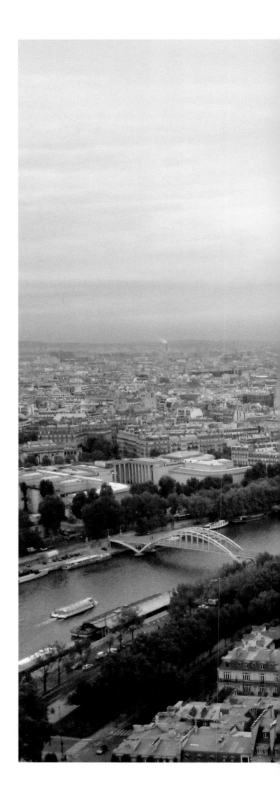

Designed by French architect Jean Nouvel, the Musée du quai Branly fulfills the wish of former President Jacques Chirac to create a singular place in Paris for the display of art and artifacts from the non-European cultures of Africa, Asia, Oceania, and the Americas. Chirac, fascinated with such cultures from his youth, pressed for the creation of this museum, into which collections were moved from other Paris institutions. The museum now houses more than 300,000 objects, treasures from indigenous peoples around the globe, with about 3500 on view at any given time.

Gilles Clément, who is variously described as a botanist, ecologist, entomologist, artist, garden designer, philosopher, horticulturist, professor, and writer, believes the garden he made at the Musée du quai Branly is the best example of his working with nature. His inspiration for the design of the museum garden came from his knowledge of native vegetation throughout the world and from his study of ancient cultural symbols that are intriguingly common to the many civilizations represented within the walls of the museum.

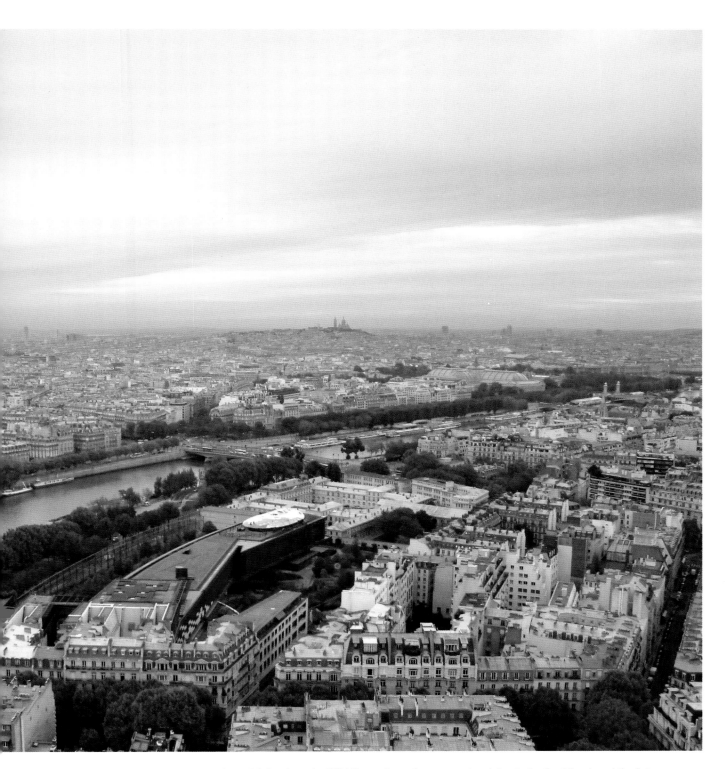

An aerial view from the Eiffel Tower shows the museum in relation to the Quai Branly and the Seine.

The Musée du quai Branly, which opened in the summer of
2006, is named for its location on the busy roadway that curves
along the Seine near the Eiffel Tower. The river-facing façade of
the museum also follows that curve, as does a 600-foot-long and
40-foot-high glass wall built flush against the public sidewalk,
shielding the museum and its grounds from the street. This trans-
parent wall helps quiet the noise from the Quai Branly's multi-
ple lanes of traffic while maintaining a visual link between the
museum and the urban scene. Inside the museum, curving pas-
sageways draw visitors through the exhibition spaces.

In the context of the traditional, ordered geometry of
post-Haussmann Paris, these curves signal a new vision, one that
is evident as well in the museum's garden designed by Clément.
He has created a museum landscape that appears, at first glance,
to be completely accidental. Rather, it has been designed to
reflect not only the mission of the Musée du quai Branly, but also
his own long-standing ideas about creating natural landscapes.

These ideas were informed by Clément's childhood in the
French countryside, where he loved to spend time in his parents'
garden. At school, he confessed, he was the worst, most lazy stu-
dent, always dreaming and drawing. When he was fifteen, a high
school teacher told him about the profession of landscape archi-
tecture, which would combine his interests in drawing and gar-
dening. Clément discovered that when given the opportunity to
learn more about nature—his real interest—he was not lazy at all.

The training and life experiences that led Clément to his
multi-faceted career and to the design of this garden can be seen,
rather like the design of the museum, to eschew a straight line.
Landscape architects, he feels, should align themselves with
gardeners. While working in his parents' garden, he realized
that maintaining gardens was all about killing things: a sort of
military operation, with sprays and poisons. His own seminal
experience involved using his father's sprayer without enough
protection. After inhaling toxic powder, he collapsed and was in
a coma for two days. As he later said, "We kill the insect, but we
kill the gardener, too."

Clément works in a light-filled Paris studio, surrounded by
books, paintings, plants, display cases of butterflies, comfort-
able sofas, a piano, an old hobby-horse, a bowl of shells, art sup-
plies, and a drawing board covered with pastel sketches. Despite
his comforts here, Clément is in Paris "only in transit." His "real
bed" is in the Creuse Valley in Limousin, a scenic rural area of
woods, valleys, and streams. In the 1970s Clément bought land
here near his childhood home and began to experiment with a
new way of gardening, one that is "with and not against nature."
It is this basic philosophy that informs all of his work. "Are the
geometrical forms of the landscape architect the right way to pro-
tect life?" he asks rhetorically. "It is very expensive to maintain a
formal garden—with lawn and hedges—and to use poison. Is it
worth it? Or right?"

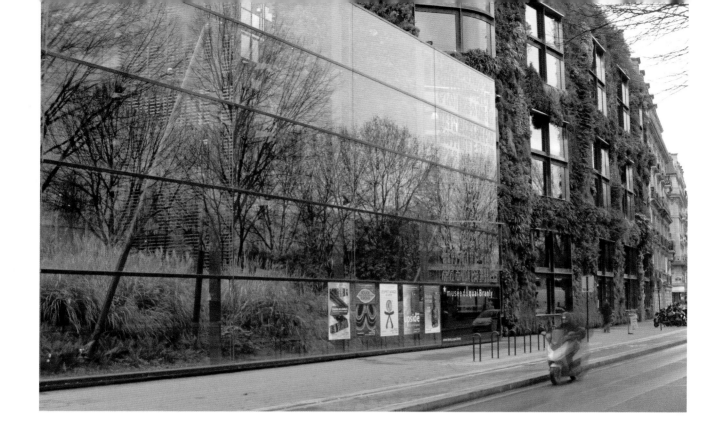

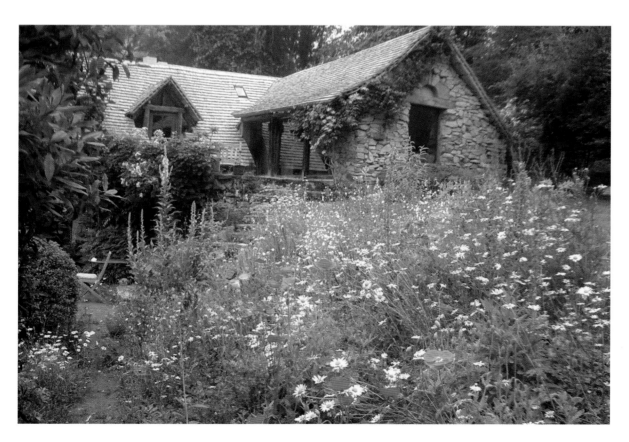

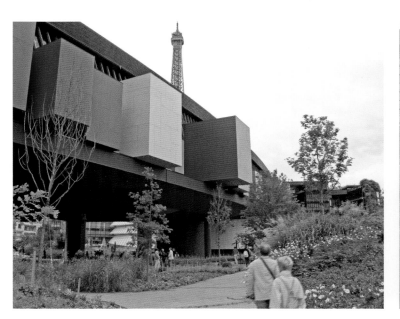

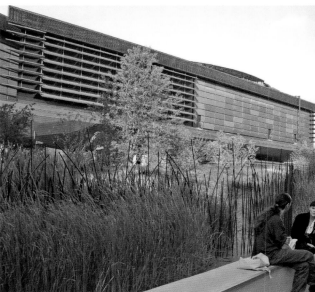

This view of the entry façade of the Musée du quai Branly includes Clément's plantings.

On the south side of the museum, a pond, lush vegetation, and a twig-like fence provide a pleasant view for pedestrians who stop to sit on the street-side wall.

OPPOSITE TOP Flowering trees are spaced widely enough to allow sunlight to reach the understory plants.

OPPOSITE BOTTOM Clément's landscape plan for the Musée du quai Branly shows the garden's many organic curved paths.

Jean Nouvel's museum building has disparate facades and idiosyncratic colorful features. It exhibits an irreverent disengagement from the architecture of its neighbors, which are characteristic nineteenth-century buildings, and by extension from traditional European architecture. Instead, the Musée du quai Branly is bold and playful. The rear façade bears almost no relation to the front of the building. One section, which houses administrative offices, is famously clothed in a vertical wall of living plants designed by Patrick Blanc.

Clément's first design decision was to model the museum garden on a savannah, a landscape characterized by widely spaced tree canopies that allow light to reach the carpet of herbaceous plants that cover the ground. The Musée du quai Branly garden is not a dark landscape, Clément said, because trees are sparse in a savannah. He placed larger trees on the north side of the building and smaller ones on the south side, where the museum would receive more light.

The paths through this savannah-like landscape are organic, curved, and inviting, and they invariably lead past flowering trees and generous herbaceous plantings to a water feature or a quiet place to sit. Though his predilection is for native plants, Clément also used ornamental plants, such as flowering cherry trees and magnolias, for the pleasure they give to visitors in the spring. In the fall, grasses of many varieties, including stately miscanthus, occupy several garden areas and catch the autumn light with their tall, feathery blooms.

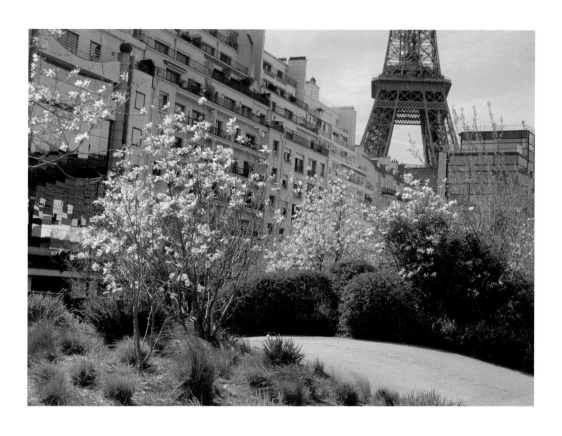

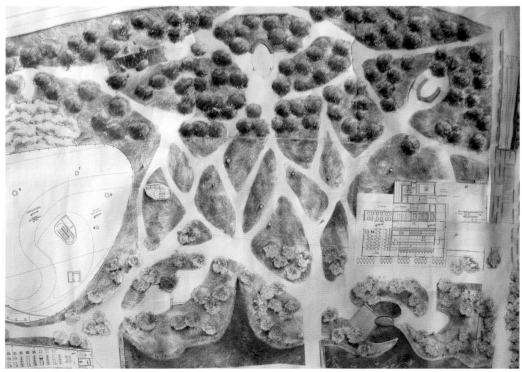

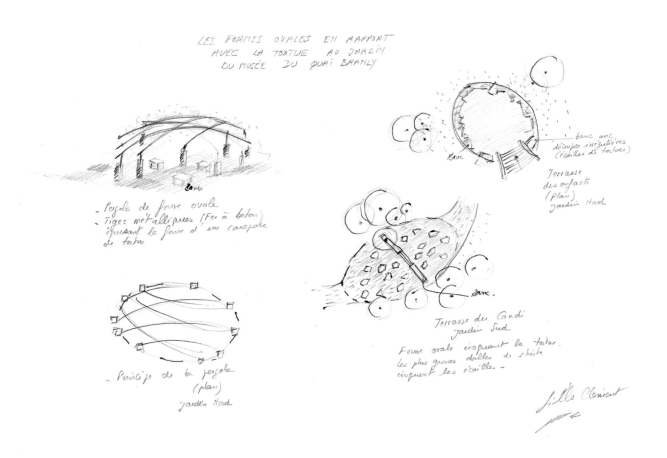

Clément made sketches of the turtle-inspired elements in his garden surrounding the museum.

In his desire to imbue the garden with the symbols and images prevalent in the cultures represented in the museum, Clément read many different texts, and he was delighted to discover that the turtle was a common motif for most early civilizations. In Asia, the Buddha sits on a turtle. In Africa, the turtle is a kind of seat where people sit to be judged. In Amerindian South America, it is the shape of a place: the village is oval, like a turtle, and the tail gives the direction to the river. The turtle figures in legends and folklore around the world and in creation myths in many cultures. The turtle is a symbol of creativity in Tibet. In feng shui, a turtle at the back door of a house or in the back garden by a pond is said to attract good fortune. It can be a symbol of longevity, cleverness, or even trickery.

So, with Clément's assistance, the turtle is everywhere in the museum's garden. As his sketches reveal, he decided to give the turtle's shape to as many places as possible. These include a covered sitting area in the front garden, an open sitting area behind the museum, and a small pond that appeals to children. If it is somewhat a stretch to apprehend this symbol in all its manifestations in the garden, nonetheless it is there.

In his process of design, Clément made many sketches, not only of turtles but also of insects and plants (mostly savannah plants) and showed them to Jean Nouvel. Over 300 images are imprinted in the concrete pathways that flow through the garden, though Clément regrets that they are now difficult to see, with the wear of heavy foot traffic.

One of his favorite images is that of the dragonfly, a creature that has inhabited the Earth for millions of years and that is represented both in the garden's pavement and in the Paris air near the pond on summer days. For Clément, the dragonfly's metamorphosis from aquatic nymph to winged insect embodies the essence of this garden and all our landscapes, both natural and man-made. Change is the very nature of gardens, he said, and that is fine with him.

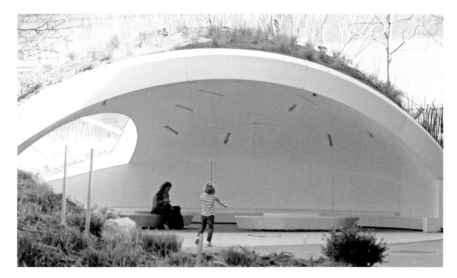

A small amphitheater in the front garden is shaped like a turtle's shell.

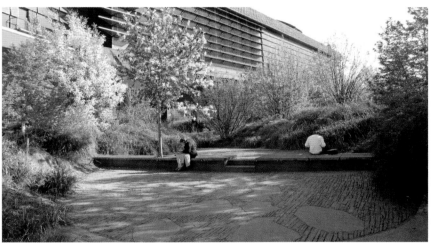

In a turtle-shaped sitting area, the paving contains flat, turtle-shaped stones.

With the pond behind him, a young boy sits on a wall among the spring-flowering trees and burgeoning grasses.

GARY HILDERBRAND

OLD QUARRY RESIDENCE
GUILFORD, CONNECTICUT
COMPLETED IN 2012

Gary Hilderbrand was inspired by the historical use of this waterfront property, once part of an extensive granite quarry that provided the stone for the base of the Statue of Liberty and other major building projects in the Northeast.

These granite stones, carefully arranged in serried rows around a tailings pit, had littered this site for almost a century, evidence of the old days of the working quarry. Hilderbrand's vision was to use the discarded stone in artful compositions that mediate between the past and the present.

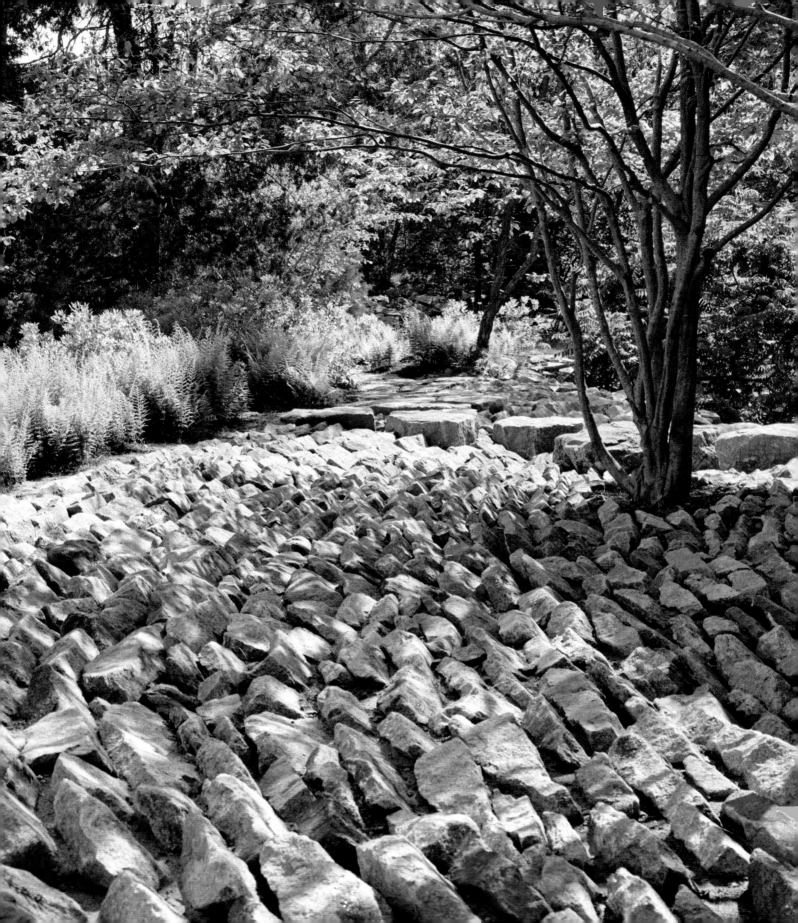

Gary Hilderbrand's project, a waterfront home in Guilford, Connecticut, is on the former site of Beattie's Quarry, and the enormous amount of stone debris here became the inspiration for his landscape design. Littering the property, lying where they had been left for a hundred years, were tons of granite tailings, pieces of stone not suitable for commercial use. According to Hilderbrand, the site was absolutely strewn with rock, a tangible memory of the quarry's earlier days.

Where others saw rubble, Hilderbrand saw possibilities. Much of this stone was handsome, and some pieces showed the characteristic pink of the local granite. Hilderbrand also became fascinated with the local quarries' contributions to the building of New England's cities. Conveniently located near the Connecticut shoreline, these quarries shipped granite south to New York City and north throughout New England. They also became home to many immigrants from Italy and northern Europe who, skilled in their trade, labored under dangerous conditions to free heavy blocks of granite from the mammoth ledges formed millennia ago.

During the boom times of urban growth in the late nineteenth century, Connecticut's several Stony Creek quarries were bustling with activity, meeting the demand for high-quality granite in building projects throughout the northeastern United States. Most of these quarries, in the towns of Branford and Guilford, have since disappeared, but they left their mark—not only in stone monuments and buildings, but also in the piles of granite that were left behind—in some cases covering the ground for acres.

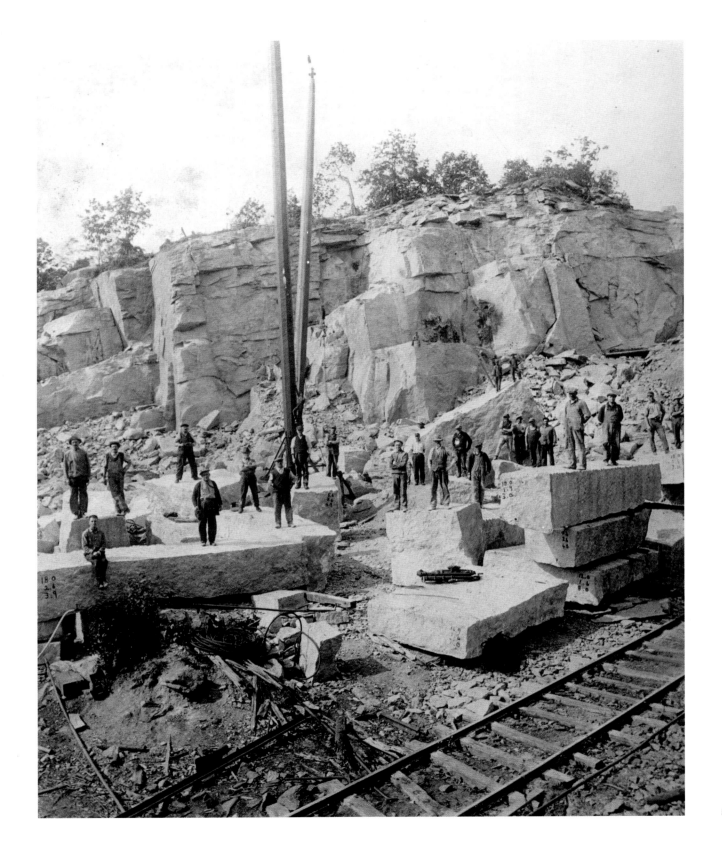

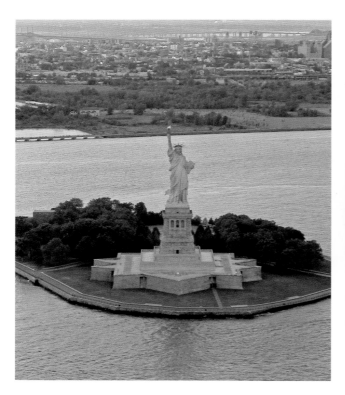

Beattie's Quarry provided all the pink granite
for the pedestal of the Statue of Liberty.

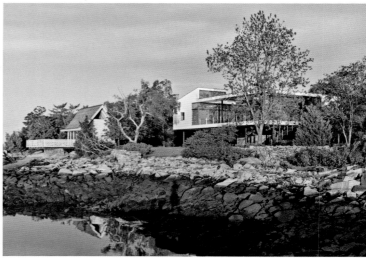

A view of the property from the water
includes granite debris from the old quarry
along the shore.

John Beattie's quarry, located directly on the waters of the Long Island Sound in Guilford, opened in 1870 and at one time employed more than 500 workers. Beattie, a Scottish immigrant, built a village within the quarry that included his home, a meeting hall, a grocery store, a boardinghouse, and many small houses for his workers. Using his own fleet of schooners, he shipped the distinctive pink stone along the coast for use in railroad bridges, plazas, lighthouses, and civic monuments. Most famously, he provided the enormous pink granite pedestal blocks—some weighing more than 6 tons—for the base of the Statue of Liberty.

Beattie's Quarry closed during World War I. After John Beattie's death, the quarry land was purchased and subdivided. Dozens of private homes were built in this area, but much of the quarry stone remained, both in the exposed ledges and on the ground. In 2004, Hilderbrand's clients bought a home here on a mostly flat, relatively small piece of land along the shoreline.

The owners, both architects, meticulously restored the existing 1950s house, designed by minimalist sculptor Tony Smith. They also built a small addition that connects to the original house with a glass-walled bridge. The house designed by Smith floats on steel columns, and all of the living space is on the second floor, a prescient decision in light of the severity of recent storms and coastal flooding.

Most of the homes at the old quarry along the water's edge are built in a traditional style and are typically surrounded by green lawns. From his first visit to the site, Hilderbrand felt that the architecture and the setting called for a different approach, one that was organic and low maintenance. Importantly, he wanted to use what was already there, augmenting the mostly native existing plants that had proved tough and resilient.

Studying the nearby quarry ledge, he noticed that native oaks and black cherries had seeded themselves and were thriving. In his plant list, he specified these trees and other plants that were well adapted to the challenging coastal conditions: hay-scented fern, blueberry sod, bearberry, and juniper.

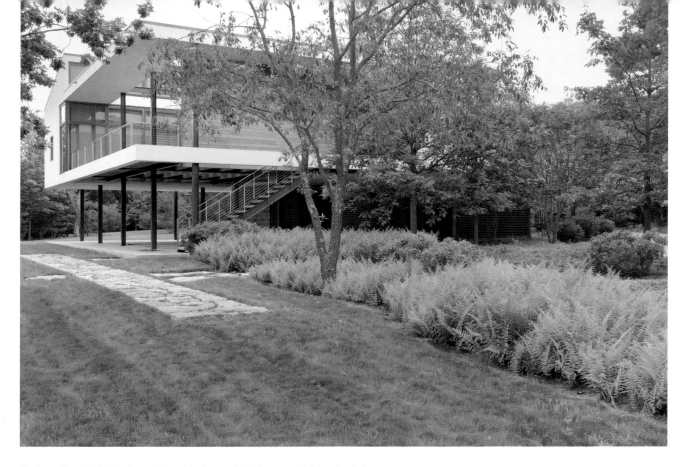

Sculptor Tony Smith designed the original part of this home, which is raised above the land on steel posts. The stone walk, inspired by stone jetties along the East Coast, also evokes a stone walk at Katsura Imperial Villa in Japan.

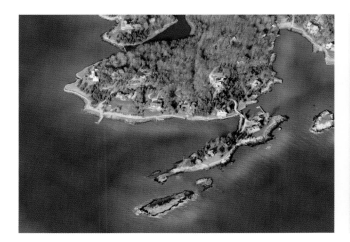

An aerial view of the property (circled in red) shows the Connecticut coastline in Guilford and neighboring homes.

An abandoned face of the old quarry can be seen across the road from the residence.

On the waterfront side of the site, this entry path connects the house to the stepping stone path to the driveway. Rather than plant lawn around the house, Hilderbrand specified a meadow of low-growing fescues.

An old stone jetty and lighthouse, not far from this residence, is the type of pier that inspired Hilderbrand's stone walkways.

From the driveway, Hilderbrand created a path through his new plantings of native shrubs and groundcovers. The stones, all found on the site, are arranged casually.

On a spring afternoon, as lawn mowers suddenly revved up in a neighboring yard, Hilderbrand winced at the noise. He had just stated that his goal was to make this place feel rural, calm, and quiet. To this purpose, he had ruled out any lawn. But he wanted to plant something low in front of the house in order to respect Tony Smith's simple and elegant building slab. His answer was a short meadow, created with a blend of low fescues that cope well with storm surges and salt-laden sea winds. While not very tall, this planting looks wild and breezy.

Across this front meadow, two narrow stone paths, inspired by the surfaces of the nearby stone jetties, relate to each other in an elegant way but do not meet. Though they are functional, Hilderbrand also used them poetically, to invoke recollected jetties along the New England coast.

Several stepping-stone paths weave through this landscape, making use of the ubiquitous granite found on the site. These paths are as understated as they are practical and contribute to the informality of the landscape.

This piece of pink granite is characteristic of the stone from the Stony Creek quarries.

The extensive amount of discarded granite tailings found on the site inspired their reuse in this striking composition by Hilderbrand. This passage connects a new addition to the home built in the 1950s.

Although he could have recommended that all the quarry stone be carted away, as so many local homeowners had done, Hilderbrand wanted to use the granite in a manner that would honor local history and, as he said, "capture the characteristics of the quarry," where stone was everywhere, on the vertical surfaces and strewn on the ground. Instead of discarding it, he would abstract it into art in a way that he called garden-like. To maintain the feeling of old quarry stone, he asked the masons to make every effort to use the stone as it was when it was left a century ago, rather than to chip or break it.

One exceptional pink granite stone was chosen as the entry step to the house. For the garage apron, a series of granite stones were incised with the kind of parallel splitting marks often found on quarried stone. Four "really nicely cut stones" were chosen by Hilderbrand to connect the two buildings at the ground level. Also, many existing stones were left near the entrance drive just as they were found, as a kind of historic marker of the old quarry. Tumbling carelessly down a slight slope among the trees and ferns, they are a reminder of how the property looked on the day of Hilderbrand's first visit.

Near the entry drive to the property, the site has been left mostly undisturbed, with the quarry stones still scattered as they were found.

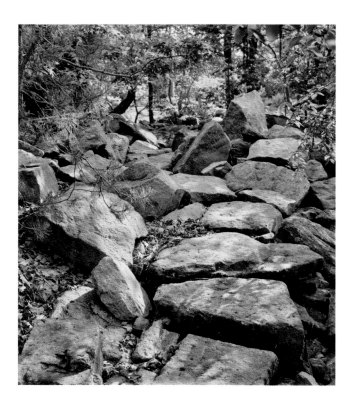

A careful look reveals that a subtle path has been created from the random rubble of the granite stones.

Hilderbrand's rough sketch indicates how he imagined the reorganization of the stones, shown as dark marks, which had completely covered the property.

Hilderbrand's most dramatic and artful use of the granite from the site is a unique and original composition of stones that begins in the tight space between the two parts of the house and continues in a gentle arc toward the tailings pit not far away. In the small area between the two buildings, these rocks, only slightly dressed by the masons, are diagonally stacked in rows, creating a work that is as much sculpture as landscape.

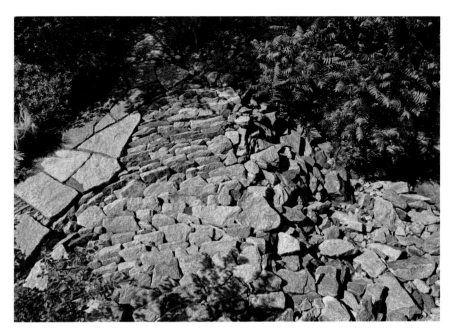

Hilderbrand created an imaginative composition in the tailings pit, with formal and tidy regularity at the top giving way to the original state of disorder at the bottom.

The tailings pit, a remnant of Beattie's Quarry, held discarded stones. As it has done for more than a century, the pit collects water during high tides. Hilderbrand manipulated some of the flat stones at the edge of the pit to create walking paths. In the pit itself, the design of angled stacked stones circles the inside of the upper section of the pit, but this arrangement gradually breaks down—from a clear pattern to a chaos of stones—until, at the bottom, there is no pattern at all, just the tailings as they were left a century ago.

Though his firm produced many sketches of this area to present his design concept for reordering the granite tailings to the clients and masons, Hilderbrand admitted it was a difficult notion to express in drawings, and some decisions about the pattern and placement of stones were made on the site. Because there was no way to give clear instructions to the masons as to how to organize the rock, he and firm principals Beka Sturges and Eric Kramer spent hundreds of hours on the property, in a robust collaboration with the masons.

Hilderbrand created a quiet seating area in front of the old mound of granite tailings, which he augmented by adding more stones.

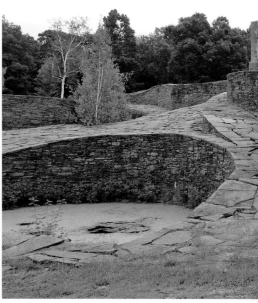

In the bluestone quarry he purchased, Harvey Fite created Opus 40 by hand, using stone from the site to create an eccentric series of monumental walls, terraces, platforms, ramps, spirals, and steps, all without mortar. One dramatic portion of this multi-acre work is shown here.

Near the pit is a mound of rejected quarry stone that Hilderbrand also kept on the site, as an interesting juxtaposition to the form of the pit. "How do we make these idiosyncratic things an asset?" Hilderbrand asked himself. He built up the mound to give it more significance, moving the rock around to make the meadow larger. Now he very much likes the quiet place to sit that he created near the mound.

When he began to think about how to incorporate all the remnant rock into the landscape, he realized there were not many precedents. One he knew from a young age is Opus 40 by Harvey Fite, who purchased a 12-acre abandoned bluestone quarry in Ulster County, New York, in 1938 and worked for the rest of his life—almost forty years—to build a 6.5-acre monument in stone. Using masonry techniques he learned from studying the ancient Mayans, Fite used only traditional quarryman tools and no mortar to create his giant stone earthwork, now a sculpture park and museum.

Hilderbrand's evocative stone compositions in Connecticut are a product of his inventive imagination, informed by his memories of Opus 40 and his knowledge of the rough days of the old granite quarry and the generation of men who shaped the stone into the building blocks of American cities.

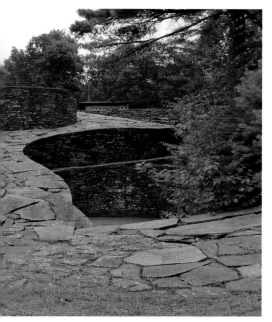

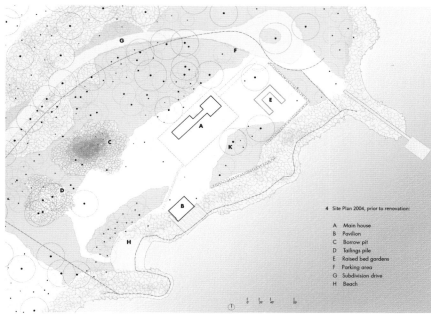

This plan shows the site before Hilderbrand's
work here.

A later site plan shows both the addition to
the house and the realization of Hilderbrand's
landscape designs.

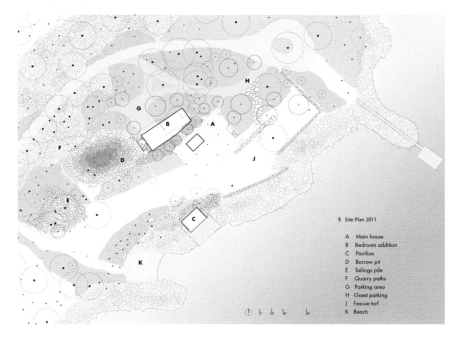

CHARLES JENCKS

**DIVIDING CELLS, MAGGIE'S CANCER CARING CENTRE
INVERNESS, SCOTLAND
COMPLETED IN 2005**

*Charles Jencks' design for
Maggie's Cancer Caring
Centre in Inverness was
inspired by the idea of
healthy human immune
cells combating cancer.*

An aerial view of Maggie's Cancer
Caring Centre in Inverness
shows the building as a dividing
cell, while the two mounds with
spiral paths represent the divided
daughter cells.

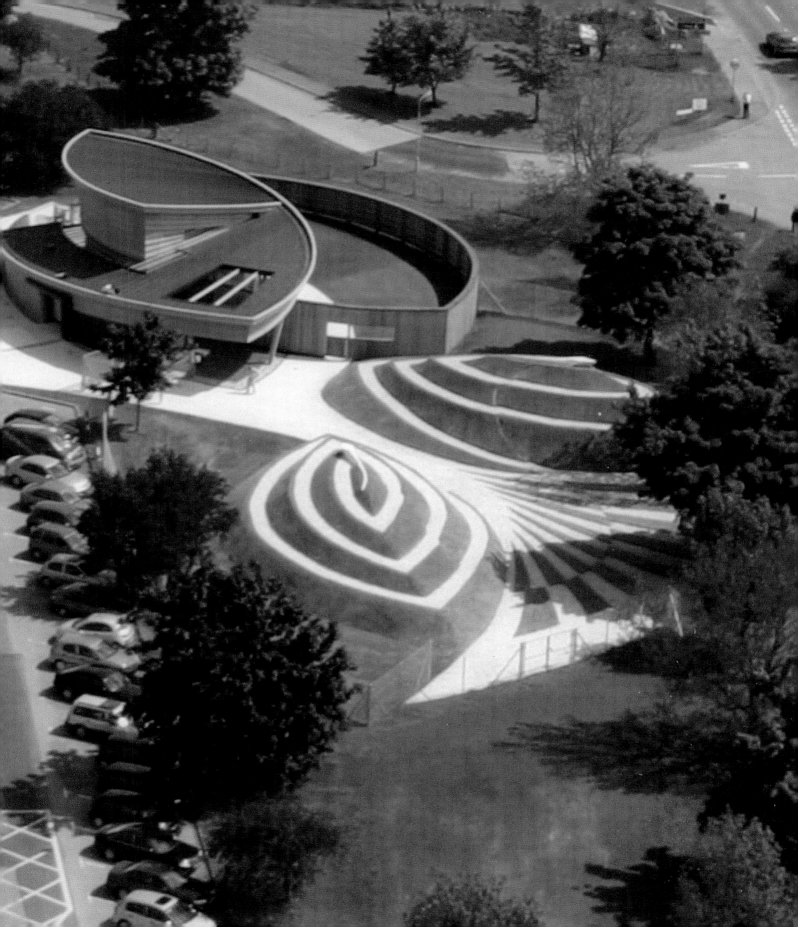

"We shape our buildings, and afterwards our buildings shape us," wrote Winston Churchill in 1944. This belief is intrinsic to the roles of architecture and landscape design in Maggie's Cancer Caring Centres. For the building and the landscape of Maggie's Centre in Inverness, Scotland, Charles Jencks suggested shapes that he hoped would deliver a message of health to all who visited. His original concept, based on the way cells divide, became a singular composition in which both the building and the landscape tell the same story.

For Jencks, the depiction of healthy cells in the garden was a personal statement and a hopeful, optimistic one, but it was grounded both literally and figuratively. Jencks knew that much of today's cancer research focuses on the idea that the key to vanquishing the disease may lie in our bodies' healthy cells. Immunotherapy utilizes specialized cells of a patient's immune system that are primed to recognize specific tumor cells as abnormal and to eliminate them through the body's normal mechanism for dealing with outside invaders.

Maggie's Cancer Caring Centres are small, disparate buildings, constructed near major hospitals in Great Britain and other countries, that offer cancer patients and their families support, information, and advice, while providing a place for a cup of tea, informational videos, counseling, companionship, privacy, and perhaps a yoga, exercise, or nutrition class. These buildings have been designed to welcome and comfort visitors and to provide a sense of the joyful possibilities of life, even in the face of life-threatening disease.

Maggie's Centres are the legacy of the late Maggie Keswick, a garden designer and the author of *The Chinese Garden: History, Art and Architecture*. Maggie (as she was known to all) was born in Scotland, but spent most of her childhood in China. She read Middle English at Oxford and studied at the Architectural Association in London, where she met her future husband, Charles Jencks, the American-born architectural writer and critic. As a garden designer, she collaborated on projects with the architect Frank Gehry, the sculptor Claes Oldenburg, and, beginning in 1989, with her husband on their 30-acre Garden of Cosmic Speculation in southwestern Scotland.

Charles Jencks and Maggie Keswick at a gathering in Paris in 1981.

Diagnosed with breast cancer at the age of forty-seven, Maggie Keswick had surgery and then, believing herself cured, put the illness behind her. When the cancer "roared back," in Jencks' words, three years later, Maggie realized that cancer patients and their families had needs that were not being met by National Health Service hospitals, where there was little access to information for decision-making about treatments and no time for comforting or counseling. She imagined a drop-in cancer caring center, free and open to the public, and she created a blueprint for such a place based on her own experiences. Maggie was actively working on plans for the first center, in an unused stable block she had noticed on the grounds of her Edinburgh hospital, when she died in 1995. That first Maggie's Cancer Caring Centre, named in her honor, opened in 1997.

The Maggie's Centre in Inverness, the northernmost city in Great Britain, is the fourth to be built. The design is the result of a collaboration between the architect David Page and Charles Jencks, who had previously worked together on the Maggie's Centre in Glasgow. Page invited Jencks to design the garden around the proposed Inverness building. As Jencks remembers, he was flying across the Atlantic from the United States on his way to Scotland for a meeting with Page when he began scribbling garden forms on a scrap of paper. The shapes he drew were healthy cells undergoing the phases of division.

Jencks had learned much about cell biology during Maggie's illness. He knew that cells communicate with each other, helping them to control their microenvironment, and that they undergo a replication process called mitosis. This process involves cells duplicating their genetic material and then dividing to form two cells. When a person has cancer, however, the process of the normal cell cycle, in which new cells are formed at a regulated pace, goes out of control. The malignant cells experience unrestrained growth, multiplying rapidly to form tumors.

After sketching on the plane, Jencks made a decision: the landscape at Maggie's Centre in Inverness would be based on the positive imagery of healthy cells undergoing controlled mitosis. It was a given that his garden would include landforms, a signature of his landscape work. "In gardens," he said, "I do always use symbolic things to engage the mind. Symbolism in a garden makes you slow down, and think, and relax."

David Page liked the idea of the cell imagery so much that he proposed designing his building around Jencks' diagrammatic garden scheme. In his building design, Page inverted the forms: while Jencks' garden cells rise above the ground plane as almond-shaped turf mounds with spiral paths that invite climbing, in Page's building the roof goes down and looks a bit like a boat. The same vesica shape—created when two circles with the same radius intersect so that the center of each circle lies on the perimeter of the other—is apparent in both the building and the mounds.

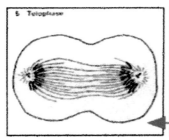
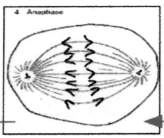
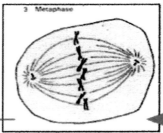
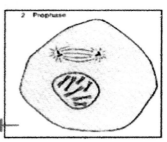

telophase

metaphase

anaphase

prophase

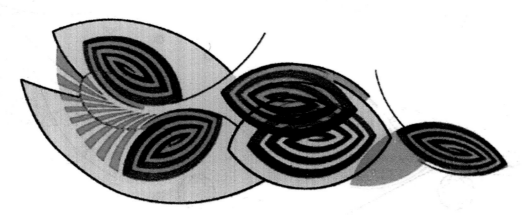

Jencks related his design of the garden to the way in which
cells divide, as seen in this diagram.

73

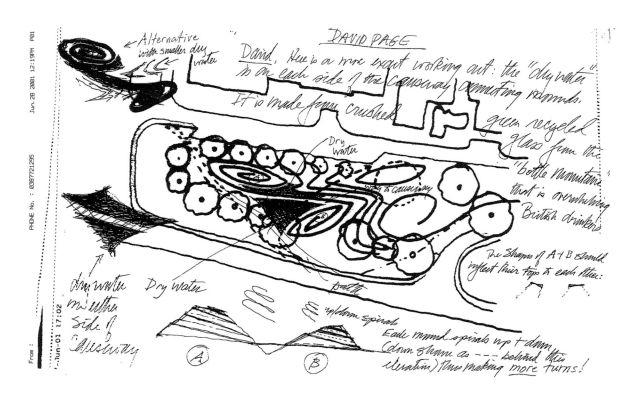

In this early sketch, Jencks' note to the architect reads, "David, here is a more exact working out."

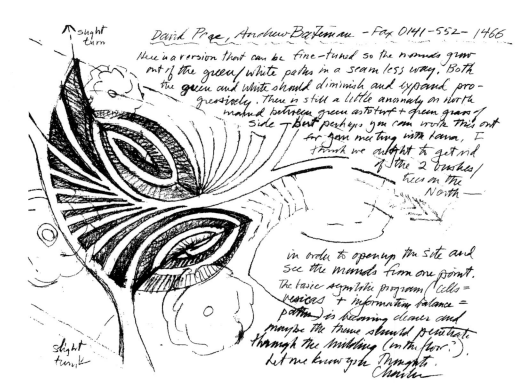

On this sketch that he faxed to the architect David Page, Jencks wrote, "Here is a version that can be fine-tuned so the mounds grow out of the green/white paths in a seamless way."

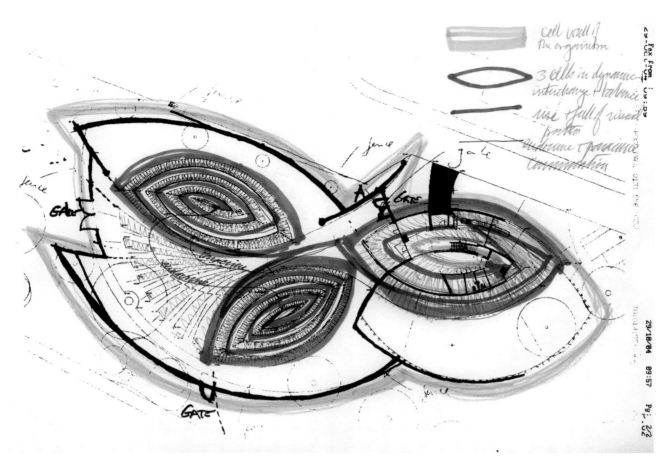

Fax from : 29-OCT-04 09:09 29/10/04 09:57 Pg. 2/2

cell wall of the organism

3 cells in dynamic interchange + balance

rise + fall of visual poetic

Jencks' concept sketch shows the proposed building as a cell in the process of dividing, while the two garden mounds to the left represent the divided cells.

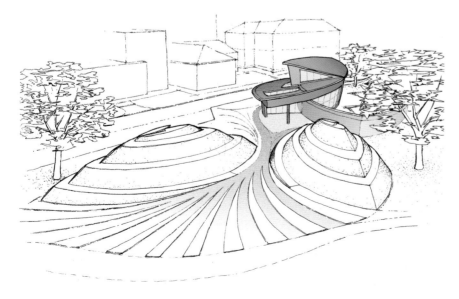

Jencks made this study for the mounds and the building.

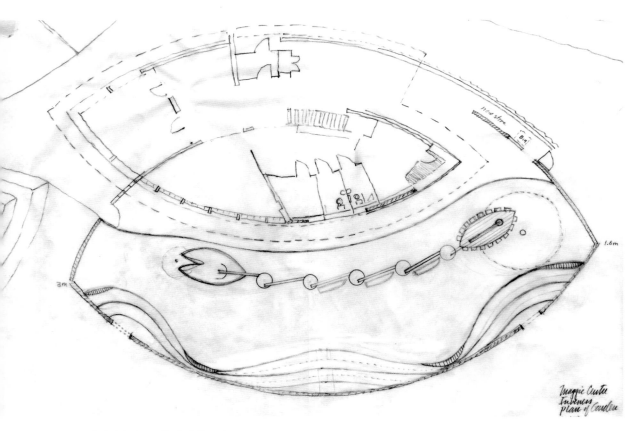

A sketch shows the building plan,
imagined as two cells dividing.

In plan, the composition of building and gardens ranges across the site from east to west. On the east side of the building, in the garden, is a single mounded cell. Then, the building itself forms a dividing cell. Biologically, as Jencks explained, this is the telophase moment of mitosis, when two distinct cells become apparent. On the west side of the building, the larger part of the garden contains the divided cells represented by two large adjacent mounds. Near these two mounds, a series of lightening shapes are carved in turf on the ground, surrounded by gravel. For Jencks, these agitated forms graphically represent the necessary communication between healthy cells. Jencks pointed out that symbolic communication continues in the shadow lines that, almost unnoticeably, "wander up the sides of the mounds."

Visitors, too, can wander up the sides of the mounds in single file, walking on the crunchy gravel paths in a spiral to the top, where a symbolic nucleus takes the form of white almond-shaped benches. On the top of each bench is an ambigram drawn in red, with spiral lines and the words "time spiral," which can be read right side up or upside down, an expression of Jencks' wide-ranging interest in using word play, symbols, and historical motifs in his gardens.

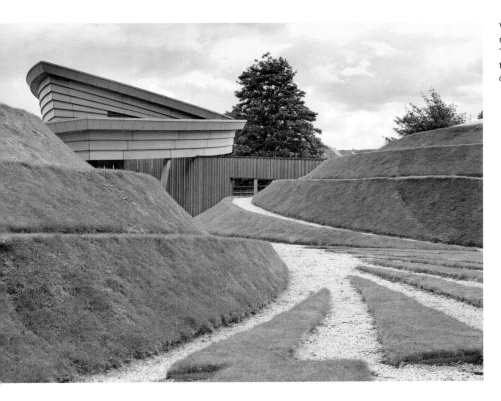

Visitors enter the building between the two mounds, representing the healthy divided cells. The lightening-like forms on the ground also travel up the sides of the mound, representing communication between the cells.

This site plan develops Jencks' concept. He and the architect worked together to express, in landscape and building, the idea of healthy human immune cells combating cancer.

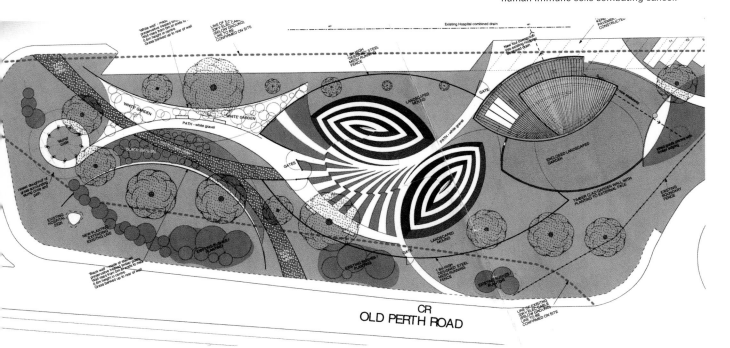

CR
OLD PERTH ROAD

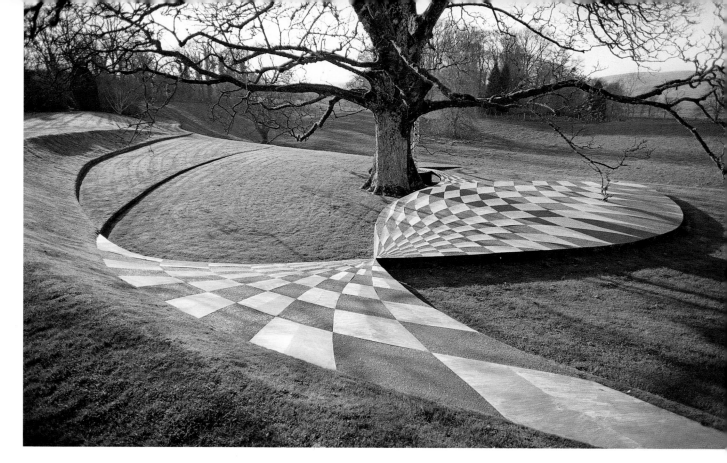

Jencks' Black Hole Terrace, which depicts the distortion of time and space caused by a black hole, is a feature in his Garden of Cosmic Speculation in Scotland.

This spiral form, a favorite of Jencks, is one he used early in his garden-making career in the creation of the Garden of Cosmic Speculation, begun with Maggie on the grounds of her parents' estate. The garden now contains forty major areas with features such as bridges, terraces, sculpture, and landforms. He used the spiral form elsewhere as well, in Italy, for example, in his Spirals of Time garden in Parco del Portello, Milan. For Jencks, it is a shape that resonates with natural forms and evolution. At Maggie's Cancer Caring Centre in Inverness, the spiral is tightened and has a taut insistent energy. The green and white patterns on the ground recall the graphic energy of the Black Hole Terrace at the Garden of Cosmic Speculation.

As in all the centers, the interior of Maggie's Centre in Inverness is meant to be warm and welcoming.

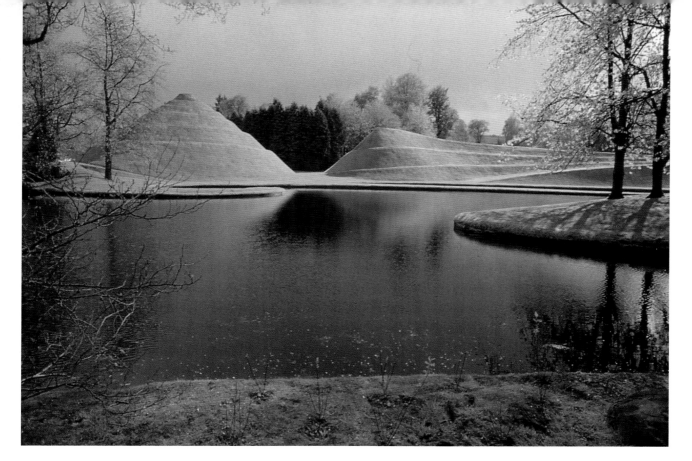

Here at the Garden of Cosmic Speculation, Jencks built large mounds with the soil removed to create the lakes, which Maggie designed. Like the mounded cells at the Maggie's Centre garden, one can climb each of these on a spiral path.

The spirals on the cell mounds in the landscape are carried through to the inside of Page's building, where the fluid space curves and turns. Though dramatic and theatrical, the building's interior is also warm and embracing, and, like all other Maggie's Centres, offers encouragement and hope to patients and their families. The symbolic message in the garden—that of healthy cells reproducing and communicating—is also meant to offer hope to cancer patients as they move through the outdoor space. A shared language of shape, color, and imagery connects the building and the garden. Like the building, Jencks' garden is meant to shape visitors' lives in a positive way. Or as Maggie Keswick wrote, "What matters is not to lose the joy of living in the fear of dying."

MARY MARGARET JONES

**DISCOVERY GREEN
HOUSTON, TEXAS
OPENED IN 2008**

*Mary Margaret Jones' design
for Discovery Green was
inspired by both local garden
traditions and the women
Jones refers to as "the strong
women of Houston."*

A long planting bed of white
azaleas evokes Houston's
storied Azalea Trail, a spring
tradition that still endures. The
colorful metal sculpture in the
background by artist Margo
Sawyer is one of several works
of art in the park.

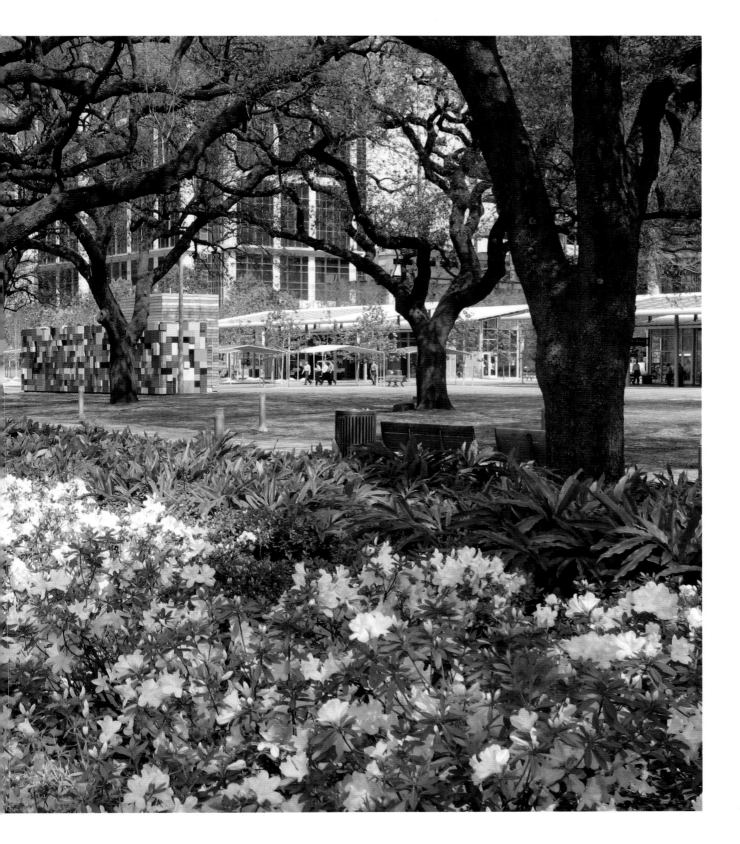

Mary Margaret Jones, who grew up near Houston, Texas, was impressed by gardens at an early age. High mounds of robust azaleas, in shades of pink and red, almost hid her family home. She remembers her mother winning all the garden club awards for flower arranging and a grandmother who always brought a new plant when she visited. Jones' childhood also included excursions to Houston's famous annual Azalea Trail, a city tradition that began in the 1930s and still runs for three days each March, organized by the women of the River Oaks Garden Club. Jones' memories include not only the colorful azaleas, but, more significantly, the dignified atmosphere of the River Oaks neighborhood that hosted the event: green lawns and large overhanging trees that shaded the streets and provided a sense of calm and of refuge from the heat.

These early experiences of flowers, plants, and gardens led Jones to become a landscape architect, and, by her own account, they influenced her landscape plan for Houston's Discovery Green. It was her intimate knowledge of Houston's garden traditions and her understanding of the city's hot and humid summers that helped her win the commission to design this new park, the brainchild of three-term Houston Mayor Bill White. Mayor White's vision was ambitious: to transform 12 acres of downtown parking lots—in an area viewed as desolate and forbidding—into a vibrant year-round park that would draw people from throughout the Houston area.

At the time Jones was engaged as the park's designer, an extensive program had been established. Meant to appeal to as many people as possible and to bring life to a bleak downtown area, this program included places to eat, playgrounds, a large performance space, outdoor sculpture, a lake, a picnic area, a tree house, a bocce court, shuffleboard, and two dog runs. The park's activities, as envisioned by the public and the civic leaders, included concerts, movies, flea markets, farmers' markets, exercise classes, kayaking, and ice skating.

According to Jones, it was a huge challenge to include all these elements within the 12-acre site. She was given a preliminary plan that showed the major components scattered around the park, and she quickly realized that this arrangement, which would have required multiple paved pathways, left little room for an actual park.

Instead, Jones found another way to organize the space, inspired by both the local garden traditions and the local activists she refers to as "the strong women of Houston," for whom parks and gardens were both a pleasure and a cause. Among them, Ima Hogg was a Texas legend, known for her civic contributions to the Houston community and for her outstanding philanthropy. She built one of her homes, called Bayou Bend, in the River Oaks neighborhood and developed extensive gardens to surround the house. Hogg's properties have become museums and parks, open to the public. Though she had died in 1975, she was still a presence is Jones' mind. Nancy Kinder is a respected, long-time advocate for urban green spaces, and it was vital to the success of the park that Kinder agreed to be the founding chair of the Discovery Green Conservancy, a nonprofit citizens group that worked with the city and with local foundations to make the park a reality.

Maconda Brown O'Connor, the third member of Jones' triumvirate, took an active part in the planning process for Discovery Green. O'Connor's father was Houston businessman George R. Brown, and the project's organizing group met at the offices of the Brown Foundation. During these meetings, when all the required park activities threatened to overwhelm

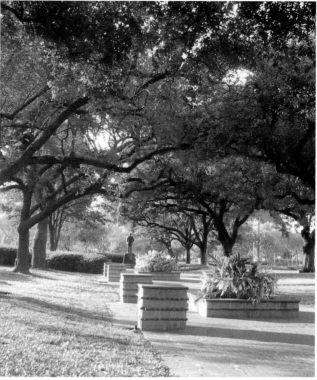

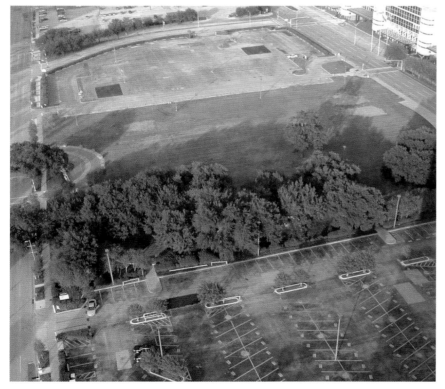

TOP LEFT Miss Ima Hogg is seated at Bayou Bend, next to her famous azaleas.

TOP RIGHT This existing allée of live oaks on the site resonated with Jones' memories of the old shaded neighborhoods that she loved in Houston. These trees remain as an important design element of Discovery Green.

LEFT Parking lots covered most of the site of the future Discovery Green.

Jones' task involved fitting a remarkable array of activities into Discovery Green.

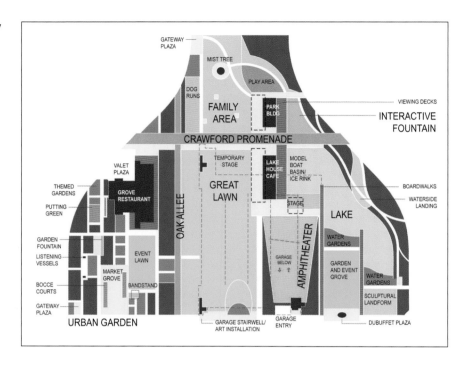

the landscape, O'Connor stated bluntly that she did not intend to help pay for something that was not beautiful. Her message, "Make it green and make it beautiful," became a mantra for Jones, whose goal was to make the park feel like the inviting neighborhood oases she remembered from her childhood, rather than an amusement park.

In studying the site, Jones recognized the existing row of live oaks that lined a former street within the park's boundaries as a great asset. Though the street was gone, the trees formed a shady allée, running more or less north–south. The strength of this linear geometry led to Jones' design strategy of closing Crawford Street, which ran perpendicular to the oak allée, to create two wide pedestrian pathways that crossed at right angles. Crawford Street became a promenade, and after considering various options, Jones clipped most of the program elements along that path.

This scheme created a clear spatial plan within the park, so visitors always know where they are. In addition, this design met O'Connor's request for a "green and beautiful" place by allowing room for a generous 2-acre lawn, the largest single element in the park and one that provides the same kind of open space that attracts people to urban green spaces, such as the Great Lawn of Central Park in New York City, Jones' present home town.

Other features fell into place, as Jones' plan was like a geometric puzzle into which the various program elements were fit. As a result of this organization of the activities and spaces, visitors navigate easily through the park, from the play areas to the dog runs to water features, gardens, and a restaurant. Parking is underground, and the sloped lawn above the garage entrance creates

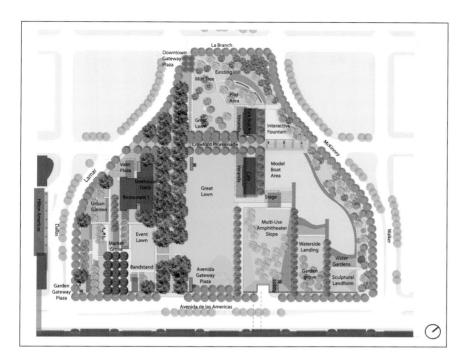

The Discovery Green plan shows the existing allée of live oaks and the adjacent 2-acre lawn, as well as the many features Jones was able to include in her plan.

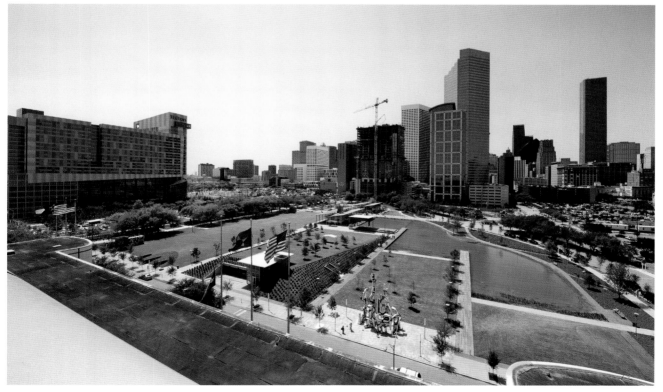

A long aerial view of the park shows the 2-acre lawn adjacent to the oak allée, the garage entrance below a sloping amphitheater, and the lake with its long boardwalks.

Trees, gardens, lawn, and activity spaces have
replaced the old parking lots.

Visitors stroll in the shade of the live oak allée.
This wide path was once a road.

amphitheater seating for performances. Throughout, there are
interactive sculptures by local artists, as well as a major work by
French artist Jean Dubuffet. Houston, with its own museum dis-
trict, is a city of art as well as gardens.

On the program's wish list was a tree house, so visitors could
experience being within the branches of the oak allée. At Jones'
suggestion, the restaurant was designed with a second story, so
that diners on the upper terrace would feel that they are in the
trees. Recently, a new deck with moveable tables and chairs was
added in the shade of the allée near the restaurant. As Jones notes,
in this steamy climate everybody wants to be in the shade. To this
end, the planting plan included many new trees.

MARY MARGARET JONES

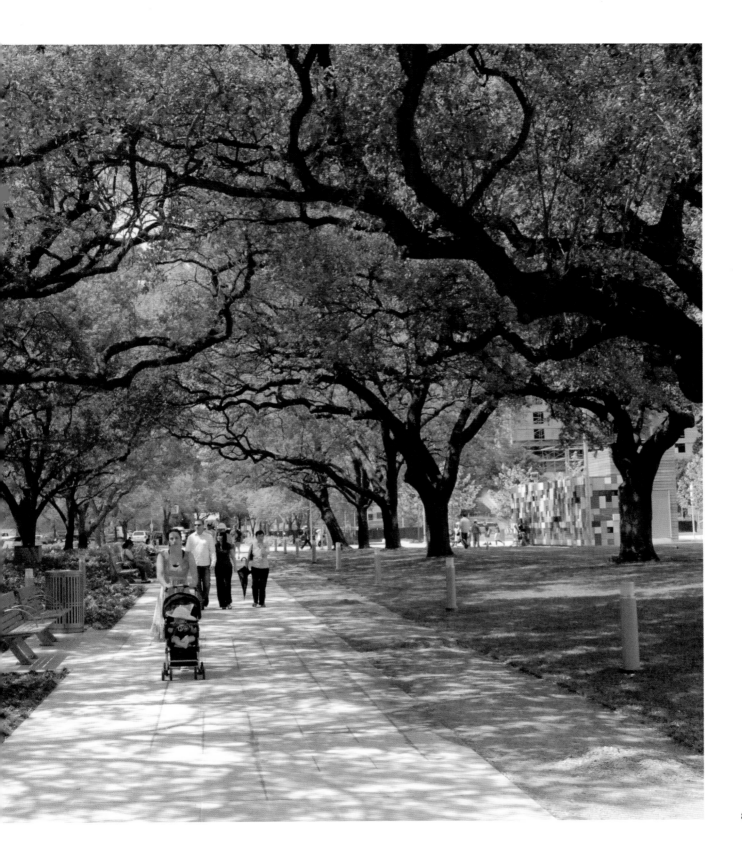

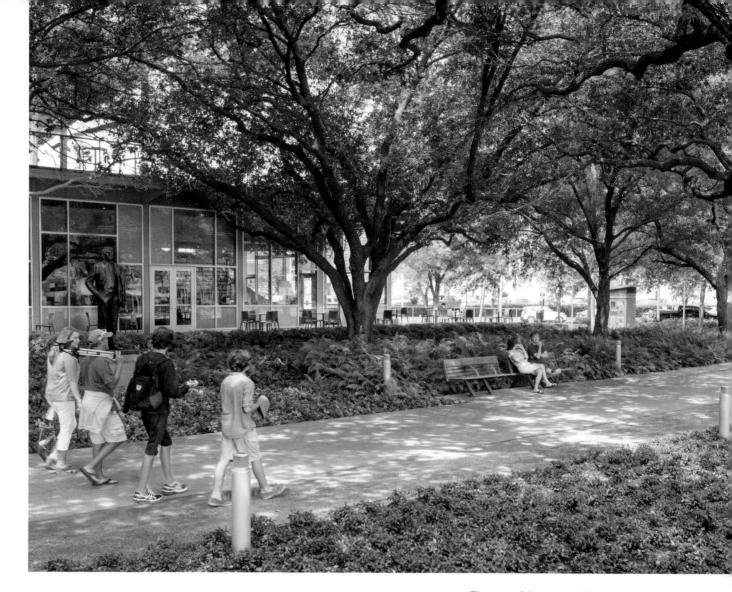

The trees of the inviting allée are now lushly underplanted with groundcovers.

OPPOSITE TOP In the extensive garden area close to the restaurant, colorful plantings contrast with the more muted palette elsewhere in the park. In the background are artist Doug Hollis' limestone *Listening Vessels*.

OPPOSITE BOTTOM An aerial view of the garden area shows the rectilinear layout of the beds of themed plants.

Near the restaurant are urban gardens in a rectangular pattern, planned by theme: one garden is for scent, another for butterflies, another for native plants. These garden areas provide color and charm, and Houston's traditional azaleas have found a place here as well.

One feature of her design has particular resonance for Jones: two long parallel boardwalks overhang the lake she designed for model boats and kayaking in summer and ice skating in winter. These walkways evoke another memory of her Texas youth, the piers that reach far out into Galveston Bay, where she spent many summer days on outings with childhood friends. The boardwalks in Discovery Green, which reach into the pond, are enjoyed by children and are also a popular site for wedding photographs.

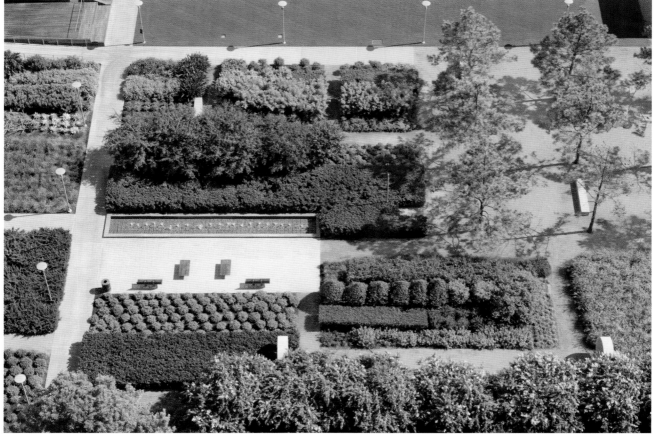

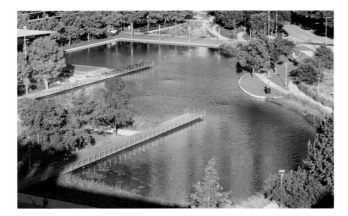

These boardwalks at Discovery Green recall the long Galveston Bay piers that Jones remembers from her childhood.

The long piers at Galveston Bay, which she had visited as a young girl, inspired Jones' docks at Discovery Green.

In keeping with the traditions of Houston's old neighborhoods and those of the nineteenth-century urban parks in England and the United States, Discovery Green has flowers and trees as well as activity spaces. The park employs twelve park staff members and hosts activities on an almost daily basis. These include annual Halloween costume parties, Saturday yoga classes, farmers' markets, dance and music performances, and movie nights. Family birthday parties are frequent here. In winter, large ornaments that feature the faces of Houston residents are hung from the trees, a symbol that this park has been created for the enjoyment of local people. Maconda Brown O'Connor, who demanded that the park be green and beautiful, is honored by a collection of tall loblolly pines called Maconda's Grove. The "strong women" of Houston, past, present, and future, have every reason to be proud of the transformative downtown park created by Mary Margaret Jones.

Children beating Houston's summer heat in the interactive spray fountains.

The park is often filled to capacity for performances.

MIKYOUNG KIM

CROWN SKY GARDEN
CHICAGO, ILLINOIS
COMPLETED IN 2012

Mikyoung Kim's visual inspiration for this hospital project began with ribbons, an often-worn symbol of caring and support, and her use of luminous resin for the sinuous walls was inspired by the work of sculptor Eva Hesse.

An overhead view of the Crown Sky Garden shows the ribbon-like layout of Kim's resin walls.

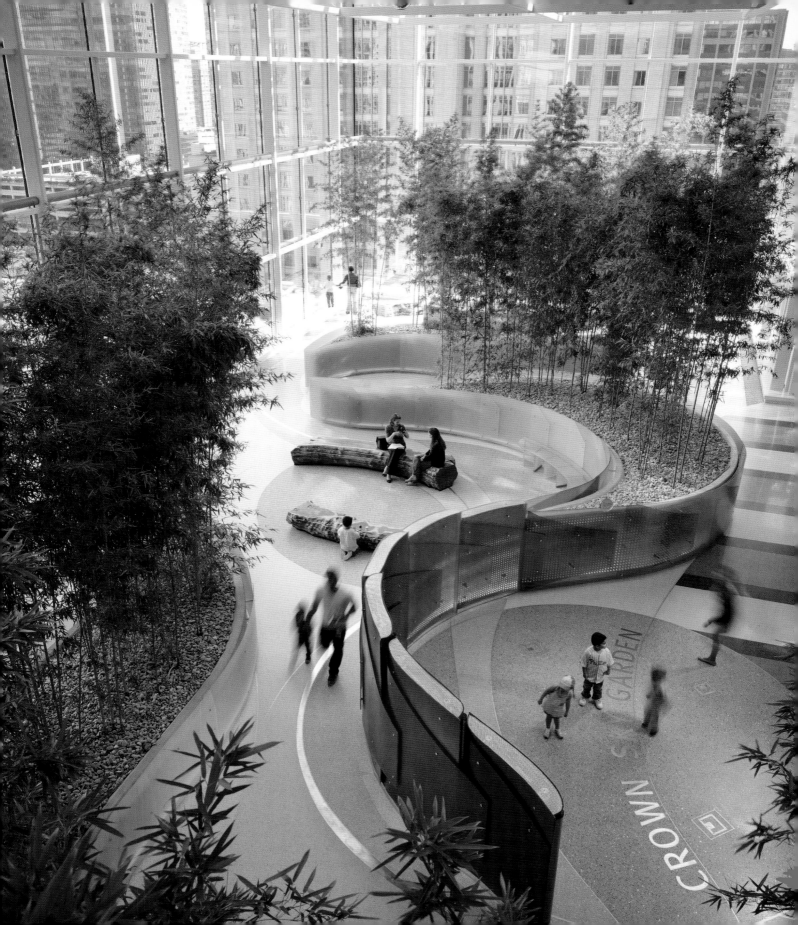

According to Mikyoung Kim, the young patients who use the Crown Sky Garden at the Ann and Robert H. Lurie Children's Hospital in Chicago receive a wide range of care. Some are recovering from major surgery and may remain in this hospital for a very long time. The 5000-square-foot enclosed rooftop garden was created to provide sunlight and a connection to nature for these children, their families, and the hospital staff.

An oasis need not be in a desert or even out of doors, and the Crown Sky Garden provides the requisite oasis elements of water and plants while also offering amusement and refuge. This garden is both lively and calm, a kind of abstracted landscape where changes in light, color, and sound are controlled by the movements of the patients and their visitors.

From the beginning, Kim was inspired by the children's ideas about what the garden could and should be. As these young patients spoke with her, she made a diagram of their thoughts in her notebook, almost like a musical score. Kim said that her diagram illustrated the complexity of the children's aspirations for the rooftop garden.

Kim's visual inspiration for this project began with ribbons, as she thought about how they are worn as symbols of support—often for those in need. She found an image of colorful overlapping ribbons and hung it on her office wall. Then she made a collage, imagining her color scheme.

At first, the ribbon image was just the beginning of a concept, as Kim imagined ribbon-like forms flowing through the rectilinear space. Then the ribbons became a series of curving walls that created quiet areas where small groups could gather in privacy while allowing enough open space for children to move around freely, something the children themselves had requested in her meetings with them. In the finished garden, bamboo groves occupy some of the spaces within these undulating walls, which are illuminated and contain sound, light, and water.

Kim's collage for the project, which she called a "sketch," shows her initial thoughts about colors in the garden.

OPPOSITE TOP Kim's early concept plan for the Crown Sky Garden shows the ribbon motif flowing through the space.

OPPOSITE BOTTOM Children run through the garden spaces. The bubbling wall of multi-colored marbles can be seen in the background.

As the material for her garden walls Mikyoung Kim chose resin, which met the hygienic requirements of the hospital. Although she had used sheets of resin in her previous landscapes, her interest in resin and other liquefied materials began during her college years. After acute tendonitis ended her plans for a career as a concert pianist, Kim began to focus on sculpture, and she found she had a special interest in malleable materials like plaster and clay. For one of her early pieces she made partial casts of her hands. Mounted on a wall, this sculpture reached out toward the opposite wall to a cast of one perfect hand. As this piece suggests, she was mourning the loss of her ability to make music, even as she was finding a way to express herself through sculpture.

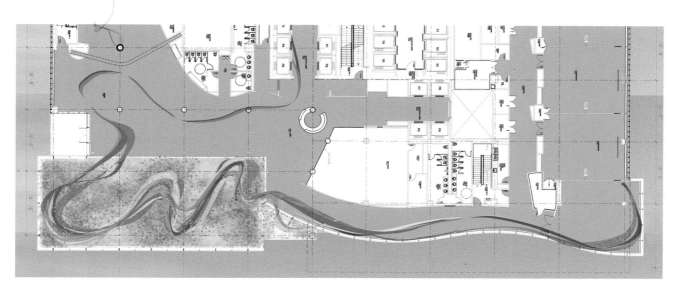

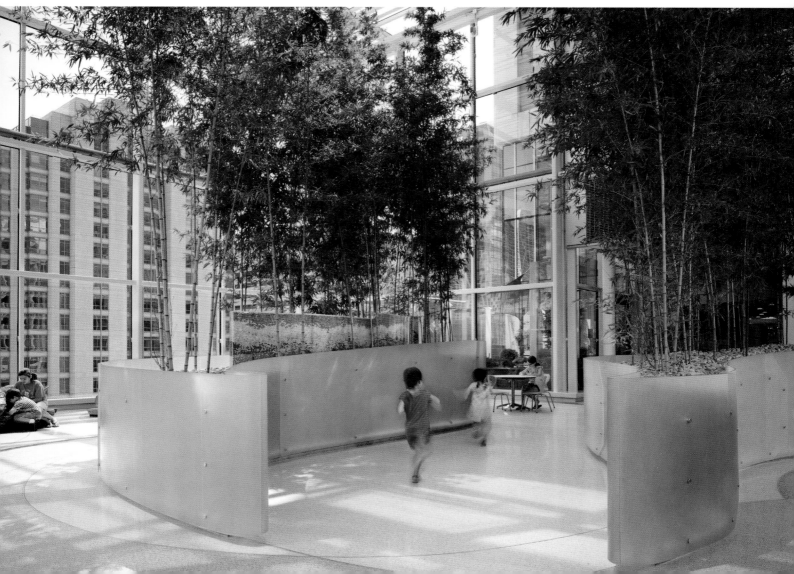

Kim is shown as a college student in a master class with Leon Fleischer before her planned concert career was cut short by severe tendonitis.

TOP RIGHT Kim's hand sculpture reflects her anguish at the loss of her ability to play the piano.

Eva Hesse's work, such as the 1968 *Repetition Nineteen III* in fiberglass and polyester resin, was an important inspiration for Kim.

One of Kim's early influences as a sculptor was Eva Hesse, an artist who pioneered the use of fluid materials such as latex, fiberglass, and polyester resin. Kim cited a work she saw by Hesse at the Yale Art Gallery as an important inspiration. "It allowed me to think about structural systems that were more organic and fluid—," Kim said, letting the thought hang in the air. She continued, referring to the systems she sees in Hesse's art, "There is a kind of modularity to the Crown Sky Garden's resin wall. There is a layering, and I think the luminosity of the wall is also inspired by some of Hesse's work."

Two of Kim's previous landscape projects also can be seen as precursors of—if not direct inspirations for—her Crown Sky Garden design. In 2007 Kim created a fence of Cor-Ten steel that, while serving as a corral for a family's dog, is also an arresting piece of sculpture that evokes skeletal shapes. Inspired by the structure of oak leaves and the photographs of Étienne-Jules Marey, it weaves through a wooded 3-acre landscape in Massachusetts. Thinking back to this fence, a structure that both divides and connects, Kim said, "If I had not done that project, probably the form of the Sky Garden would be very different."

The other precursor was one of her earliest projects. While still in graduate school, Kim was intrigued by the way in which sculptural walls can connect people and offer an opportunity for imaginative play, even as they act as dividers. For a school-yard in Hartford, Connecticut, she created multiple curving walls of colored concrete, pierced with openings of various sizes and at different heights that encourage spontaneous games of hide-and-seek. Kim considers the Crown Sky Garden, completed almost twenty-five years after the Hartford project, the next step from the schoolyard, where, for the first time, she created walls not as barriers or partitions, but as places to play.

Kim's *Flex Fence* winds through the woods and presages the curving resin walls of the Crown Sky Garden.

Kim's 1998 schoolyard project was a precursor to the Crown Sky Garden in the use of curving walls that provide some privacy while stimulating impromptu play.

The movement of people in the space turns on various lights in the resin walls.

Site Score: Fountain Sound and Rhythm

Interactive Sound Element in Wood

bubble, drip, gurgle, murmur, tr

glug bubble SPLASH! droplets SPLAT!!

splash glug plop pop gurgle drip......drip.....drip drip

slurp bubbles gurgle super slurp puddle splash

Kim's sound score for the garden includes water motifs.

In the Chicago hospital, both the walls and the children play. Kim explained that the garden is a kind of musical instrument that plays when the children interact with it. The cast bronze hands of former patients invite visitors and patients to place their own hands within them, an action that triggers sounds of nature. Sensors in the ceiling also respond to the speed of the children's movements, activating lights in the walls.

The cast hands, which recall Kim's college sculpture project, are imbedded in logs that literally bring pieces of Chicago into the garden. The design team envisaged a huge local tree that would be repurposed as part of the garden, and they waited for an appropriate giant to fall in a storm. With good timing, and the help of an urban forester, they acquired such a tree, a massive mulberry that had been planted in Chicago by Frederick Law Olmsted during the time of the Columbian Exposition in 1893.

The tree's massive logs were cut and kiln dried for a year. Kim worked with a craft workshop to turn them into interactive sound logs, which are also lit from within. The old tree had substantial rot, but Kim did not want it cleaned up. Instead, at her suggestion, amber-colored resin was cast into the rotted areas—a kind of metaphor for healing—and speakers for the sounds were punched into the resin. "The healing process often leaves a scar," said Kim, who wanted to honor the recovery process, not mask it.

An oasis must have water, but because of health concerns and the requirements of infection control, the hospital vetoed the open fountains that Kim originally proposed. The water in the garden had to be completely contained, and Kim's solution was inspired by something very close to home: her son's large collection of marbles from all over the world. Kim, who enjoyed playing marbles with him, was equally charmed by the variety of their colors and patterns.

A warm hand placed in the bench's recessed handprint triggers nature sounds that come from within the bench.

After this mulberry tree was felled by a severe storm, the harvested logs were dried and crafted into sound-producing benches for the garden.

Resin creates amber light within the wooden logs of the benches. Speakers are recessed into the amber.

Kim's son has loved marbles since early childhood, as evidenced by the collection that inspired her marble-filled wall of bubbling water.

The Crown Sky Garden glows at night within the Chicago cityscape.

Stacked glass marbles are organized by color within walls containing bubbler fountains that animate the garden. They also provide a sound barrier for two large quiet spaces. Best of all, in Kim's mind, the last few marbles in these walls were placed there by Kim's "initial kids," the children who lobbied for this garden and met with her to share their ideas. No longer children, they returned to the Crown Sky Garden to help her place the last few marbles into the bubbling wall.

Gardens have proven to be places that aid the healing process, and the Lurie Children's Hospital is part of a consortium of hospitals studying how therapeutic gardens reduce patient recovery time. Though they may be helped to heal by this garden, for the young patients and their families the enclosed rooftop oasis is simply a magical place to be.

PETER LATZ

LANDSCAPE PARK DUISBURG NORD
DUISBURG, GERMANY
OPENED IN 1994

Inspired by the legend of the medieval German king Barbarossa and the Greek myth of Ariadne and Theseus, Peter Latz retained the concrete bunkers and decaying machinery at a former industrial site both as important reminders of the past and compelling landmarks that would help visitors to find their way.

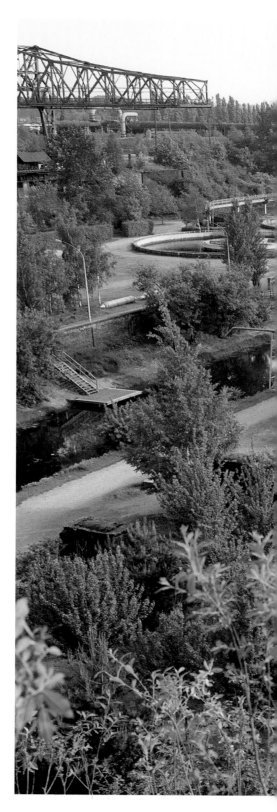

This view down into the former ore bunkers, now transformed into imaginative walled gardens, is emblematic of the ways in which Peter Latz reimagined the derelict industrial site in Duisburg, Germany, as a public park.

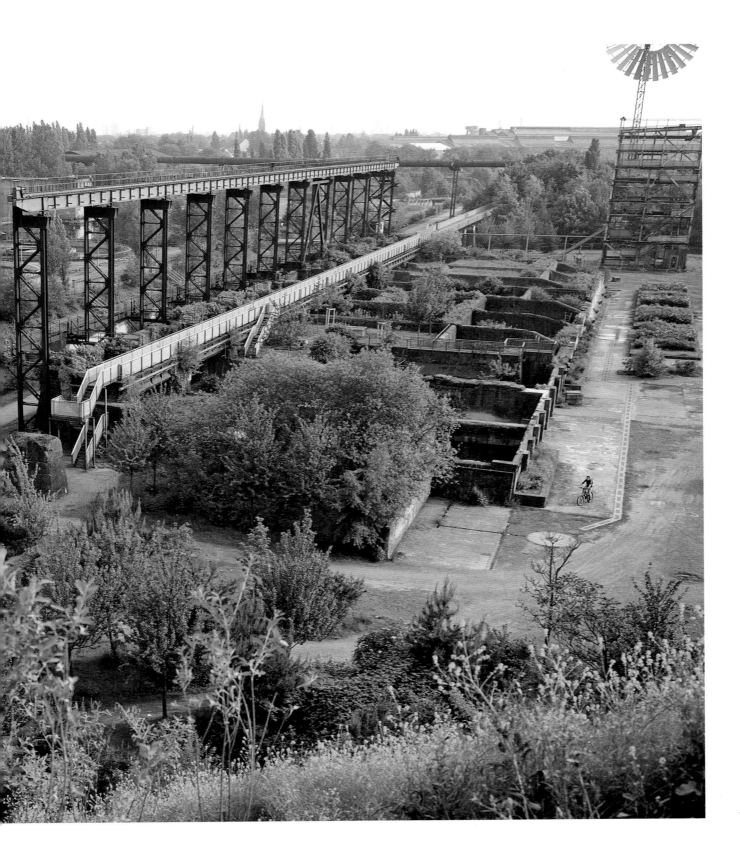

Latz told the story of a young boy, walking with his father through the vast complex of the former Thyssen steelworks in Duisburg, which had been closed since 1985. The boy asks his father, a former worker there, if the falcons still flew around the tall towers of the blast furnaces. The father said, "Yes."

Latz knew that his audience would recall the famous legend of Barbarossa, the medieval German king who drowned in the Saleph River in 1190, during the Third Crusade. According to legend, Barbarossa, a charismatic leader of mythic strength, did not die, but sleeps in a cave under the Kyffhäuser hills in Bavaria. He will awaken to restore Germany to its ancient greatness only when the falcons no longer fly around his mountain.

Latz's story and its appeal to the power of collective memory was a plea to preserve, not destroy, the "magic mountains" of concrete bunkers and decaying machinery that most people perceived as eyesores. Rather than erasing these structures, Latz wanted to retain them and to incorporate them into a new kind of landscape, one in which nature—both wild and cultivated—and the stabilized and preserved industrial remnants enhanced each other. Where his competitors, he said, only kept the blast furnaces as a picturesque forms, Latz saw value in using these structures, not only as important reminders of the past, but also as large and compelling landmarks that would help visitors to find their way around the future park.

T he transformation of a sprawling abandoned industrial complex of steel blast furnaces, ore bunkers, slag heaps, and rail lines into the vital and popular Landscape Park Duisburg Nord began with an unusual design competition, one that was collegial rather than contentious. Instead of working separately in their own offices, the five international teams vying to design the new park worked in one large office within the 500-acre debris-filled site. According to landscape architect Peter Latz, the organizers felt that all the competitors would sharpen their ideas if they were thrown together.

There were no secrets. For a year, the designers' sketches and plans were open to view, and the landscape architects talked freely with each other about their concepts. At the time of the interim presentations, however, Latz did not show sketches and plans. Rather, he "only told stories." Through stories, he believed, he could best reveal his own sources of inspiration and inspire others to embrace his unorthodox vision for the new park.

Finding one's way around the site, both literally and figuratively, was a daunting challenge for the designers and for the judges who were deciding which firm would win the commission. To address this issue, Latz told the story of Hansel and Gretel. But he knew that his educated audience would also know the ancient version of this narrative, the tale of Ariadne. In Greek mythology, Ariadne, daughter of the king of Crete, was put in charge of the labyrinth of Knossos, the domain of the man-eating Minotaur. The intended victims of this monstrous creature would be led to the maze from which escape was impossible. However, when Ariadne saw Theseus, an Athenian about to be sacrificed to the Minotaur, she fell in love at once. To save him, Ariadne gave him a ball of thread to unwind while he was in the labyrinth. Using the thread, Theseus found his way out of the maze.

Though the existing Duisburg site was an incomprehensible maze, Latz argued that it was not necessary to make a completely new circulation pattern, as people would find the breadcrumbs or the thread. With the help of clarifying elements, like the path system and the existing railroad tracks, visitors would be able to enter the park without anxiety, knowing they could always find their way. The tall industrial machines, visible from all directions, would become guiding landmarks, and they also would hold history and the memory of this area's industrial past.

Based on his stories and on his concept of working with the existing structures—as well as the significant cost savings in this approach—Latz + Partner was chosen to design the park. An overriding concept of Latz's plan was that most existing materials were to be recycled; no materials were to leave the site. Heavily polluted demolition waste that could not be used was buried in the ore bunkers, which were then sealed with concrete and covered with soil. The bunkers became a series of gardens.

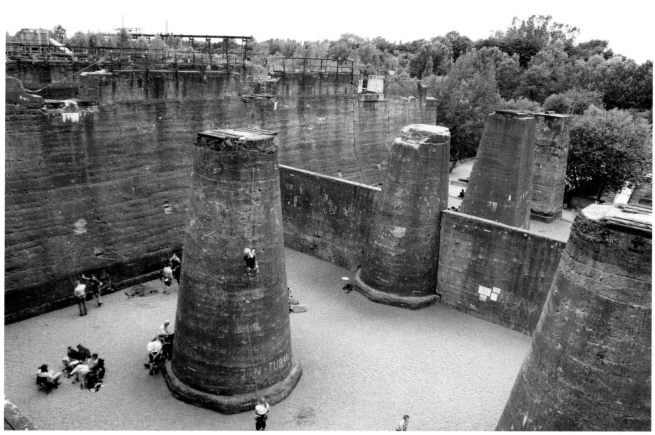

The former ore bunkers have found a new use as popular climbing walls, which for some evoke alpine scenery.

The Latin inscription on the labyrinth at the Lucca Cathedral in Italy translates, "This is the labyrinth built by Daedalus of Crete; all who entered therein were lost, save Theseus, thanks to Ariadne's thread."

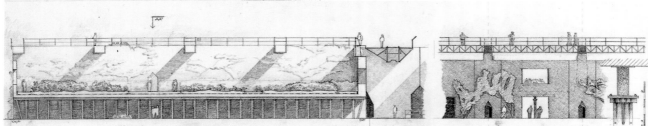

Latz's drawings for one of the bunker gardens illustrate how they can be viewed from two levels. The planting scheme here features ferns and rhododendrons.

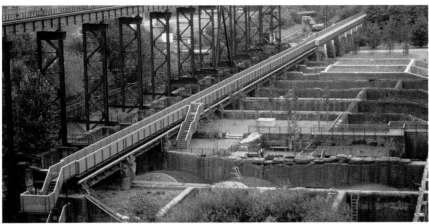

New site elements are painted blue to distinguish them from the older industrial structures at Duisburg Nord. This elevated walkway, made of recycled steel, overlooks the rectangular bunker gardens, which also are accessible from a lower level.

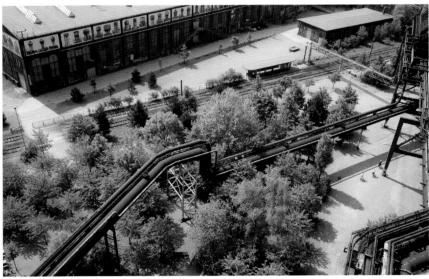

Latz + Partner's plan for Duisburg Nord shows both the new plantings as well as the old buildings that were kept as part of the area's industrial heritage.

This aerial view shows the old railway tracks still in place, as they are throughout the park. New trees soften the open spaces of the old industrial landscape. The former electrical power plant, at the top, is now an exhibition hall and event space.

Many found objects of industrial debris from the site were placed in the community garden, where visitors would see them as evocative artifacts of the past.

This fern garden, made with branches of birch trees that overgrew the old railroad tracks, is seen by Latz as a symbol of the entire project.

In collaboration with a local community group, a fenced area with flowering garden beds continues to flourish.

The very process of recycling provided more design inspiration. The Fern Spiral, for example, was made with birch wood from trees that had overgrown the railroad tracks. According to Latz, the spiral form of an unfurling fern is an old symbol for growth. Though moss now almost completely obscures the original pattern, Latz compares it to the moss gardens in Japan, adding that it only takes twenty years to become overgrown. For Latz, this small secluded garden in a former bunker is symbolic of the entire project, which he sees as a continuing process of metamorphosis.

In another area of the park, not far from residential streets, former workers from the plant and residents of adjacent quarters created an enclosed garden, using recycled materials from the site. The trees have now grown, offering shade for pleasant strolls, and the planting beds are filled with flowering perennials maintained by the park's gardeners. Among these plants, the gardeners continue to place collections of screws and bolts and other found objects from the site.

Latz believed that if his plan created interesting spaces, then people would decide how to use them. In fact, about a hundred local groups came forward, attracted by the possibilities of new venues for their activities, and these groups provided many ideas for areas within the park. An alpine club suggested that the high walls of the concrete ore bunkers could be used for climbing walls. This is now a hugely popular activity. Divers engaged to explore and clean the old canals approached the Latz team with a question: Could they use the enormous cylindrical gasometer, formerly used to store gas, as a training tank for divers? The gasometer was cleaned and filled with water. It is now fully booked by divers, one of many activity centers that keep the park filled with people.

A grove of trees stands near the gasometer, built in 1920 for storage of blast-furnace gas. It is the largest indoor diving area in Europe, used by scuba divers who explore the wrecks and artificial reefs that have been installed at the bottom of the tank.

In one of many examples of the imaginative use of materials at the site, a pipe has become a slide for children.

As the plans for the park further developed, some of the design inspirations at Duisburg Nord came from Peter Latz's own experiences and personal history. His boyhood memories of blast furnaces lighting up the sky like fireworks may have made the derelict Thyssen machinery seem like friendly dragons, rather than piles of scrap metal. The cherry trees planted in an elegant grid on a pedestrian plaza near the blast furnaces recall the fruit orchard he planted as a teenager. He sold the fruit to help support his family, then later sold the orchard to help pay for his education. One of the secret gardens in the ore bunkers, unexpectedly decorative with undulating lines of boxwood, was inspired by the parterres of Peter and Anneliese Latz's favorite garden in Italy, the Villa di Vignanello, also known as Castello Ruspoli.

Among the most successful interventions in Duisburg Nord is the canal that flows through the park for almost 2 miles. A former sewage canal that ran here was piped underground, and the new canal is now a center for recreation. Rainwater collected on the site flows through an oxygenation system and is pumped up into higher channels by an Archimedes' screw driven by wind power. The water then makes its way through the bunker gardens to fall from several heights into this clean, attractive, and accessible watercourse.

Recycled and cleaned water is fed into the formerly polluted canal.

The favorite Italian garden of Peter and Anneliese Latz is at Castello Ruspoli, north of Rome. This restored 500-year-old parterre garden, built within a high-walled terrace, served as inspiration for one of the walled gardens in the former ore bunkers.

This settling tank, which serves as a retention basin, is part of the system that provides the new canal with clean water. Visitors also see it as an unconventional water feature.

A diminutive summer meadow grows around the old railroad tracks.

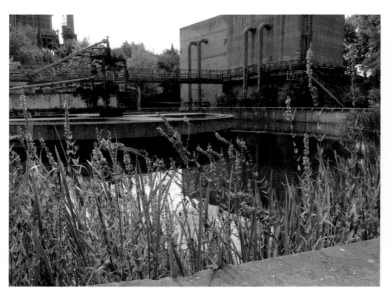

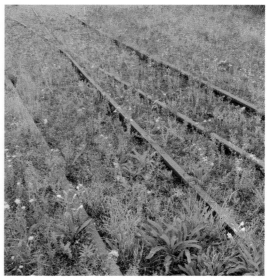

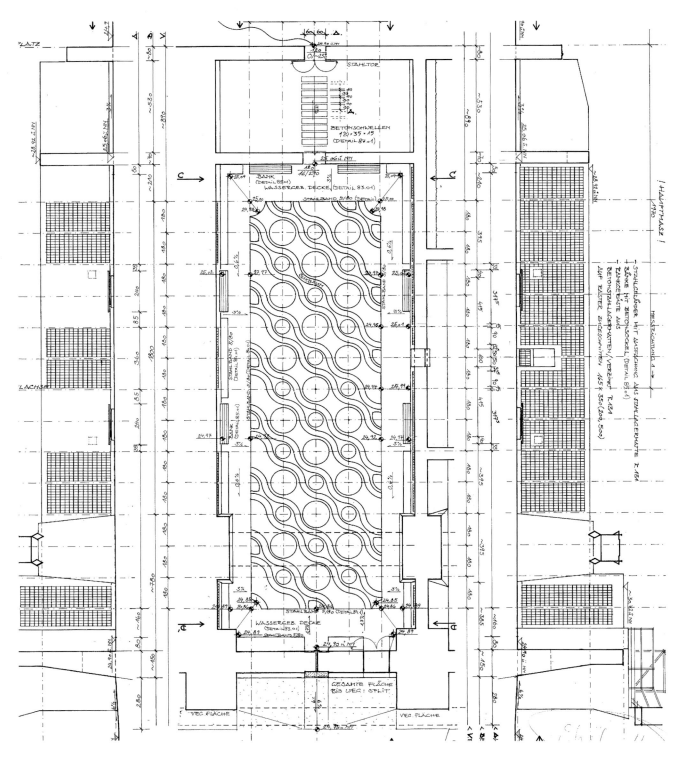

In this plan for the hydrangea garden, the wavy diagonal lines of boxwood are in playful contrast
to the heavy bunker walls. Seats invite visitors to spend time here.

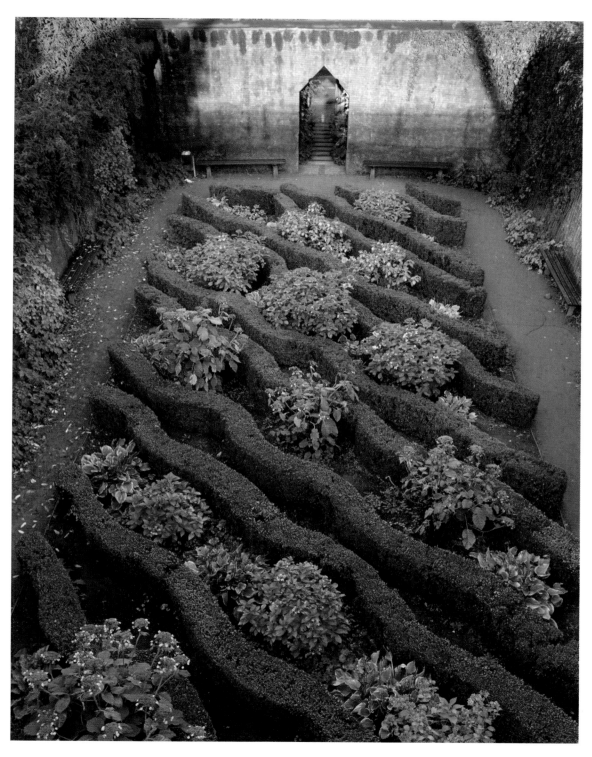

Seen here from the blue pedestrian bridge is the boxwood and hydrangea garden in a former ore bunker. All of the bunker gardens have entrances on the lower level, created by cutting through the 8-foot-thick walls with concrete saws.

The freezing and thawing of ice in a small fountain in Latz's back garden inspired the concept for the Piazza Metallica.

The central feature of the Piazza Metallica is a grid of steel plates that will rust and slowly erode in time, a metaphor for loss and memory.

The Piazza Metallica, the heart of the park, is filled with people during festivals.

Fireworks recall the times when the blast furnaces spewed fire through the night.

What Peter Latz calls the heart of the park is the Piazza Metallica, a place for festive gatherings and concerts near three former casting houses. In these buildings, which were known as the Halls of Fire, iron ingots were produced from the pig iron that flowed directly out of the blast furnace and into a bed of sand on a fireproof floor. The Piazza Metallica is named for the square metal plates, each weighing several tons, which had been used to cover the casting molds. Latz discovered them in the abandoned foundry and had them placed in a grid in the open plaza space of Casting House 1.

Latz's inspiration for their use was a small square fountain in his own backyard, where he observed the ice freezing and melting in winter. Similarly, it is expected that the forty-nine steel plates in the Piazza Metallica will rust and erode, a process that has already begun. For Latz this is a metaphor for loss, mortality, and memory, including the memory of this site. And it is a direct reminder of the melting process used in creating solid iron. Latz sees the Piazza Metallica, like the fern garden, as a symbol of metamorphosis.

Two decades after Latz presented his stories and won the competition, Landscape Park Duisburg Nord is internationally celebrated as a pioneering and imaginative work of landscape architecture, one that has brought attention to the creative reuse and recycling of structures and has inspired many other projects throughout the world. Duisburg Nord is an intensely used park, filled with tourists as well as local residents. As Latz anticipated, people find their own paths, using the giant structures as guideposts. There are places to be quiet, even with the film festivals, dance programs, theater productions, concerts, and motorbike races that take place within this new, visionary landscape. Fittingly, there are also fireworks.

But the park fulfills Latz's vision in another way. One of his stories tells how an old man, who perhaps once worked in the foundry, leads a group of children through the park and explains how all this old machinery once worked. Most of all, it is this image that inspired Peter Latz.

SHUNMYO MASUNO

GARDENS AT SAMUKAWA SHRINE
KANAGAWA PREFECTURE, JAPAN
DESIGNED IN 2009

Japanese spiritual traditions and the long history of garden-making in Japan are the inspirations for all the work of Shunmyo Masuno, a Zen Buddhist priest.

This view through the entry gate welcomes visitors to Samukawa Shrine's garden, designed by Masuno to reflect a Japanese sense of beauty and ancient Japanese values.

Eihei-ji, the main temple of the Soto school of Zen Buddhism, is located on a steep hillside and consists of many buildings surrounded by a 1000-year-old forest of cedar trees. Masuno knows this temple well, as it is the head temple of his own temple's sect.

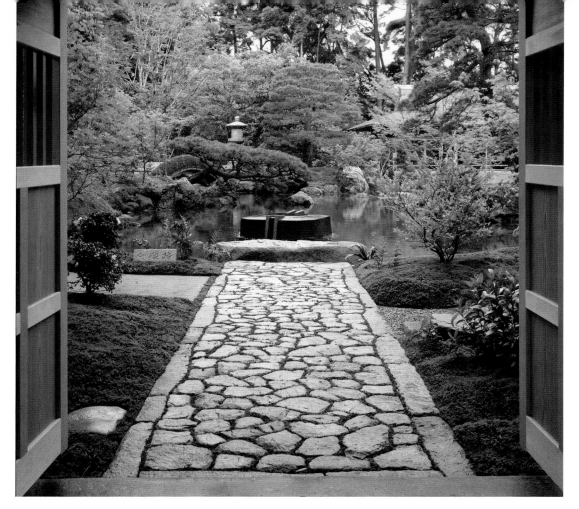

The landscape architecture office of Shunmyo Masuno is within a modern building at the foot of a leafy slope leading to Kenkoh-ji, a Zen Buddhist temple in Yokohama, Japan. Masuno, best known for his modern landscape designs, is also the head priest of Kenkoh-ji.

Over cups of green tea, Masuno, wearing his priest's robes, spoke of his design philosophy and the creation of the traditional garden at Samukawa Shrine. He explained that it was not so odd that a Zen Buddhist priest would be invited to design a garden at a Shinto shrine. Before the Meiji era (1868–1912), he explained, Buddhist temples often shared space and even some functions with Shinto shrines. Over the centuries, the Japanese people found a way to ally these beliefs, and although they officially were separated during the Meiji era, the two forms of worship still have a close relationship with each other.

Shinto, the original spiritual practice of Japan, is characterized by a belief in *kami*, or spirits, who are understood to inhabit natural phenomena such as the sun, mountains, rivers, trees, rocks, and thunder. This belief system and concomitant reverence for nature is still part of Japanese consciousness, and most Japanese today combine Buddhist and Shinto observances, regularly visiting their local Shinto shrines and maintaining both simple Buddhist and Shinto altars in their homes.

Samukawa Shrine, a Shinto complex of more than 7 acres, is located near the Sagami River in Kanagawa Prefecture, and written records confirm its existence there as early as the ninth century. The current buildings date from the late 1990s and are laid out around a large open courtyard in a pattern borrowed from Chinese imperial palace architecture. It was this building project that led the head priest at Samukawa Shrine to consult with Masuno, and this consultation led to a two-part project, the first designed to solve a problem.

By tradition, temples and shrines should be located within natural woods or by a mountain. Such areas are ideal for prayer, because they are considered divine areas where people feel safe and protected. Masuno cited the example of Eihei-ji, the imposing Zen Buddhist temple in Fukui Prefecture that is also the head temple for Kenkoh-ji. Composed of multiple wood buildings that are connected by roofed passageways, Eihei-ji steps dramatically up a mountainside and is surrounded by 100-foot-tall cedar trees.

At the old main hall at Samukawa Shrine, an appropriate forest setting had existed. However, as part of the construction project, the shrine's new main hall was built at a higher elevation, with the result that the traditional sacred grove of trees was below the building and no longer visible. Masuno's suggestion was bold: remove the trees temporarily, create a small mountain leading up to the hall's rear foundation, and replant the trees on the newly higher ground. The result is a 25-foot-high forested hillside—a new sacred wood—that looks as if it had always been there.

At the base of this newly forested slope, Masuno designed a dramatic stone wall to retain the steep hill. A break in this wall, at the centerline of the shrine, leads the eye up to the back of the main hall and provides a place for prayer. As is usual for Masuno, he chose every stone, finding one of particular beauty that serves as a raised prayer stone.

A quiet path along this wall leads through a roofed gate to an extensive garden that is the second phase of Masuno's work at Samukawa Shrine. The Shinto priest who hired Masuno asked for "a garden to realize Japanese true beauty and Japanese true sense of value," and this request became Masuno's guide. In fact, Japanese spiritual traditions and the long history of garden-making in Japan are the inspirations for all of Masuno's work, even when, as in the contemporary Cerulean Tower Tokyu hotel in Tokyo, for example, the result is the kind of modern garden for which he is best known.

This new garden at Samukawa Shrine is called Shinen, or garden for the kami. For Masuno, however, it is a Zen-inspired garden. It includes most of the elements of the traditional stroll gardens associated with both Buddhist temples and the storied residences of the Japanese aristocracy. These elements have been integral to the Japanese cultural heritage for centuries, and they are part of Masuno's birthright as well as his education in landscape architecture.

Landscape architect Shunmyo Masuno also serves as the head priest of his Zen Buddhist temple.

The retaining wall for the new 25-foot-high hillside behind the shrine also provides a place of worship, indicated by a large prayer stone selected by Masuno.

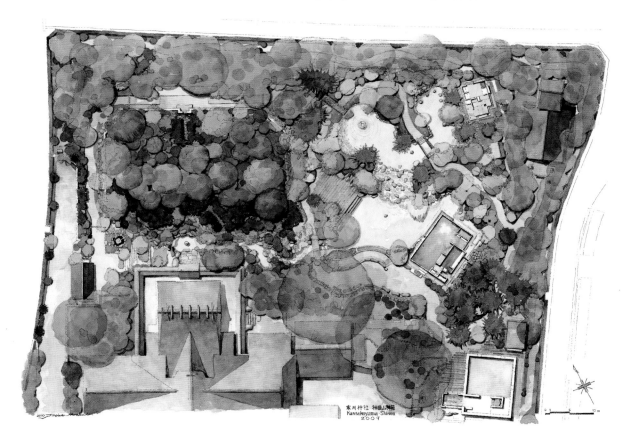

Masuno's plan for the new garden at Samukawa Shrine shows the gracefully winding path leading to the large modern teahouse at the edge of his constructed pond, where the multi-level waterfall can also be seen. The new main hall of the shrine (lower left) and the museum building (lower right) are also shown.

A stepping stone path slows one's pace at the entry to the small traditional teahouse in the garden.

Masuno chose and positioned all of the stones for this garden, including those for this bridge.

This complex terraced stone waterfall was planned by Masuno to be viewed from the large teahouse. His soil bridge is in the background.

The upright stone in front of his "dragon's gate waterfall" represents the legend that a carp swimming upstream and over the waterfall can become a dragon. In May, this image is seen throughout Japan in the colorful banners exhibited on Children's Day.

During the Heian period (794–1185), Japan moved beyond the importation of Chinese culture, and the arts of architecture, painting, and poetry flourished in more distinctively Japanese ways. In the eleventh century, the oldest existing book on garden making was written. Known as *Sakuteiki*, this treatise begins by defining the creation of a garden as "the act of setting stones upright," as designated stones were believed to act as conduits to the spirits. From this time forward in Japan, designing gardens was synonymous with the placement of stones. For Masuno, stones are the signature element in his work, and he chooses and places them with considerable care.

The importance of stone is evident at Samukawa Shrine in the well-set rocks at the edges of the pond, in the path to the small traditional teahouse, in the handsome stone bridge over the pond, in the dramatic use of stones that create his three waterfalls, and in the upright stone—imagined as a carp—that rises into one of these falls. Signifying bravery and strength, this stone recalls the legend of a carp swimming upstream and over a powerful waterfall to become a dragon, a tale associated with Children's Day in Japan. Despite this bit of excitement, the garden induces a mood of calm.

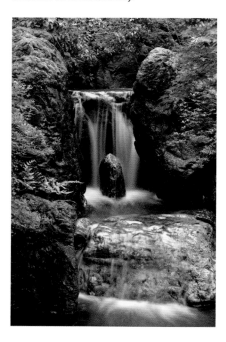

SHUNMYO MASUNO

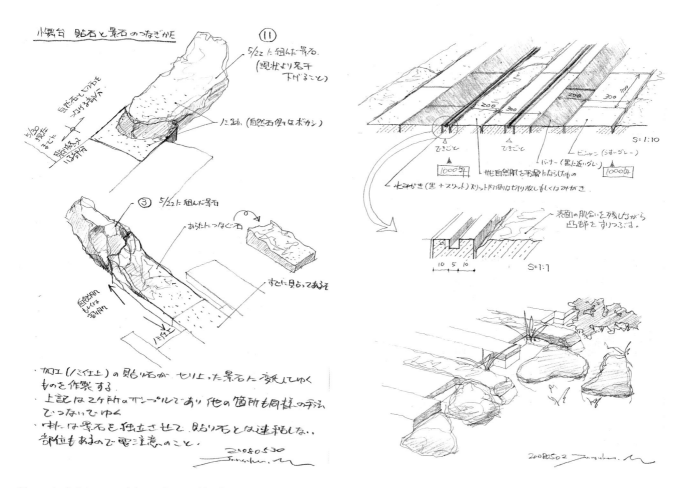

Masuno's sketches reveal the craftsmanship of his work with stone.

Artist Joe McAuliffe's work *Carp Leaping Over Dragon's Gate* recalls the ancient legend that is still a part of Japan's cultural memory today. Making prints using real fish, McAuliffe works in the Japanese gyotaku technique.

This portrait depicts Muso Soseki (1275–1351), a Zen master, garden designer, calligrapher, and poet, who designed the famous garden at Saiho-ji, now known as the Moss Temple.

The precepts of *Sakuteiki* have held through the centuries. The second one dictates: "When creating a garden, let the exceptional work of past master gardeners be your guide." For Masuno, there were two influential masters: Muso Soseki and Katsuo Saito.

A Zen Buddhist monk, Muso Soseki was born in the thirteenth century and was a calligrapher, poet, and political diplomat as well as a garden designer. He is most famous for his 1339 redesign of the temple garden at Saiho-ji, founded in the eighth century, after it had fallen into disrepair. Saiho-ji, one of the most revered and visited gardens in Japan, is also known as the Moss Temple, though the celebrated moss crept in centuries after Soseki's time.

In many ways, Saiho-ji today, with its pond, stone bridges, forested groves, and teahouse buildings, is the model for Masuno's garden at Samukawa Shrine, though the shrine's garden is much smaller in scale and has fewer changes of grade. Both Saiho-ji and Samukawa Shrine are Zen-inspired stroll gardens in which one follows a path around a central pond, taking a meditative journey that provides varied views of the pond and garden features. In Saiho-ji there is almost always a mood of silence. On some days, even when the garden is full of visitors, the only sounds one hears are made by the birds and by the gardeners' rakes on the mossy ground.

In his garden, Masuno also seems to refer to another Kyoto garden, Katsura, a seventeenth-century Imperial stroll garden, in which one walks around a pond, stopping frequently to admire scenic aspects. From Katsura's garden, Masuno has adapted the feature of an arching bridge with moss sides.

There is also a traditional Zen dry garden at Samukawa Shrine, where Masuno's skill in the ancient Japanese art of setting stones is apparent. This diminutive garden, open to the sky, is seen through a glass window at the end of a tunnel-like entry to the museum building, and the daylight on the garden creates a magical effect. The window is low, so that one must bend or kneel to study this elegant and simple composition of two horizontal stones on a bed of gravel.

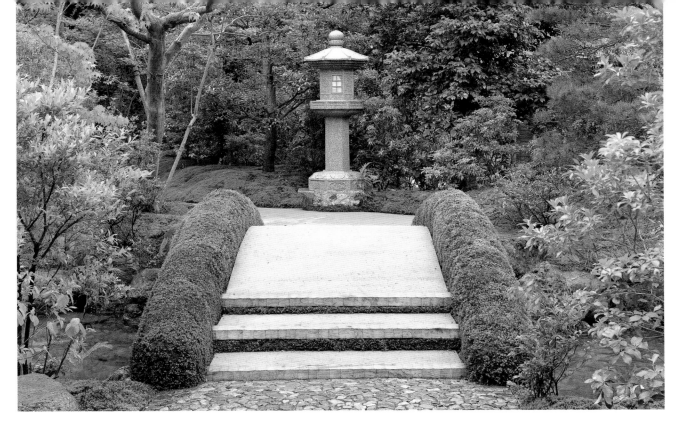

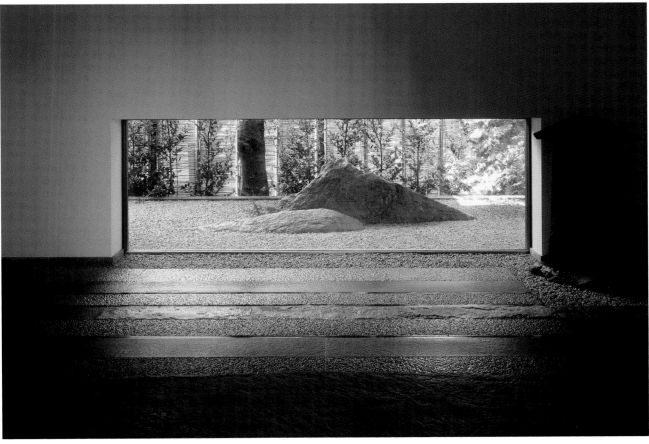

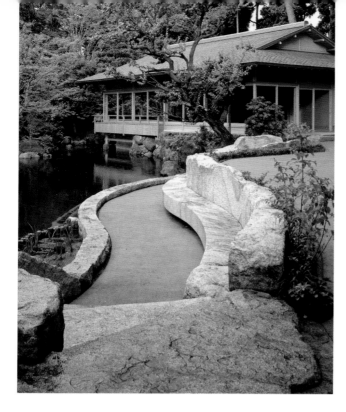

Masuno designed this large teahouse to accommodate gatherings. The wave-like arrangement of the stones along the walkway is similar to a pattern he used in the contemporary garden of the Cerulean Tower Tokyu, a hotel in downtown Tokyo.

Masuno's garden at the Cerulean Hotel in Tokyo was created to be viewed from the lobby, which he also designed. His intention was to make visitors stop, reflect, and feel calm in the middle of the bustling city.

The dramatic curving stonework at the Cerulean Tower Tokyu garden, which he designed to suggest waves moving toward a shore, evokes Masuno's use of stone near the large teahouse at Samukawa Shrine.

Masuno's second master, to whom he was apprenticed after his university education, was Katsuo Saito, who designed more than 400 gardens in Japan and abroad. In 1964, Saito wrote *Magic of Trees and Stones: Secrets of Japanese Gardening*, the title of which suggests the teachings he passed along to Masuno. From Saito, Masuno gained much knowledge about the placement of trees and stones in a garden. But, Masuno said, it was only later, when he went to the monastery for the intense training to become a priest, that he found the understanding to enlarge that knowledge. And it was this understanding that allowed him to find a new way to create his landscapes. As Masuno expressed it, after his monastery training he was no longer thinking about what was "attractive to the people" or about making a garden that was personal to him. "I changed," he said. "The most important thing of Zen is to know, to find myself in my mind. The most important things in life are not found outside of ourselves. Rather, they are the things we find inside our hearts. The most important thing for me is to know how to calm my heart. For a Zen priest to design a garden is about how to welcome people with my heart."

For all his projects, Masuno begins with thinking about the space and how to welcome people, and then he considers what atmosphere is most suitable for this space. "Then the form comes," he said.

At Samukawa Shrine, his goal for the garden was "to make the people very calm, the mind very calm, and to have people want to stay for a long time—just to sit not thinking." The large tea pavilion he designed functions very well for that purpose, and, if visitors speak at all, it is in hushed tones.

Masuno's goal of slowing people down was the same in Tokyo's Cerulean Tower Tokyu hotel, though this garden of curving stone terraces, some with plantings, is of a modern design. "Young people are rushing, and they are always thinking business, business, business. I wanted to make a place where they look at the garden, think about themselves, and keep calm," he said. In both of these gardens, Masuno is following a most important edict in *Sakuteiki*, to "create a subtle atmosphere, reflecting again and again on one's memories of wild nature."

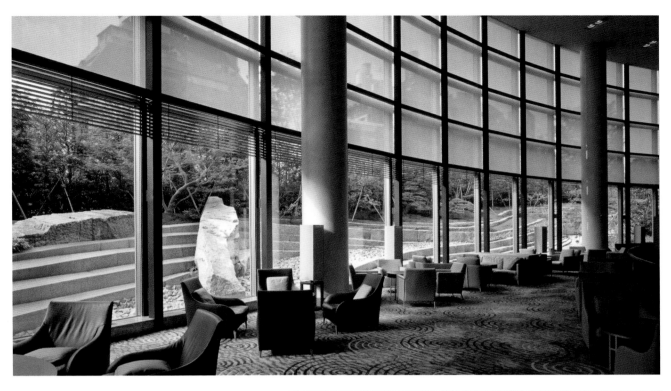

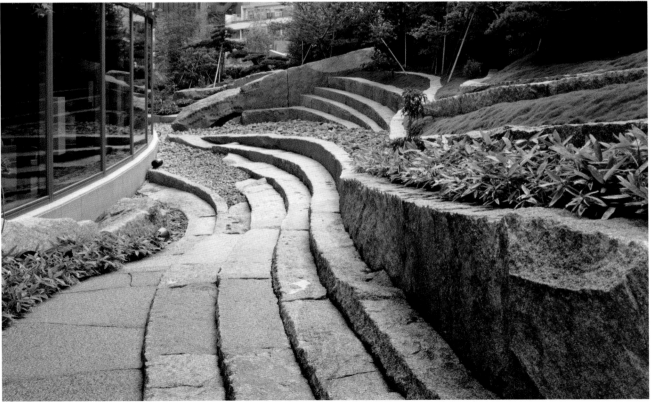

SIGNE NIELSEN

FULTON LANDING
BROOKLYN, NEW YORK
COMPLETED IN 1997

Signe Nielsen found inspiration in the magnificent Brooklyn Bridge adjacent to her site, as well as in the decorative patterns of the indigenous Delaware tribe and in Walt Whitman's famous poem "Crossing Brooklyn Ferry."

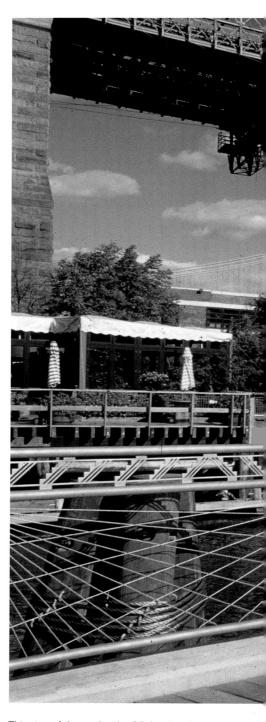

This view of the north side of Fulton Landing, with the Brooklyn Bridge overhead, shows the way in which Nielsen's fence cables reiterate those of the bridge. The Native American motif on the fence and the marine cleats Nielsen used as benches can also be seen.

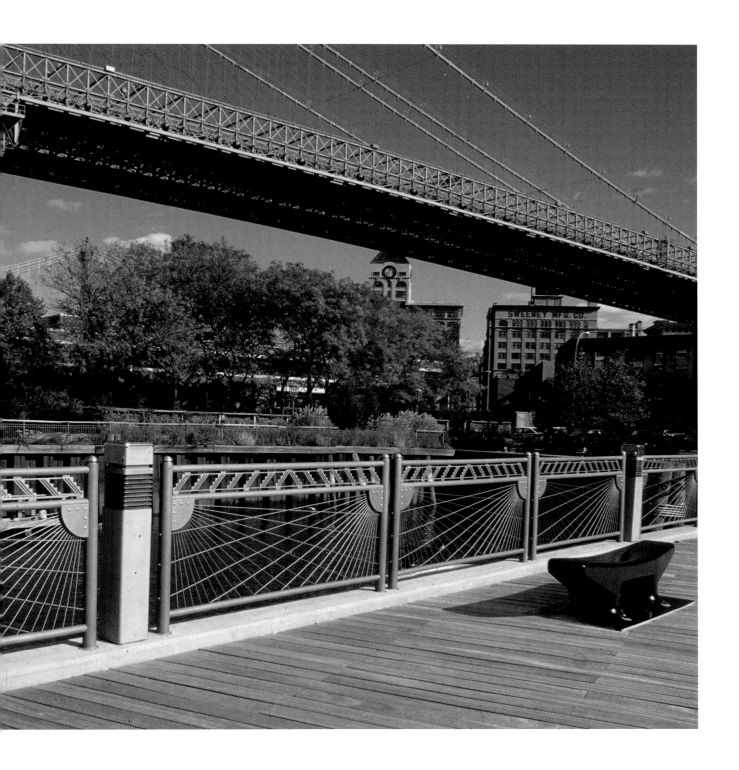

The Brooklyn Bridge was Signe Nielsen's greatest design inspiration for Fulton Landing. Her epiphany came when she was standing on the burned-out remains of the former dock, wondering what in the world she was going to do with this unpromising site. She just looked up and said, "Well, there's an idea." She also looked across the river to the Manhattan skyline and asked herself rhetorically what she could possibly design that could stand in front of that view and hold up to it over time. It was at that moment that an idea became obvious: pay homage to the bridge by using the pattern of the cables in her fence.

A New York City native, Signe Nielsen trained in classical ballet and danced with George Balanchine's company before attending Smith College in Northampton, Massachusetts, creating her own major in urban planning. Smith's New England campus, laid out in the nineteenth century by Frederick Law Olmsted as a botanic garden and arboretum, made a strong impression on her and helped shape her decision to become a landscape architect. Nielsen now has designed more than 400 projects, and her firm has created landscapes for theaters, museums, libraries, botanical gardens, courthouses, memorials, and 20 miles of public waterfront spaces, most in New York City. Yet this small project, done many years ago, stands out in her mind for the satisfaction she had from following her muse. Fulton Landing is a project about which Nielsen is passionate, and she speaks of it with a rush of energy.

This site, like most others fronting New York Harbor at that time, consisted of a run-down pier, used then, as now, as a dock for Bargemusic, a popular venue for classical concerts held in a converted coffee barge. Though the dock was derelict, the immediate neighborhood had several lively attractions, including some well-known restaurants that drew people into this old neighborhood. Nearby, a landmark building at 28 Old Fulton Street had been the home of the *Brooklyn Eagle*, a newspaper published for more than a century that had once been edited by Walt Whitman.

In this urban context, Signe Nielsen's charge was to reimagine the site as both a boat pier and a public gathering place. At her office she made several concept drawings for the project on yellow trace. The concepts were imaginative, but they were also all wrong. She now remembers ruefully that she made a typical student mistake: too many ideas in too little space. Walking toward the site with her sketches, she saw her error at once, and she realized she would have to subtract.

Nielsen understood that this place called for less design effort and more of an appreciation of what was already there: the bridge's powerful presence overhead, the stunning views across the river to Manhattan, and the East River itself, filled with the constant progress of vessels of every kind: tugs, barges, sailboats, yachts, water taxis, and the famous Circle Line cruise ships that have been circumnavigating Manhattan since 1945.

As she looked up at the Brooklyn Bridge, she realized two things: that she could use elements of the bridge as her main inspiration and that she needed something more here than a design concept to complement the view. She wanted to give visitors something that would bring them back again and again. That something, she decided, was a sense of the history of the place. The site had been home to a community of Native Americans, followed by a Dutch settlement that was then taken over by the English. It had been a bustling port and the site of an important Revolutionary War battle. The pier's ferry service to Manhattan had operated since the 1640s and was elegized in Walt Whitman's poem. And then, innovative nineteenth-century technology had led to the epic construction of the Brooklyn Bridge.

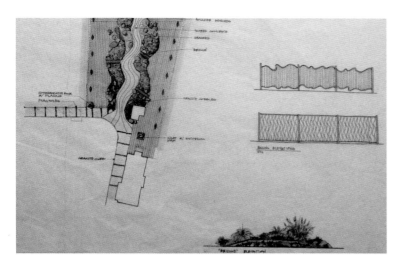

Nielsen created several concept designs before she decided that her project should not introduce forms that would compete with the Brooklyn Bridge and the history of the site.

This view of the Brooklyn Bridge from Fulton Landing inspired Nielsen's design.

Nielsen based her fence motif on designs she found during her research at several museums, including the National Museum of the American Indian in Washington, D.C.

Nielsen wanted to try to incorporate all of these elements into her design for Fulton Landing, while creating an appealing place for people to enjoy access to the waterfront. Her research of the site's history began in New York, with visits to the Brooklyn Historical Society, the New York Public Library, and the National Museum of the American Indian in lower Manhattan, eventually leading her to the National Museum of the American Indian in Washington, D.C.

For millennia before European settlement, this area was part of the mid-Atlantic coastal homeland of the Lenape tribe, also known as Delaware Indians. They lived communally, with shared ownership of the land, and they made dugout canoes and tools of stone, bone, and wood. They also crafted clothing of deerskin and made baskets and pottery. Expanding European settlements pushed most Lenape out of their homeland by the eighteenth century.

To acknowledge the presence of those who lived in this area long ago, Nielsen adapted a Native American motif as a design element, incorporating a traditional Delaware decorative pattern into the fence around her park. In addition, she created several plaques that would inform visitors of the place of Native Americans in the history this area.

The drawing for one of Nielsen's historical plaques at Fulton Landing locates the Native American settlements in the area and shows the path, now Brooklyn's Fulton Street, that they used to reach the river. A "Native Crossing Point," used until the seventeenth century, is also shown at the present location of Fulton Landing.

OPPOSITE The motif on the fence was adapted from designs of the Native Americans who lived in this area.

SIGNE NIELSEN

One of several historical plaques in Nielsen's design honors Cornelis Dircksen, the first ferry master in 1640, when the ferries were driven by oars.

A 1767 map shows the location of the present Manhattan (top) and Brooklyn (bottom) separated by the East River. The site of the "Brookland Ferry" landing is indicated, more than a century before the construction of the Brooklyn Bridge.

The site itself, a boat pier at the end of Old Fulton Street, is one of Brooklyn's most historic places. Ferry service began here in 1640, with boats that were rowed or sailed across the strong current of the East River to connect Brooklyn and Manhattan, which was then called New Amsterdam. In those early times, passengers might wait days for the weather to clear before making the crossing.

A Dutch village, known as "het Veer" or "the Ferry," grew up around the original ferry landing and was incorporated as Breuckelen, named after a town in the Netherlands, in 1646. Two decades later it was in English hands and part of the Province of New York. Several of the plaques in the park illustrate maps from this era.

By the 1770s, the area was a busy marketplace, with slaughterhouses, breweries, shops, inns, and taverns. In August 1776, it was the site of the Battle of Brooklyn, the first major engagement fought in the American Revolutionary War after independence was declared. British troops forced George Washington's Continental Army off positions near what is now Prospect Park and Brooklyn Heights. Realizing that his army could be destroyed, Washington led all his troops in boats across the East River

during a single night, saving his forces. This tactical retreat is considered one of Washington's most brilliant triumphs, and Nielsen has commemorated the event on a marker at Fulton Landing.

Old Fulton Street, which terminates at the Fulton Landing site, was named in honor of Robert Fulton, who developed the first commercially successful steamboat. Beginning in 1814, his Fulton Ferry Company revolutionized travel, carrying passengers back and forth across the East River until 1924. The history of this ferry line became part of Nielsen's design; one of her bronze plaques is a facsimile of the four-cent ticket.

SIGNE NIELSEN

This circular plaque shows a detail of the 1767 map.

Walt Whitman appears on the frontispiece for an edition of *Leaves of Grass*. His lines referring to the Fulton Ferry are an integral part of her fence design.

This ferry service was used by Walt Whitman and inspired his poem "Crossing Brooklyn Ferry" from *Leaves of Grass*. It was his experience of riding the steam ferry from Manhattan to his home in Brooklyn in the late afternoon that Whitman evokes in his poem. Part of it reads, "On the ferry-boats the hundreds and hundreds that cross, returning home, are more curious to me than you suppose, / And you that shall cross from shore to shore years hence are more to me, and more in my meditations, than you might suppose."

In imagining and addressing ferry riders "years hence," Whitman suggests that the ferry crossings were about shared experiences, the continuity of life, and the relationships of human beings across time. In this way, the poem resonates with the goals of Signe Nielsen for this site and for all her work. She cares very much that her designs stand the test of time and are not "of the moment."

Nielsen used the following lines from Whitman's poem in the pier's steel fence:

> Flow on, river! flow with the flood-tide, and ebb with the
> ebb-tide!
> Frolic on, crested and scallop-edg'd waves!
> Gorgeous clouds of the sunset! drench with your splendor
> me, or the men and women generations after me!
> Cross from shore to shore, countless crowds of passengers!
> Stand up, tall masts of Mannahatta! stand up, beautiful hills
> of Brooklyn!
> Throb, baffled and curious brain! throw out questions and
> answers!

This undated photograph shows the Fulton Ferry, plying the East River.

Nielsen included this section of Whitman's "Crossing Brooklyn Ferry" in the fence: "Stand up, tall masts of Mannahatta!"

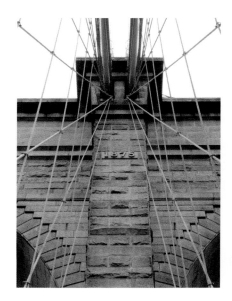

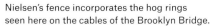

Nielsen's fence incorporates the hog rings seen here on the cables of the Brooklyn Bridge.

The Brooklyn Bridge inspired this graceful cable pattern.

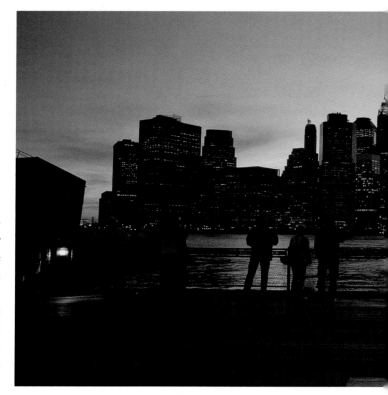

The opening of the Brooklyn Bridge in 1883 led to the gradual demise of the ferry, and service finally ended in 1942. After the terrorist attacks on September 11, 2001, however, the service was restored at Fulton Landing and continues to this day from the adjacent pier that is part of Brooklyn Bridge Park.

On a December day, dozens of people lined up to make the crossing, while others disembarked to enjoy the revitalized Brooklyn Ferry District. Walt Whitman, who imagined this voyage continuing with "men and women generations after me" into the "years hence," might be gratified.

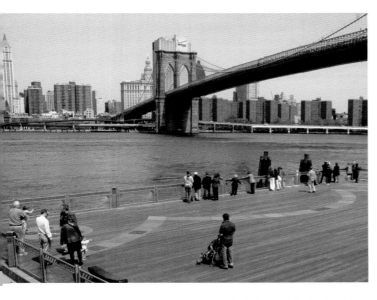

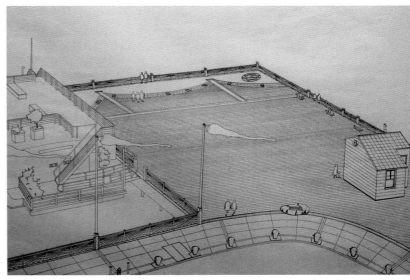

Nielsen set historical plaques into the cable-like pattern on the decking at Fulton Landing.

Nielsen's axonometric drawing shows the final design.

Fulton Landing is a popular place to view the sunset over Manhattan and the East River.

In homage to the much-admired cables of the Brooklyn Bridge, Nielsen developed this cable system, shown in an interior view.

CORNELIA HAHN OBERLANDER

VANDUSEN BOTANICAL GARDEN VISITOR CENTRE
VANCOUVER, CANADA
COMPLETED IN 2011

Karl Blossfeldt's early photograph of a gently undulating orchid leaf inspired Cornelia Oberlander to suggest the form of the green roof atop the VanDusen Botanical Garden Visitor Centre. In her planting design, Oberlander used only the local native plants recorded by eighteenth-century naturalist Archibald Menzies.

In this view of the VanDusen Botanical Garden Visitor Centre, the leaf forms of the roof reach to touch the ground.

Cornelia Oberlander sits among some of her extensive collection of books. *Art Forms in Nature* is a favorite.

For the technologically advanced VanDusen Botanical Garden Visitor's Centre project, Cornelia Oberlander sought and found inspiration in pictures and stories from historical books in her own home library. Karl Blossfeldt's stunning photographs in *The Alphabet of Plants*, images from the nineteenth and early twentieth centuries, provided an inspiration for architectural form, and *Mr. Menzies' Garden Legacy: Plant Collecting on the Northwest Coast*, the tale of an eighteenth-century sea voyage, provided the inspiration for her planting palette.

Oberlander's orchid leaf concept is clear in the planting plan for the roof.

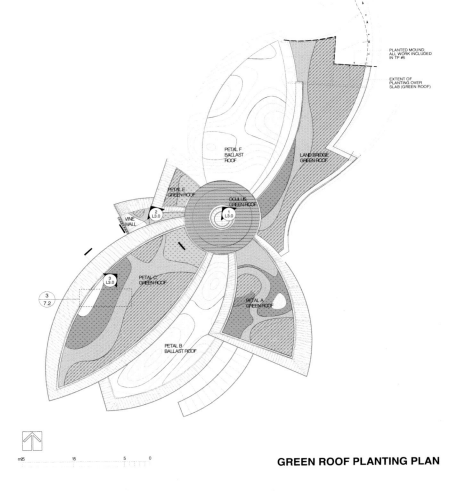

PLANTED MOUND;
ALL WORK INCLUDED
IN TP #5

EXTENT OF
PLANTING OVER
SLAB (GREEN ROOF)

PETAL F
BALLAST
ROOF

LAND BRIDGE
GREEN ROOF

PETAL E
GREEN ROOF

OCULUS
GREEN ROOF

VINE
WALL

PETAL C
GREEN ROOF

PETAL A
GREEN ROOF

PETAL B
BALLAST ROOF

GREEN ROOF PLANTING PLAN

Created on the grounds of a former golf course, the VanDusen Botanical Garden in Vancouver, British Columbia, opened in 1975, after the site was saved from intensive real estate development through community activism and the philanthropy of a local timber magnate, W. J. VanDusen. The 55-acre garden is a popular local institution that contains worldwide plant collections thriving in the temperate climate and frequent soft rains of Vancouver.

By 2005, the garden's plants and educational programs were doing well, but more space was needed, both for administration and to serve the public. In response, a new visitor center was proposed, a building that would include classrooms, offices, lecture spaces, meeting rooms, a library, a shop, and a café, while disturbing as little as possible of the existing landscape. The garden gathered a team that included both architect Peter Busby of Perkins + Will and Vancouver landscape architect Cornelia Hahn Oberlander in collaboration with Sharp & Diamond Landscape, Inc., to design the building and the grounds.

Oberlander is considered a national treasure in Canada for her many contributions to the practice of landscape architecture. She is known for her minimalist aesthetic, her commitment to sustainable landscapes, and her artistic responses to design challenges. Intellectually, she delights in the design process and in finding the perfect image in her mind to inspire each project, such as the painting *Terre Sauvage* by artist A. Y. Jackson for her taiga landscape at the National Gallery of Art in Ottawa, the Hanging Gardens of Babylon for the exterior planters on the upper floors of the Canadian Chancery building in Washington D.C., or an aerial view of the Mackenzie River Delta for the roof garden of the Canadian Chancery in Berlin. In Vancouver, she collaborated with the architect Arthur Ericson to create the setting for the University of British Columbia Museum of Anthropology, honoring the culture of the Haida people.

144

This plan shows the leaf-like forms of the roof garden and the planting areas near the new building, where Oberlander used only native plants recorded by the eighteenth-century naturalist Archibald Menzies.

Oberlander's landscape for the Museum of Anthropology reflects the heritage of the local First Nations. The building and the landscape recall the longhouses that are sited at the edge of the forest near the shoreline and shale beaches.

It was only natural that Oberlander turned to books to find design inspiration for this new commission in Vancouver. Books have been an enduring touchstone since her childhood in suburban Berlin, where her family home contained an extensive library that included several horticulture books written by her mother, Beate Hahn. In Oberlander's adopted city of Vancouver there are books everywhere: rows and rows of books on shelves, tables, and even neatly stacked on the floors of her glass-walled home and office.

As she began to conceive ideas for the project, the green roof on the VanDusen Botanical Garden Visitor Centre was on Oberlander's mind. That there would be a green roof was not in question. The visitor center was being designed to meet the Living Building Challenge, the most advanced measure of sustainability in the environment.

Also, building and site must achieve a fit, which is an Oberlander specialty, and she wanted something unique for the new visitor center, not an ordinary rectilinear, plant-covered roof. She imagined something more organic, a shape that evoked natural forms, such as those of plant leaves. Perhaps the roof would not even stay on the top of the building but might dip down and touch the ground at some points.

She remembered a favorite book, *Art Forms in Nature*, which she had known since her childhood in her family's library in Germany before the war. It was a volume of flower photographs by Karl Blossfeldt, most taken in the late nineteenth century. His photos, unique in their time, celebrate the curvilinear lines of budding flowers and unfolding leaves. She reached for *The Alphabet of Plants*, another book of Blossfeldt's photographs. There, she spotted an image of the sprouting leaves of a young orchid plant and had her Eureka moment: the roof of the visitor center could be shaped like overlapping orchid leaves, with each curving leaf to carry a green field of plants. However, Blossfeldt's photograph was not of a local orchid, so Oberlander found an image of a native and thus more appropriate orchid in another book.

The next morning she called the design team's office and, in a case of Eureka striking twice, she discovered they had looked at the same Blossfeldt photograph. In the end, they agreed that the shape of a native orchid would be perfect for the roof.

The dramatic roof of undulating leaves is the glory of the VanDusen Botanical Garden Visitor Centre. The leaf-like roof segments arch and reach toward the ground, with part of their surfaces visible to passers-by. The plant material used was chosen to reflect the Pacific Northwest coastal grassland community, and the roof is covered with native fescues that grow no taller than 6 inches and need mowing only once a year. Interspersed are native flowering bulbs such as yellow glacier lily, white fawn lily, checker lily, nodding onion, and great camas. The effect is soft and enticing in every season.

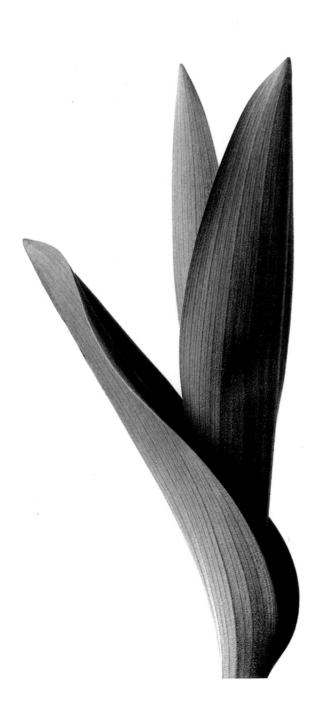

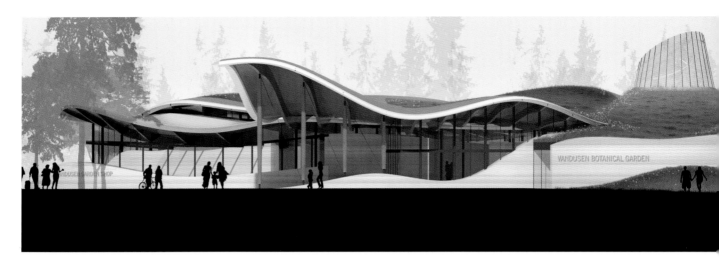

In this drawing, the leaf-like forms of the roof seem to undulate, as if they were a living plant.

Nodding onions bloom on one segment of the roof.

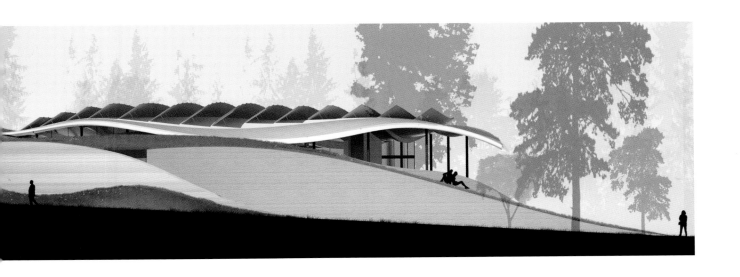

The green roof also contains solar panels.

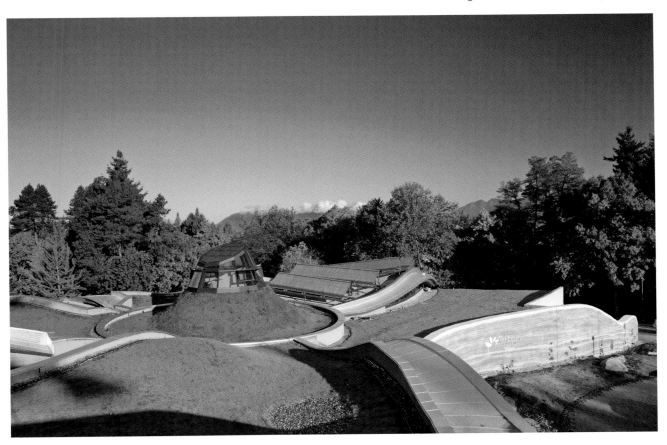

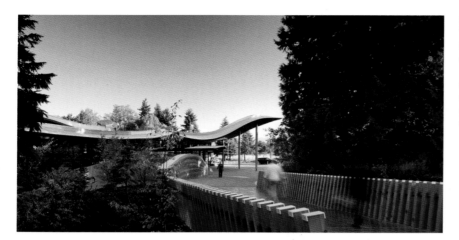

On either side of this entry bridge to the VanDusen Botanical Garden Visitor Centre, Oberlander's plantings are knit into the existing landscape.

OPPOSITE Oberlander's rain garden, both decorative and practical, contains only native plants known to be in the area in the eighteenth century.

Oberlander and the design team were also charged with creating a planting scheme that would blend the new building with the botanical garden's existing landscape. Oberlander favors a native plant palette in her work, and a quiet one at that. Her gardens are never about color. As she has often said, "Cornelia's landscapes do not have flowers!"

Oberlander knew she wanted the new plantings to look natural, almost as if she had not been there. She had done something similar at the Museum of Anthropology, where she created a landscape of meadows and mounds seeded with the indigenous grasses and wildflowers that would have been familiar to the native people whose art is celebrated in the museum.

Similarly, Oberlander wanted the plants at the VanDusen Botanical Garden to be native as well. In her library, she found *Mr. Menzies' Garden Legacy: Plant Collecting on the Northwest Coast* by Clive L. Justice. She read again the story she knew well of the famous Vancouver Expedition, the historic voyage of the HMS *Discovery*, a full-rigged ship with a crew of a hundred, captained by George Vancouver. Archibald Menzies, a Scottish surgeon, botanist, and naturalist, took part in this pioneering expedition, which explored and charted the Pacific coast of North America from 1791 to 1795. During the voyage Menzies documented many plant species unknown in Europe, and returned with dried specimens, seeds, and plants.

Inspired by the story, Oberlander had found the plant palette for the VanDusen Botanical Garden. In a series of zones determined by site conditions, she specified only those species that Menzies had recorded as native to the area, including trees such as river birch, Pacific dogwood, and *Arbutus menziesii*, commonly called Pacific madrone. She used kinnikinnick as a groundcover, and she planted blue Oregon iris in the bottom of swales. For the rain garden, which she particularly likes, Oberlander used three plants that would clean the water: juncus, water sedge, and *Iris pseudacorus*, or yellow flag. Her voice filled with satisfaction as she recalled how she stood in the water in her high boots and directed exactly where each rock and plant should be placed.

In this way, Oberlander created a subtle, seamless integration of the new landscape with the existing native vegetation and the botanical garden's more decorative plantings nearby. Her focus on native plants reinforces the ecological mission of the VanDusen Botanical Garden in the twenty-first century. As a strong advocate for the use of native plants in every landscape, Oberlander hopes that visitors will appreciate what they see, take the message home, and plant native varieties in their own gardens.

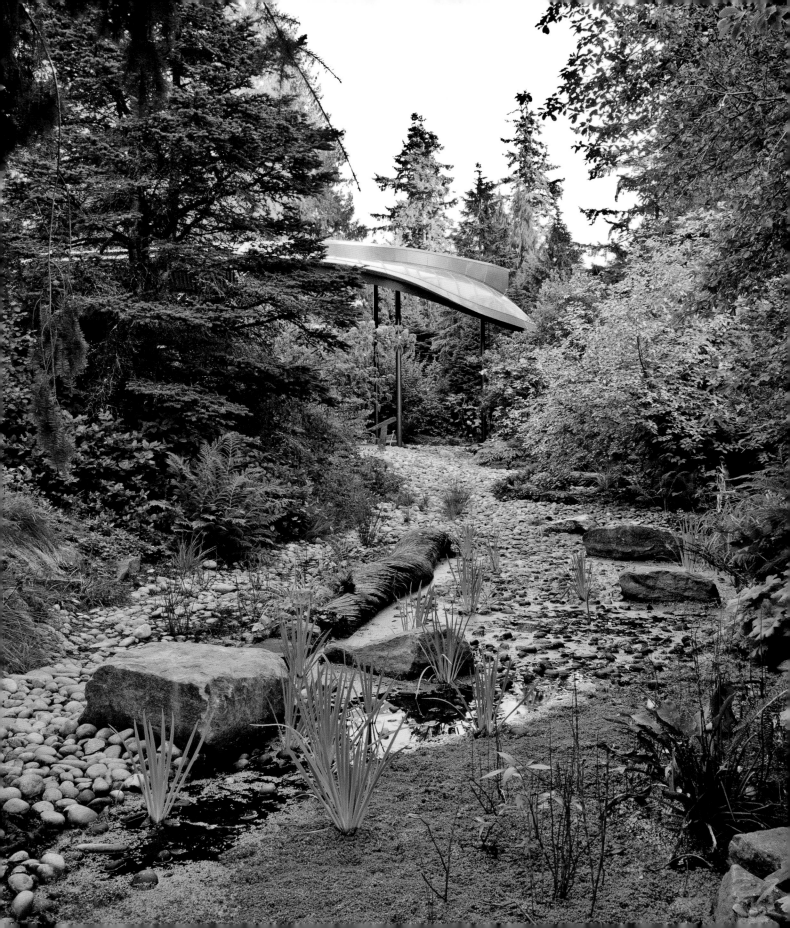

LAURIE OLIN

THE AMERICAN ACADEMY IN ROME LANDSCAPE REDESIGN
ROME, ITALY
DESIGNED IN 1990

When called upon to renew the landscape at the American Academy in Rome, Laurie Olin drew inspiration from rural traditions of the Janiculum Hill neighborhood, from ancient and Renaissance-period Italian gardens, and from the Roman fountains he knew so well.

Inspired by the dozens of Italian gardens he visited during his stays in Rome, Laurie Olin created a secret garden at the academy's Villa Aurelia, with a rustic fountain made the traditional way, with rough red tufa stone.

Although Laurie Olin, whose office is in Philadelphia, has worked on projects throughout the world, in undertaking the redesign of the landscape at the American Academy, he was very much at home, on land he regarded as his own back garden. Olin, who won the Rome Prize in the 1970s, spent two meaningful years at the American Academy as a fellow and returned often as a visitor and an academy trustee.

Respectful of the traditions and history of the academy, Olin made changes that are almost undetectable, as if he had just tidied it up a bit. And yet, he removed an old tennis court, added a grove of productive olive trees, created a large inviting lawn for fellows' activities, planted fruit trees, and suggested a sizable vegetable garden of raised beds. At the Villa Aurelia, an academy property across the street from the main building, he designed an appealing flower-filled entrance drive, replaced derelict hedges, and made a secret garden in a centuries-old style.

In all that he did, Olin was guided by the determination to make the academy's landscape suitably "Roman." A sense of what is Roman—as opposed to what is Italian or Florentine or Siennese or Venetian—pervades the changes that Olin suggested for the grounds of the academy. This Roman sensibility, which can be seen in architecture, gardens, urban plazas, and sculpture, has a grandeur that looks back to the days of the emperors and to the Renaissance princes and cardinals, who, most of all, built to impress. Nowhere was Olin's goal more successful than in the fountain he designed for the entrance to the academy, inspired by the scale of Rome and by the many urban fountains he studied and sketched during his time there.

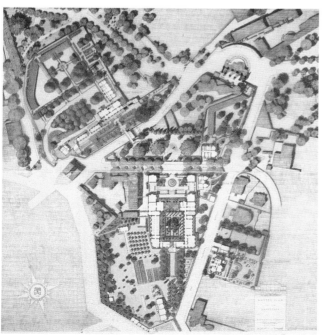

Olin's 1990 plan for the Master Plan Report, drawn in colored pencil, shows the multiple properties of the American Academy in Rome and presents his preliminary design ideas for the campus.

Founded by a group of artists, architects, and financiers, the American Academy in Rome occupies a stately 1914 McKim, Mead & White building as well as several surrounding properties on 10 acres high above Rome on Janiculum Hill. For more than a century, poets, artists, writers, scholars, composers, preservationists, architects, and landscape architects have come here to work on projects of their own choosing, learning from each other and from the city of Rome. Invariably the fellows' lives are stamped by this experience. For Olin, it was his graduate school. He said he came back to the United States a landscape architect.

His two years at the American Academy provided a collegial atmosphere in the company of other artists and scholars. Most of all, Olin said, it taught him to live like a Roman, a lifestyle he described as encouraging both a heightened appreciation of the arts and a civilized way of conducting one's day, including an unhurried lunch with a glass of wine.

Olin's memories of the academy include not only the shapes and scents of specific plants that were there during his stay, but also the sounds, such as the thumps of tennis balls under the library window or "the little church where the bells ring every afternoon." It is a place about which he feels nostalgic and proprietary, mentioning an old Papal Wall "in our own back garden."

During a visit as a trustee in the 1980s, however, Olin saw that the familiar landscape had changed. The signature pine trees were all dead or dying of a beetle infestation. Cars were parked on lawns, and oil was being changed in the back garden. Dereliction was everywhere: across the street, at the Villa Aurelia, there were missing trees, unruly hedges, and trash was being burned on the lawn.

Olin sounded the alarm to the trustees and went to work, donating his time and creating a Master Plan Report, which included an assessment of the existing landscape as well as information about the academy's history from 1889 to 1989. Olin stressed that the report and the subsequent garden alterations were a collaborative effort, and he gave much credit to his committee members: Adele Chatfield-Taylor, president and CEO of the American Academy from 1988 to 2013; the architect, Christina Pugliese, who supervised restoration work; and Alessandra Vinceguerra, who is responsible for the gardens and their plantings.

The major landscape changes that followed the acceptance of the report took place around both the McKim, Mead & White building and the older Villa Aurelia. One part of the redesign was particularly personal to Olin. During his days at the academy, he had looked down from his studio in the ochre-colored stucco and limestone McKim building every day at the "dopey little rose bed" that greeted visitors in the center of the entry court as they passed through the tall iron gates from the Via Angelo Masina. He felt that what belonged there was not a flower bed but a fountain. But not just any fountain; it had to be "Roman and proper."

Precedents and inspirations were everywhere in Rome, and Olin studied many while considering his design proposal. Finally, he made a sketch that incorporated two of the fountains he had most admired during his expeditions around the city. The first of these, the fountain by seventeenth-century architect Carlo Fontana opposite the Ponte Sisto in Trastevere, inspired his upper basin. The seat profile of the Fontana del Moro in Piazza Navona inspired Olin's lower basin. Another favorite fountain was an inspiration as well for its strong and graceful shape: the ancient Roman basin near St. Ivo, in a passageway toward the Pantheon. The fountain Olin designed was not a copy of any of these, but it was influenced by all of them. And, importantly to him, the new fountain evokes the spirit of these old fountains.

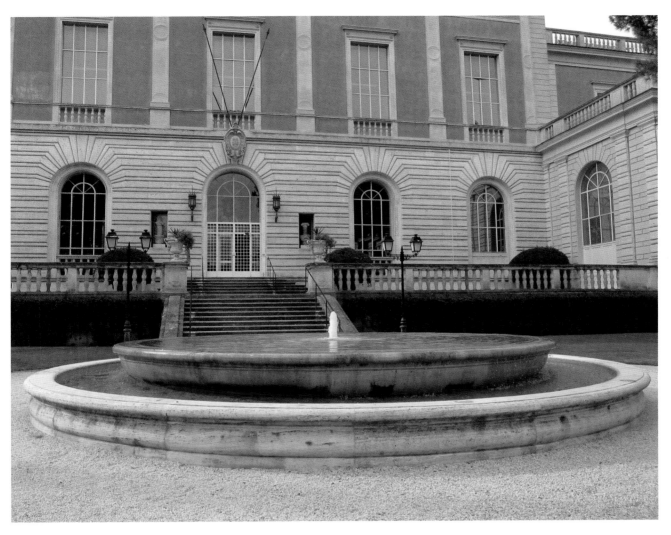

Olin's drawing for his proposed fountain at the academy combined elements of favorite Roman fountains.

Olin sketched his proposed plan to enhance
this area after the removal of the tennis court
and the parked cars.

TOP In Olin's sketch of the former grounds
at the back of the academy building, cars are
shown parked indiscriminately.

Most visitors to the academy assume that Olin's fountain,
which is perfectly in scale with the buildings and the courtyard,
was always there. After he sketched his design, he found a set of
early plans that showed, in fact, that a fountain, rather than a
flowerbed, originally had been envisioned for the entry court-
yard. Displaying a rendering of that century-old fountain design,
he noted that it was too small in scale, much too timid, and not
Roman at all.

According to Olin, he felt the distinctive quality of things
Roman each time he returned to the city after traveling to other
parts of Italy. Rome itself, both in its ancient days and during
the Renaissance, became the inspiration for all aspects of Olin's
design proposals.

At Olin's urging and with the support of others, a 1920s ten-
nis court built close to the McKim, Mead & White building was
removed from the back garden, allowing for several landscape
enhancements. Olin's sketches of this area show the incursion
of parked cars into the garden area, as well as his suggestions for
improvements. In accordance with Olin's plan, a winding path
now leads to the much-used back gate and to the Casa Rustica, a
former roadside tavern that predates the academy. The land was
regraded, and a wide lawn, gently rolling in places, provides a gen-
erous park-like space for fellows' activities.

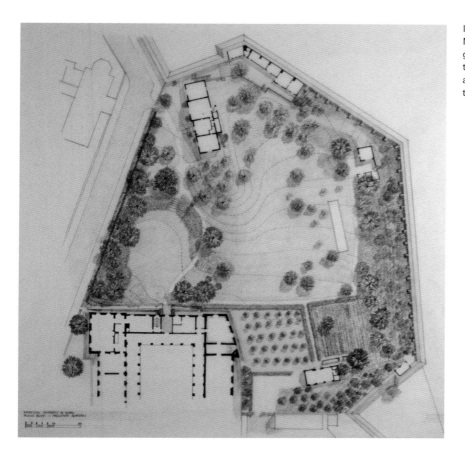

In his plan for the area behind the academy's McKim Mead & White building, Olin proposed gently regrading the land among the existing trees, redefining the paths, and creating an olive grove to recall the ancient farming traditions of this area.

Olin's gently winding walkway to the back gate and the inviting open space are shown here in the long shadows of afternoon.

The newly expanded lawn invites fellows and their families to enjoy quiet moments as well as lively group activities.

Each fall, academy fellows harvest the olives from Olin's olive grove and receive a jar of the oil as a reward for their efforts.

OPPOSITE TOP A productive garden of vegetables and fruit trees supplies most of the needs of the academy's kitchen and recalls antecedents in ancient Roman estates.

OPPOSITE BOTTOM The redesigned entry drive to the Villa Aurelia, across the street from the academy building, presents a welcoming arrangement of flowering plants, including exuberant wisteria.

One can look across to the far edge of the lawn now and see the grove of olive trees that Rome fellows harvest each fall. This orchard was Olin's idea, though he claims "any Roman layman would think of that." But Olin was thinking of the history of the place: this area of the back garden was once, like the legendary Roman Campagnia outside of the city and the neighboring Monteverde Vecchio area, a place for farming. A sense of this rural history may be seen in seventeenth-century views by painter Claude Lorraine.

And so, appropriately enough, the garden at the academy now also includes plum, peach, apricot, and pomegranate trees and a highly productive garden of raised vegetable and herb beds approved by restaurateur and author Alice Waters, who, as part of the Rome Sustainable Food Project, consults here on all things related to food. For Olin, this area of the garden exemplifies *rus in urbe*, or country in the city, a term coined by Martial in his first-century *Twelfth Book of Epigrams*. Even the bay hedges here are useful, providing the academy kitchen with leaves for seasoning.

Across the street, at the academy's Villa Aurelia, parts of the garden remain somewhat as they were in the time of Clara Jessup Heyland, an American from Philadelphia who purchased the property in 1885. She and her gardeners created the formal layout of the gardens here, and later she bequeathed the villa to the fledgling American Academy in Rome.

At the Villa Aurelia, Olin specified that the garden was to be cleaned up and missing trees replaced. New pines were planted here, and live oaks were pruned into their former parasol shapes, a Roman tradition dating to first century B.C., Olin noted. The central fountain in this garden was restored to working condition. Unlike the back garden at the McKim building, which has an open quality, the older Villa Aurelia garden is darker, more heavily planted, and overgrown, with hidden corners.

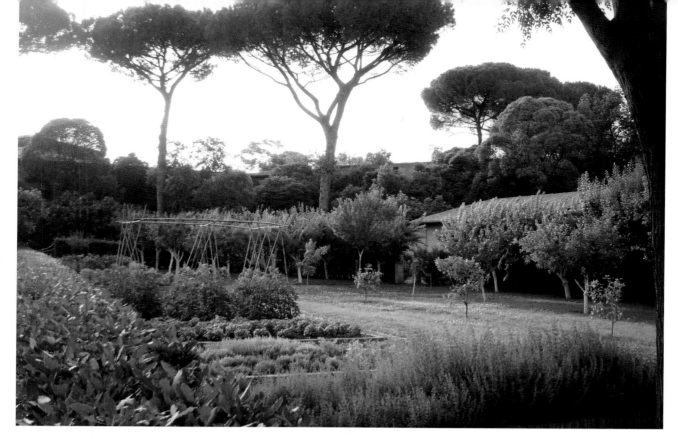

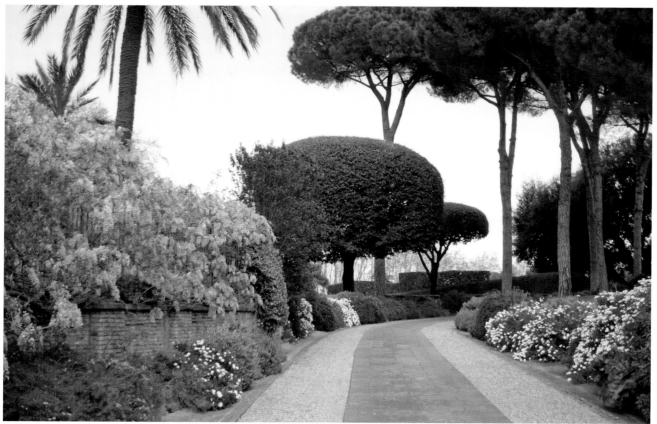

With some simple improvements, such as replanting missing parts of hedges, Olin restored the garden at the back of the Villa Aurelia.

Olin often visited, drew, and photographed this plant-filled basin in the grotto at the Villa Madama, one of many precedents for his secret garden fountain.

In one such corner, in the area where the trash was being burned, Olin suggested a new feature: a *giardino segreto*, inspired by the secret gardens of the ancient and Renaissance Italian villas. Examples of such secret gardens abound in Italy, and most sixteenth-century gardens have a walled space off to one side, a place not immediately evident to visitors, which often includes fountains, rough walls, or a grotto. Olin's secret garden at the Villa Aurelia features a fountain that he acknowledged was inspired by the rough, moss-covered fountains that spill and drip water into dark pools like ancient sacred springs. Well-known examples that Olin visited are the One Hundred Fountains at the Villa d'Este and the mossy water-spouting stone faces at the top of the Villa Lante. One of his favorites is at the sixteenth-century Villa Madama.

The idea for Olin's secret garden fountain came to him all at once and complete. He drew the sketch, and the fountain was built exactly that way. Fittingly, it now looks old and a bit decrepit. Like many such old fountains Olin has admired, his incorporates random rubble found on the site, including old Roman pottery that he has recycled as faucets that drip water into the pool. As in the gardens of centuries ago, the sounds of the dripping water are a delightful feature. Olin's stated goal for his secret garden at the Villa Aurelia might extend to his reimagining of all of the academy's gardens: he wanted to create a *locus amoenus*, a place of amenity to which the muses might come.

Laurie Olin's experience at the academy was a graduate course in the arts: listening to composers play their own work, visiting the artists in their studios, conversing at meals with scholars and writers. The Roman gardens he visited charmed and delighted him. But he was most influenced by the city itself. Rome's many layers of history, culture, and art—and its color and energy—changed his life and then inspired him for a lifetime.

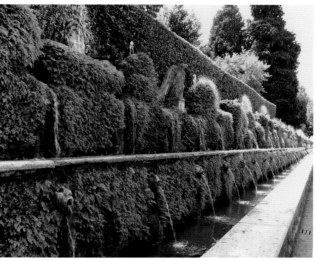

Olin worked out some of his fountain ideas, such as the rusticated tufa walls, in this sketch.

The Hundred Fountains at the sixteenth-century Villa d'Este, where multiple water jets flow into the long rustic trough, is a precursor to Olin's fountain in his secret garden. The Villa d'Este is located in Tivoli, not far from Rome.

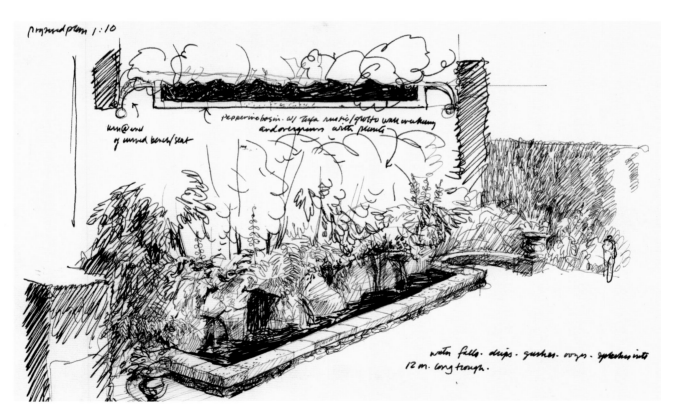

In Olin's multiple-view sketches for the secret garden at the Villa Aurelia, the fountain has rough, rusticated tufa walls and plants are growing both in the water and within the walls. The hedges that conceal this area of the garden are also seen in this sketch.

KEN SMITH

MUSEUM OF MODERN ART ROOF GARDEN
NEW YORK, NEW YORK
DESIGNED IN 2004

Ken Smith cited as inspirations patterns of camouflage as well as two gardens created in the late 1950s: the patently synthetic garden in the Jacques Tati film Mon Oncle *and the rooftop garden at the* UNESCO *headquarters in Paris by Isamu Noguchi.*

Smith's design, based on camouflage patterns and influenced by a French film and Japanese dry gardens, includes elements that, from a distance, resemble real plants, rocks, and water.

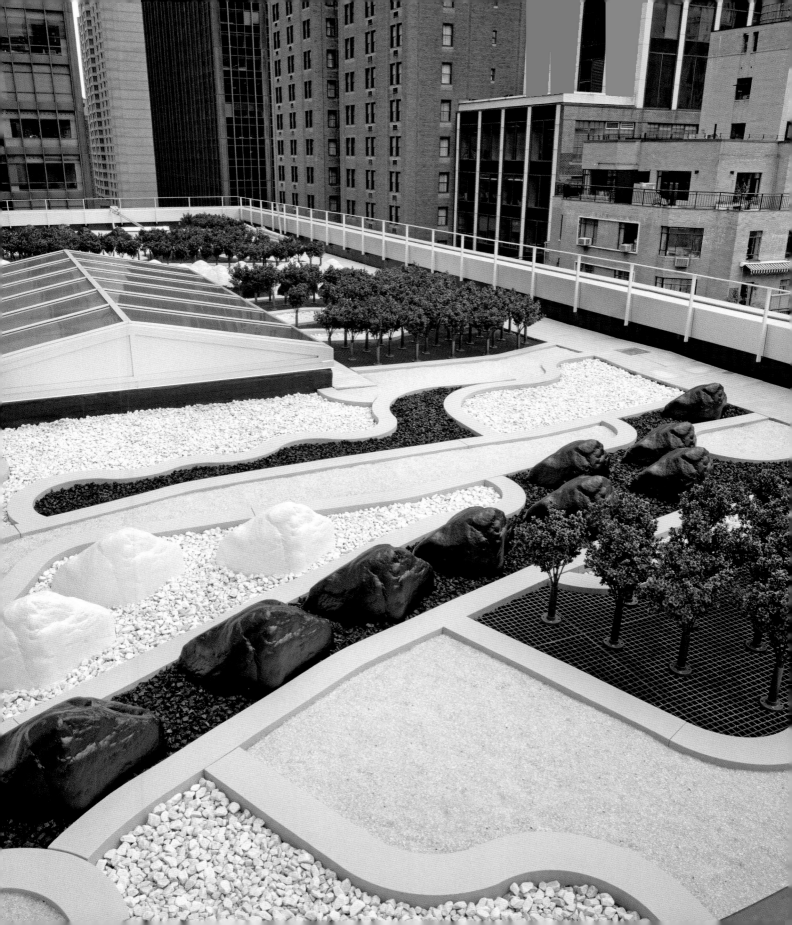

"Do you know *Mon Oncle*?" asked Ken Smith. "Because that was one rather strange inspiration for the Museum of Modern Art project." In the 1958 film by Jacques Tati, a mother, father, and their young son live in a sterile mid-century modern, gadget-filled house. Their enclosed front garden, walled off from the life of the street, is totally synthetic, with a ground plane of abstract shapes filled with colored gravel. The large fish in the garden's pool is made of metal and spouts water into the air at the push of a button. An absurdly curved front walkway challenges forward movement. The small green balls of evergreens that dot this landscape are obviously plastic. Any real leaf falling into this garden is quickly whisked away. It is no wonder that the boy prefers to leave this antiseptic atmosphere, which the film satirizes, to spend time with his eccentric uncle in the messy world beyond the gates.

Viewing the garden scenes in *Mon Oncle*, one can see the clear influence of the film on the design and materials of Smith's roof for the Museum of Modern Art (MoMA) in New York, which is similarly and purposefully synthetic. But before Smith thought about *Mon Oncle*, there was another key inspiration for his design, one that came to him in response to the demands of garden's most important constituency: those who would be looking down at it.

The set for the film *Mon Oncle* was one of
Ken Smith's inspirations for the Museum of
Modern Art roof.

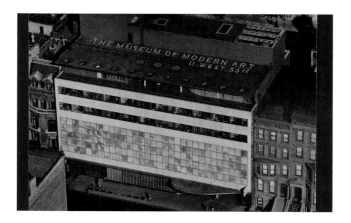

As can be seen in this 1939 photograph, MoMA previously used its roof to attract attention.

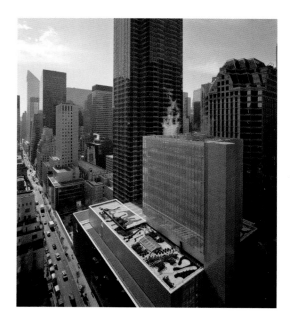

An aerial view of one section of Ken Smith's MoMA rooftop includes some of the many tall buildings that overlook it.

Smith's project, a sixth-floor, 17,400-square-foot roof, was built over the new art galleries created during MoMA's 2004 expansion and remodeling by architect Yoshio Taniguchi. The museum hired Smith to create a decorative rooftop, rather than a garden, on this new space. The site would not be accessible to the public, and living plants were not in the program. But the roof is quite visible to residents of the adjacent fifty-two-story Museum Tower, and MoMA had an obligation to provide an appealing view for them and to disguise the barren reality of a large asphalt-covered roof. Smith's proposed designs were subject to the review and approval of the tower's board.

It was inevitable, perhaps, that Smith would think of the idea of camouflage for this rooftop, for his charge was to hide the roof and to create a new visual reality: to pretend to the viewer that the roof was something it was not. For Smith, playing with the overt pretense of hiding something—using camouflage as a visual metaphor—had wit. In speaking of the idea of wit in the garden, he was reminded of a book in his collection, *Gardens Make Me Laugh*, by James Rose. Just looking at the book jacket makes Smith laugh, something he does easily and often.

There is precedent for attracting attention from above at MoMA, where, decades ago, the roof had been used as a signboard, telegraphing its identity and mission to the sky. On top of the 1939 building, large letters spelled out MoMA's address, 11 West 53rd Street, in suitably modern, sans-serif type.

Ken Smith enjoys a moment in his garden, which is inaccessible to the public.

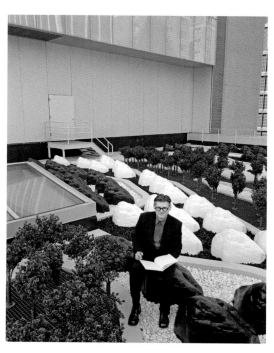

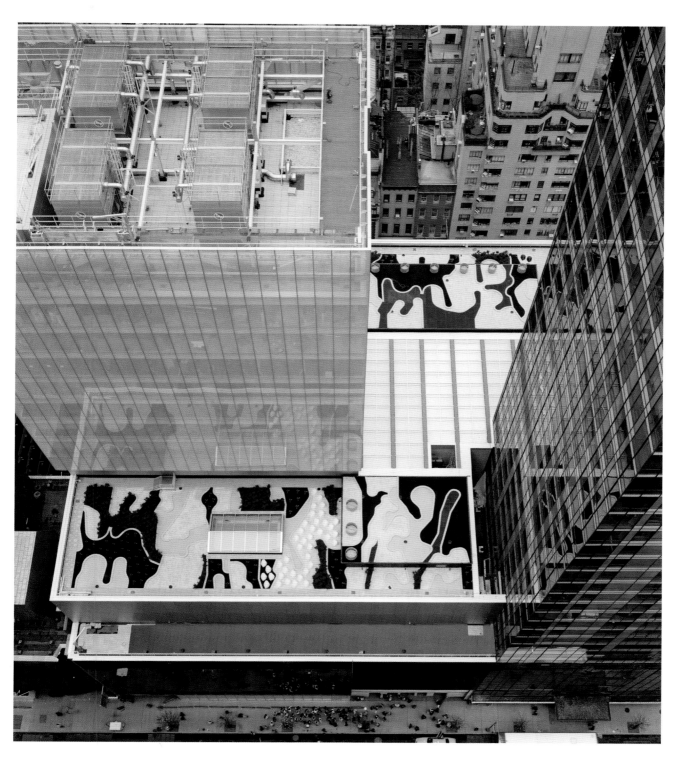

This view, which clearly evokes the patterns of camouflage,
includes two parts of the rooftop landscape.

These camouflage-print pants, purchased and worn by Ken Smith's wife, Priscilla McGeehon, inspired his design for the MoMA roof.

By the time Smith was commissioned to design the new rooftop landscape for MoMA, he had been thinking of camouflage for a long time. His imagination was drawn to the subject during the 1980s, when, while doing research in the library at Harvard's Graduate School of Design, he discovered by chance a 1939 article in the journal *Pencil Points.* At that time, on the eve of World War II, the military uses of camouflage were of growing importance. Smith was fascinated by the article and by the science and art needed to devise appropriate camouflage patterns for varied situations: individual buildings, for example, or cities, farm fields, airports, tanks, or battleships. Later, Smith made some camouflage drawings just for his own interest, thinking about the many ways that landscape architects had always used camouflage strategies as part of their practice: in blending former mine sites into the surrounding landscape, for example, or in creating places, such as Central Park in New York, that were designed to give the impression that they had always been there.

But the moment of inspiration for the use of a camouflage motif on the MoMA roof came when Smith saw a pair of pants his wife, Priscilla McGeehon, had bought—for a dollar or two, he seems to remember—on a downtown New York City street. By this time camouflage had begun to be an urban fashion statement, detached from its origins. The pants were orange, yellow, and brown, but it was the shapes Smith was after, not the colors. An assistant made a photocopy of the pants, and then they worked together to modify the shapes and to make them, in Smith's words, "more synthetic." They reduced the camouflage patterns to large, medium, and small circles, and then added to this graphic inventory a straight line, a T-intersection, and a splayed line. With these simple geometries, they transformed the designs on the pants into a prototype. The result was a satisfying abstraction of camouflage.

For his presentation to MoMA, Smith and his team created drawings and models of four rooftop schemes, each one reflecting a camouflage strategy outlined in a 1942 article in *Architect and Engineer* magazine that Smith had found: imitation, deception, decoy, and confusion. Smith's imitation scheme used rectilinear shapes to imitate the surrounding buildings, vents, elevator shafts, and skylights. The deception scheme, making something seem what it is not, used curvilinear, camouflage-like forms. For decoy, the strategy of building a dummy target or false structure, Smith created a rooftop construction of folded forms. Finally, for the confusion strategy he proposed enormous daisy shapes floating on a striped background. For all of the schemes, the proposed materials included artificial rocks and shrubs and crushed colored glass.

As part of the presentation of his deception scheme to the Museum Tower's board, Smith showed images of sculptor Isamu Noguchi's Peace Garden on the roof of the UNESCO building in Paris, a 1958 modern rooftop landscape. Noguchi used dwarf trees, 80 tons of rocks, a pond, and green hummocks in curvilinear shapes, abstracting elements of a traditional Japanese garden in his modern design. After studying the four proposals and the models, the Museum Tower board chose the deception camouflage scheme.

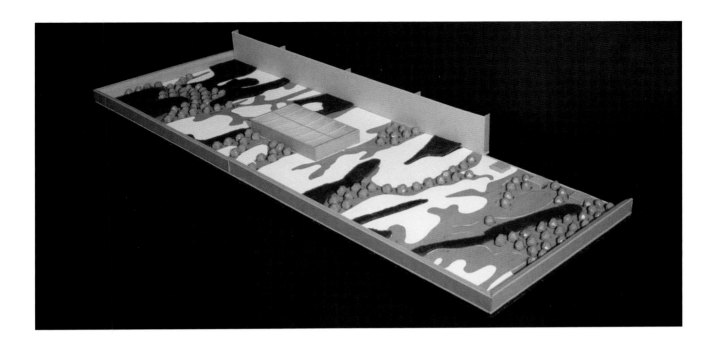

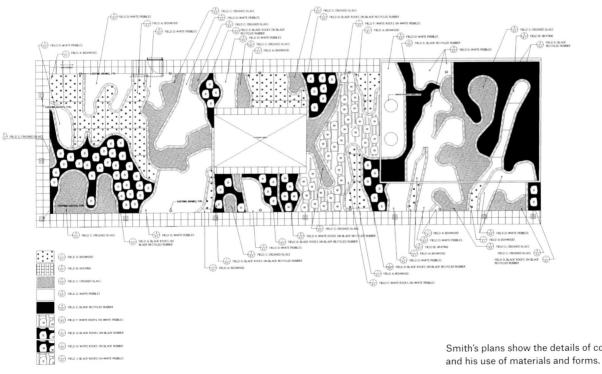

Smith's plans show the details of construction and his use of materials and forms.

TOP This study model helped convince the Museum Tower's board to select the deception camouflage approach.

KEN SMITH

Smith's garden for MoMA evokes his original concept of camouflage, and, especially in its artificial palette of materials, looks back to the garden in *Mon Oncle*. In addition, like Noguchi's UNESCO garden, it also recalls elements of Japanese gardens that Smith knows well from his many visits to Japan. One that especially appeals to him is The Ocean, a centuries-old gravel garden in Daisen-in at Daitoku-ji in Kyoto, with its pair of enigmatic cones set asymmetrically in a rectangle of raked gravel. Like the MoMA garden, it is without living plants, highly abstracted, and, like all Japanese dry gardens, it is meant to be observed, not entered. Another garden in the same temple complex as Daisen-in is the more recent garden of Zuiho-in, created in 1961 by Mirei Shigemori, who also appears to have had a strong affinity for the shapes of camouflage.

These several gardens, along with the concept of camouflage, served as inspiration for Smith's design at the museum. But the garden he created on this midtown New York City rooftop is distinctly his own, and it fulfills the directive he was given when he was commissioned by MoMA: to make a garden for us that is also work of art.

172

In Zuiho-in, the raked gravel and the
camouflage-like forms seem to presage
Smith's MoMA roof.

STEPHEN STIMSON

**SOUTHWEST CONCOURSE
AT THE UNIVERSITY OF MASSACHUSETTS
AMHERST, MASSACHUSETTS
DESIGNED IN 2009**

*Stephen Stimson's design
inspirations at a western
Massachusetts campus were
rooted in his life-long knowledge
of local farming traditions
and in his understanding of
agrarian ecology.*

Inspired by the form of a local oxbow of the Connecticut River, Stimson accommodated large amounts of runoff in this area, which is to the side of the wide central walkway and his constructed river.

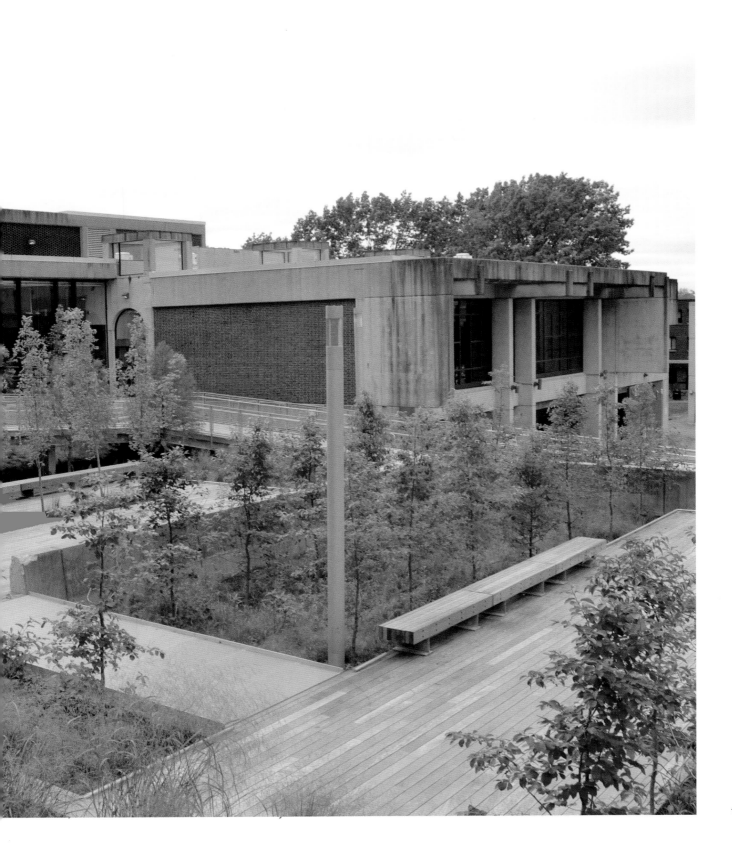

An aerial view shows the still-agrarian landscape in the Pioneer Valley of the Connecticut River.

Stephen Stimson's love of long country lanes and stone pasture walls comes from his childhood on a dairy farm that has been in his family since 1743. These rural elements, part of his strong bond with a five-generation agricultural past, became an inspiration at the Amherst campus of the University of Massachusetts, about 50 miles west of his family's land.

Stimson, who spent his undergraduate years here, was called in when it became necessary to replace underground infrastructure, including steam pipes, in the Southwest Concourse. Informed by his own past and by the ecological history of the area, he immediately saw this as an opportunity to bring the surrounding native landscape and the agrarian heritage of the Pioneer Valley back to this part of the campus.

176

Stimson's photograph of his family's farm shows the rural landscape into which he was born.

The Oxbow by Thomas Cole depicts the dramatic bend in the Connecticut River that inspired part of Stimson's design.

Stimson's riverbed runs north–south through this area of the campus, and this diagram indicates his plan to replace much of the existing concrete with plantings.

The project at the university was intimidating in its bleakness. In the 1970s, 5 acres of former farmland had been paved over, and a group of dormitories, each twenty-two stories tall, was built to create a student housing complex. The area connecting the buildings was mostly concrete and truly uninviting. Seen as a kind of campus backwater, the site had been neglected, vandalized, poorly patched, and disrespected by student residents for decades.

One challenge that Stimson set for himself in redesigning this landscape was to eliminate the thirty-eight catch basins that piped runoff from the site into an already overburdened stormwater system. It was Stimson's wife, landscape architect Lauren Stimson, who came up with a way to do this, based on her knowledge of the flow patterns and the oxbows of the meandering Connecticut River, which is less than 6 miles from the campus.

Oxbows, which are U-shaped bends in the course of the river, historically have provided the richest fields, called intervale meadows, for agriculture. These fields attracted the farmers who settled here in colonial times, and farms still dot the landscape of the Pioneer Valley. Although there are several oxbows along the Connecticut River, the most dramatic is a prominent landmark in nearby Northampton, Massachusetts, that was painted in 1836 by American artist Thomas Cole.

To keep stormwater on the site and out of the stormwater system, Lauren Stimson conceived the idea of mimicking the river and its oxbows. A constructed river—a channel that is wet during rainstorms or snow melts, and otherwise dry—runs for much of the length of the 5-acre site, while abstracted oxbows provide places where the stormwater can overflow.

Stimson's sketches illustrate his concept for creating drainage on this urban campus by imitating the patterns of the local Connecticut River.

The site plan for Stimson's project at the University of Massachusetts in Amherst includes a constructed river channel and planted areas that retain stormwater on the site.

In this sketch, Stimson showed typical river morphology in the top image. Below, he laid out the early stage of his plan to "manage and cultivate" the site water and connect to the larger, regional landscape.

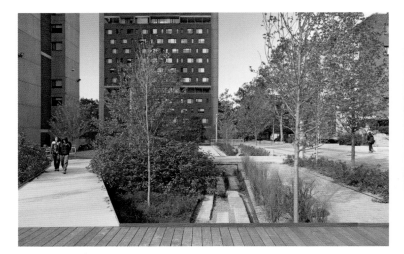

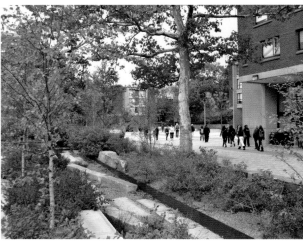

Stimson's landscape plan eliminated the catch basins on the site and replaced them with planted drainage areas. Here, in the riverbed that runs through the site, he used long lengths of local granite and planted native riparian species.

This view of the central walkway and constructed riverbed shows Stimson's dramatic use of stone and the berried plants he used for fall color. The London plane tree was one of several he was able to retain on the site. All other plantings are new.

The spine-like riverbed, an immense rain garden, is planted informally—almost wildly—with a diversity of riparian plants that can be seen along the banks of the Connecticut River, including dogwood species, pepperbush, and winterberry. The geometrically patterned oxbow areas, located off the central spine, are a counterpoint to the wildness of the riverbed and contain organized plantings of flowering crabapples and hawthorns that recall the tidy agricultural landscape of fruit orchards.

For the oxbows, Stimson created large sunken areas, or soaking gardens, where the water flows when the riverbed is full. Elevated decks with drainable soils underneath make these areas not only ecologically productive, but also socially active, and students now use them as informal gathering places. Stimson likes the sense here of feeling elevated, as if hovering above a swamp or a prairie of native grasses.

Considering these more formal spaces, Stimson recalls Dan Kiley, the landscape architect whose work he most admires. Stimson said he thinks of Kiley whenever he plants trees in a row or uses a hedge. By coincidence or design, Stimson's oxbows bear some resemblance to Kiley's Fountain Place in Dallas, Texas, designed with Peter Walker, where walkways are elevated above a watery ground at the entry plaza to an office building.

The river and oxbow scheme provides the major design element of this project and gives character to the formerly desolate site. Agricultural motifs add character as well, and where possible, Stimson's simple details allude to farming. He likes the use here of pasture-like stone walls and is pleased with benches made from found logs of white oak, bracketed together by heavy metal fastenings that remind him of farm implements.

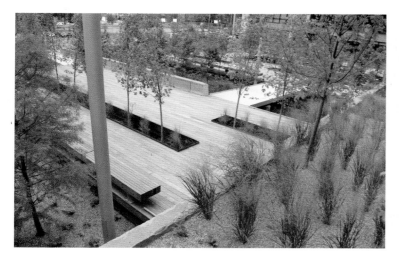

Rectilinear drainage areas were created with Cor-Ten steel and planted with water-tolerant species to accommodate runoff.

Stimson was glad to find large logs of white oak from which to make simple, sturdy benches along the main walkway. Their metal brackets recall rustic farm implements.

Dan Kiley's Fountain Place in Dallas may have inspired Stimson in the oxbow areas of the plan.

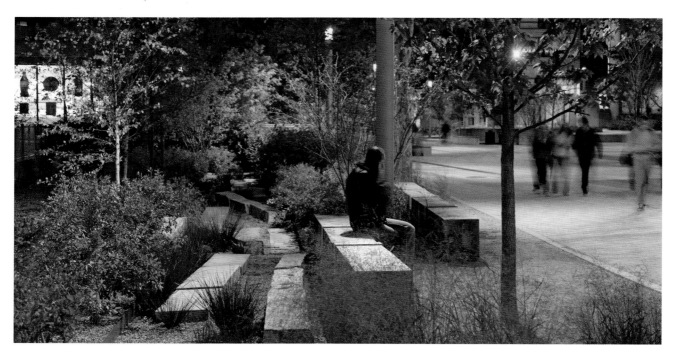

The central path, though still wide enough for deliveries and campus vehicles, is much reduced from its original size. One can see that Stimson was trying to get as close as possible to the image of a country lane with a stream running alongside it, although this country lane is paved in a contemporary pattern.

In addition to removing all of the catch basins on this site, Stimson was able to reduce the impervious paving area from seventy percent of the site's surface to forty percent. Now, more than half of the site is covered with plants, pervious paving, or gravel. What Stimson likes best is that he had a chance to interpret the environmental history of the site, while improving the ecology. It also pleases him that the Landscape Architecture Department at the University of Massachusetts now brings students here to study stormwater management, drainage, and grading.

Halfway between the campus in Amherst and Stephen Stimson's office in Cambridge is the quiet town of Princeton, Massachusetts, and the Stimson family farm. It is here, where both sets of parents live less than a mile away, that Stephen and Lauren Stimson have built a homestead, called Charbrook, for themselves.

Stimson's project in Princeton is a personal one. Charbrook has a farm layout, with a house, a barn, and fields. In the tradition of their forebears, the Stimsons made a place where they can live and work, both on the firm's landscape architecture projects and on the nursery that they have established here to test cultivars of native shrubs and trees. While they commute regularly to their Cambridge office, they consider this place a modern interpretation of the lives of their farming forefathers, though their barn contains studio space rather than cows.

Both at the Southwest Concourse at the University of Massachusetts and on the Stimson homestead, wildness is contrasted with agricultural patterns. About the Amherst redesign, Stimson noted, "We thought of this project as bringing back the ecology, but we really farmed the ecology, it is ecology in a box. We allowed it to be wild but between two straight lines." As at a farm, he said, there is a tension between the frame and the wild. For Stephen Stimson, this makes designing landscapes all the more interesting.

An aerial view of the central walkway shows Stimson's paving pattern and some of the trees he planted in rows.

LEFT AND OPPOSITE Stimson used these two axonometric sketches to develop some of the design elements of his campus plan.

Lauren Stimson's small sketch shows a proposed layout of Charbrook.

TOM STUART-SMITH

**THE WALLED GARDEN AT BROUGHTON GRANGE
NORTHAMPTONSHIRE, ENGLAND
DESIGNED IN 2000**

A large square water tank, the central feature of Tom Stuart-Smith's terraced landscape at Broughton Grange, was inspired by the water parterre at the Villa Lante north of Rome.

Stuart-Smith's square water tank reflects the clouds and recalls the more elaborate square water feature at the Villa Lante. He also was thinking of medieval fish tanks.

n 2000, as he was designing the walled garden at Broughton Grange, Tom Stuart-Smith won a Gold Medal at the Chelsea Flower Garden for a garden called Homage to Le Nôtre. There are aspects of Le Nôtre's formal ceremonial garden for Louis XIV at Versailles that resonate in Stuart-Smith's walled garden in Northamptonshire, albeit on a much smaller scale: the linear organization of trees, the use of topiary, the central water feature, and the distant views out of the garden. Stuart-Smith's direct inspiration, though, was a hillside garden of theatricality and formal geometry created a century earlier than Versailles: the Villa Lante, near Viterbo north of Rome. The Villa Lante, which is attributed to Jacopo Barozzi da Vignola, is constructed on a slope and has a clear progression of landscape motifs and concepts from top to bottom.

A visit to the Villa Lante begins at the shady top of the garden, where water emerges from carved stone masks set in a moss-covered wall. One walks down the hillside garden, though seldom along its central axis, and the water travels down, too, in a series of dramatic rills, basins, and falls before reaching the large square water parterre at the bottom.

For Stuart-Smith, this water parterre at the bottom of Villa Lante can be seen as an offering, "a plate put out to God...like a sacrifice open to the sky," and he had that thought in mind when he proposed a large square water tank as the central feature of his terraced landscape at Broughton Grange. At Lante, it is nature taking center stage, not man, he said. Viewed as one descends the garden, the water parterre is the quiet, cloud-reflecting heart of a composition of diverse landscape features that offer surprises at every change of level. This celebrated variety of garden experiences is one of the great joys of the Villa Lante.

The sixteenth-century enclosed garden at the Villa Lante steps down the slope, and each level has its own unique geometry.

An aerial view of Broughton Grange shows an irregular patchwork of stripes, dots, and squiggly lines surrounding this 350-acre Oxfordshire estate. The stripes are the parallel plough lines of farm fields, the dots are trees, and a long squiggle describes the meandering flow of a stream, Sor Brook, which flows southeast to join the River Cherwell a few miles away. Clearly visible within this bucolic composition at the edge of the Cotswolds is a long, tree-lined entry drive, the roof of a manor house, and, quite removed from the house, a large rectangular space—Stuart-Smith's walled garden—that is further subdivided into a pattern of rectangles and squares and that, viewed from overhead, contains its own share of wavy lines.

In 1992, Broughton Grange was purchased by its present owner, who, with his head gardeners, set about developing a series of traditional English gardens adjacent to his house: a knot garden, a boxwood parterre, and a pair of long perennial borders. As part of his garden expansion, he engaged Stuart-Smith to create a new garden in an old tradition: a garden within walls. The walled garden is an old landscape form, with historical precedents from ancient Mediterranean cultures to the castle and monastic gardens of medieval Europe and the sixteenth-century hillside gardens that still survive in Italy. The seventeenth-century walled Potager du Roi at Versailles, begun under Louis XIV, contained 25 acres of fruit trees and vegetables.

In England, walled gardens have long been used to shelter plants—especially edible plants—from the wind. Because of their practical rather than decorative nature, they were often sited at a distance from the main house. Even so, it was a bit of a surprise to Stuart-Smith that his assignment at Broughton Grange was to create a garden that was far out of sight of the house, with no apparent relationship to it at all. Additionally, unlike most walled gardens in England, this garden was to be created on a slope with a change of grade along its length of almost 10 feet.

Although this was Stuart-Smith's first large private garden commission, he was well prepared for the challenge by personal history, education, and design experience. As a teenager, his parents let him "mess about in the garden," and he spent all his pocket money on plants. He was inspired to study landscape design by conversations with two renowned designers, Lanning Roper and Geoffrey Jellicoe. After setting up his own practice in 1998, he gained recognition by winning multiple top awards at the annual Chelsea Flower Show in London.

In addition, he was an avid student of garden history, and his intimate knowledge of the Villa Lante led to many of the key design elements at Broughton Grange. The Villa Lante's plan suggested a way to create a walled garden on a steep hillside, and the garden's water parterre inspired Stuart-Smith's large water tank. The Villa Lante also provided another design idea: the stone Cardinal's Table, with its narrow water channel, suggested to Stuart-Smith the stone lined rill that feeds his water tank.

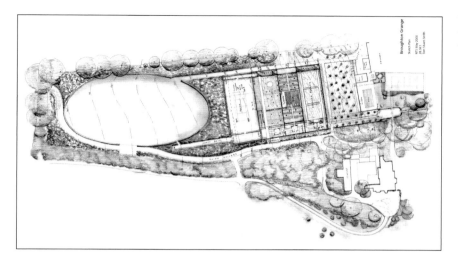

Tom Stuart-Smith's hand-drawn plan for the walled garden at Broughton Grange shows the relationship of the garden to the house.

Stuart-Smith was thinking of the Cardinal's Table at the Villa Lante when he designed this fountain element at Broughton Grange.

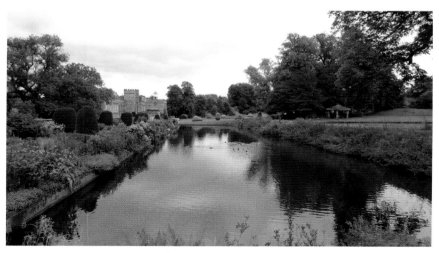

This crisply rectangular fishpond at Forde Abbey dates to medieval times. Such fish tanks were an inspiration for Stuart-Smith's tank for decorative fish.

The bucolic landscape at Broughton Grange includes many hedged fields in the distance.

Whereas the progression from the entry at the top of the Villa Lante is from mossy rusticity to the Platonic geometry of the water parterre at the bottom, at Broughton Grange Stuart-Smith created a progression of his own across the three broad terraces. At the top level of the walled garden, man controls nature in well-managed gardening. (A greenhouse is here, too.) One moves down through a second level of less intense horticulture, and then down again to the third level and an abstraction of nature in the patterns of an unusual boxwood parterre. Outside the formal garden one comes to the relative simplicity of the topiary garden and, finally, to the fields beyond.

Each of Stuart-Smith's three rectangular terraces shares the same dimensions and a tripartite division into squares. Also, each terrace includes a combination of vertical plants that are visible through the winter and seasonal perennials and annuals that, for the most part, die down to the ground in late autumn. But, as at the Villa Lante, each level provides dramatically different landscape effects.

Visitors to Broughton Grange are meant to begin at the top, near the greenhouse. This upper terrace, inspired by a Mediterranean landscape, is filled with a free-draining soil mix suitable to the tapestry of drought-resistant plants that are abundant here. A water rill separates two of the beds, and this narrow channel fittingly evokes the traditional gardens of warmer climates. Within the beds, thin, somewhat anthropomorphic, Irish yews rise above the perennials at slightly tilted angles. In the eastern-most bed is a fruit cage of espaliered apple trees, another example of the intensity of horticulture in this part of the garden. Running across this terrace is one of the wavy lines visible in aerial photos, an undulating path on which visitors, as well as the gardeners, can get closer to the plants. One senses that Stuart-Smith was having fun here as well as being practical.

The middle terrace, which contains the central water tank, is planted with lush, tall grasses and perennials to evoke an exuberant damp meadow. Accordingly, the soil is richer here. On this level Stuart-Smith sought a balance between organic, naturalistic planting and the serenity of strict geometry. In addition to the square water tank, an orderly stone grid pattern on the ground divides this terrace into rectangles, and within each rectangle stands a beech topiary with a round head on a cylindrical body, like a large version of the wooden figures found in a toddler's toy chest. At one side of the water tank there is a sitting area—the only one in the garden.

The view from this area takes in the distant hillside fields. Broken into irregular shapes by hedgerows, these fields reminded Stuart-Smith of the English landscape of his childhood, with rolling fields divided by hedge lines of trees. This scene was so essential to Stuart-Smith that he convinced the owner to limit the garden's walls to only two sides, so that the fields here would be a visual part of the garden.

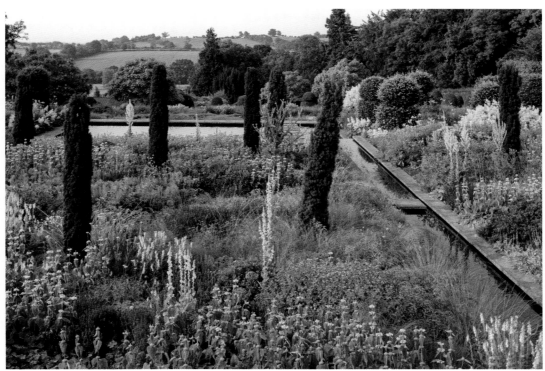

In the upper level of Stuart-Smith's walled garden, evergreen yews punctuate the flowering perennials.

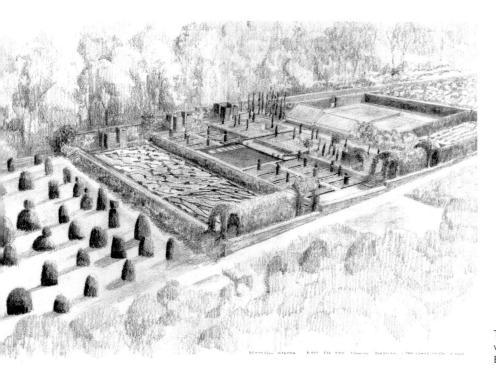

Tom Stuart-Smith's pencil drawing reveals the varied geometry within the walled garden at Broughton Grange.

When Tom Stuart-Smith observed their structures under a microscope, the leaves of ash, beech, and oak trees that surrounded the garden became the inspiration for the boxwood patterns in the lowest of the garden's three rectangular areas.

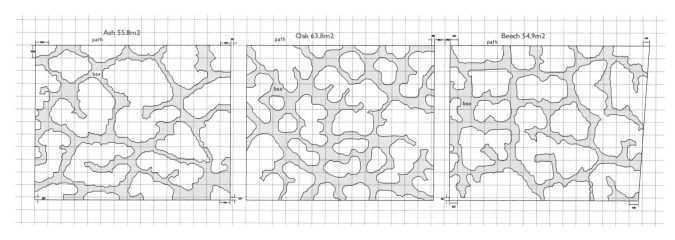

Microscopic views of leaves revealed their structure, suggesting Stuart-Smith's design of the boxwood parterres at Broughton Grange.

Stuart-Smith was also interested in a motif that would both connect to the landscape and distance one from it, and this thought led to his concept for the third and lowest terrace: to use the patterns of nature invisible to the human eye to create a design on the land. When the leaves of the existing ash, beech, and oak trees adjacent to the garden were magnified 10,000 times, their vasculature provided the patterns that Stuart-Smith used in his three unique boxwood parterres, each section mimicking the structure of a specific leaf. So this part of the garden is, at once, the most closely connected to nature and the most abstract.

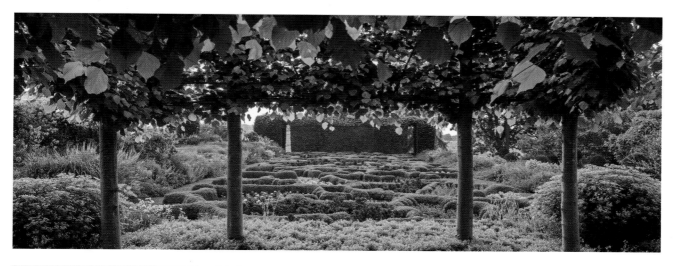

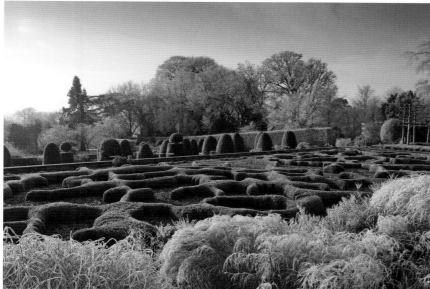
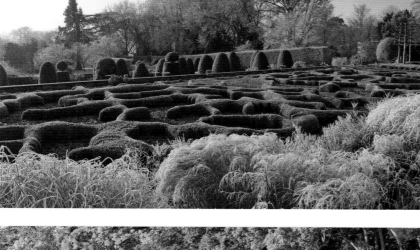

The boxwood parterre is seen across the garden from inside one of Stuart-Smith's cages of beech trees.

In winter, frost ornaments the garden, and the structure of the boxwood plantings is more evident.

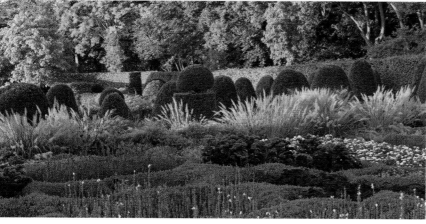

Morning sun illuminates the late-summer grasses in the boxwood parterres.

Below the south-facing terraces of the walled garden is the topiary garden, planted with twenty yews, each about 8 feet tall and 6 feet across. Most have rounded tops, and some have spherical heads. This kind of topiary is part an old tradition, seen, for example, in Jacobean gardens. But here is a modern version, not planted in straight lines or on a grid, but providing an inviting space where children might play among the green monsters.

In Stuart-Smith's mind, these rather hulking evergreen figures, planted in a purposefully random way, are much more than decorative. They are both an abstraction of the trees in the bucolic view and a connection between the walled garden and the natural landscape beyond. His preoccupation as a designer has been with the juxtaposition between different kinds of created landscapes: those, such as the Villa Lante, that impose a geometrical order on the land, and more natural and pastoral landscapes, such as those made in England in the eighteenth century.

Coincidentally, 10 miles away from Broughton Grange and overlooking the same river is William Kent's early-eighteenth-century landscape at Rousham, which is Stuart-Smith's favorite English garden. He has written that this landscape, a blend of formal and informal elements, presents "the most subtle synthesis of opposites of any historic garden that I know."

In the end, this is what Tom Stuart-Smith aimed for at Broughton Grange, a balanced juxtaposition and a synthesis between garden formality and informality, between the close-up, even microscopic, views of the natural world and the views into the greater landscapes beyond the walls. Inspired by his experiences as a life-long gardener in Hertfordshire, where his own Barn Garden serves as a horticultural and design experiment station, and by his understanding of historical gardens through the ages, he used everything he knew in the walled garden at Broughton Grange. As Kurosh Davis, a senior designer in Tom Stuart-Smith's office, said, "Ideas were forming in his head for years, and, suddenly, he got the chance to use them."

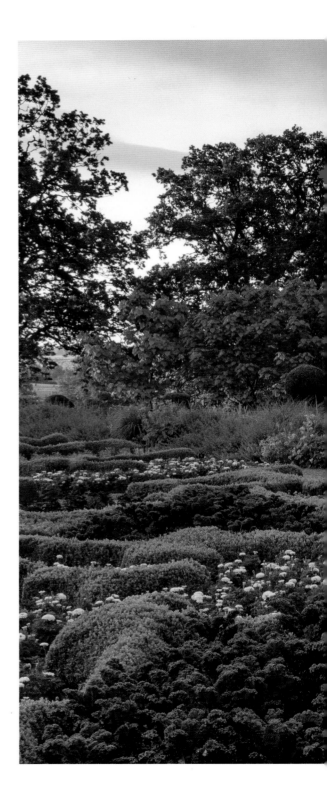

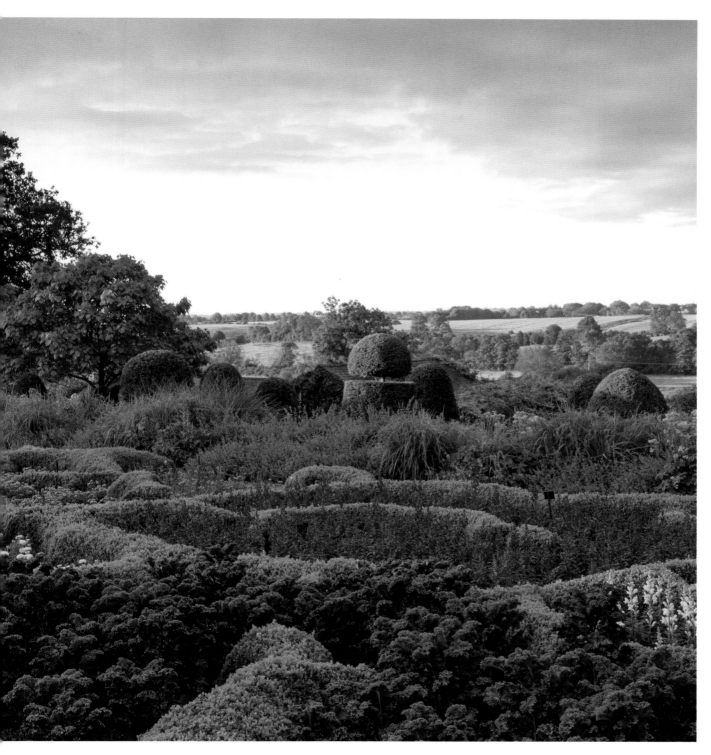

Beyond the flower-filled boxwood parterres, the tall yew topiaries and the estate's fields can be seen.

CHRISTINE TEN EYCK

**CAPRI LOUNGE GARDEN
MARFA, TEXAS
COMPLETED IN 2005**

For a landscape around a newly established event space just outside of Marfa, Texas, Christine Ten Eyck's inspirations included local history, the harsh beauty of the high desert, and her passion for the conservation of water.

Ten Eyck created shade structures from pipe and mesh, inspired by nearby oil field pipes and farm fencing. The water trough is a central feature and accepts rainwater from the roof through an overhead pipe. Gabion walls are filled with local stones and create outdoor rooms.

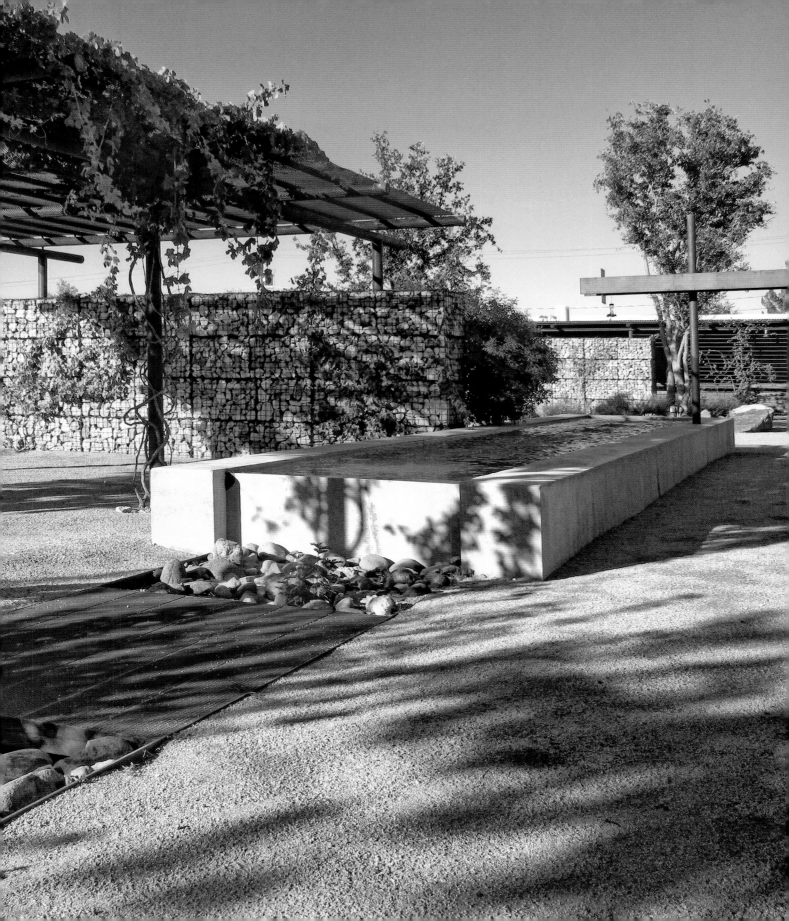

On a raft trip along the Colorado River through Grand Canyon, Christine Ten Eyck experienced a connection to water that she describes as life-changing. As a designer, she is dedicated to celebrating and conserving water.

Christine Ten Eyck, a Texas native and no stranger to deserts, is passionate about water. She traces this passion to the time she accepted an invitation to join friends on a rafting trip down the Colorado River. The seven-day journey became an epiphany and a life-changing experience. On that trip, Ten Eyck felt viscerally connected to the power, the joy, and the sheer presence of water, to the native plants and birds of the Grand Canyon, and to the raw beauty of the canyon cliffs. She resolved then that she would strive to respect the limits that the Southwest climate placed on water use and to reflect in her work the feeling for nature she found on the river.

Several of Ten Eyck's early projects in Texas and Arizona, for which she received awards and public recognition, feature small round basins or rectangular pools of water, some with restrained jets. She acknowledges her debt to the gardens of Moorish Spain, with their effective use of minimal amounts of water. In these projects she also eschewed non-native plants that required excessive irrigation in favor of tougher natives. And she has experimented with ways to capture water sustainably, even using the condensate from air conditioning units, for example, to irrigate plants in her landscapes.

Ten Eyck uses small amounts of water effectively, influenced by such Moorish courtyard fountains as this one at the Palacio de Generalife in Spain.

The small town of Marfa in a remote area of West Texas has more cows than people, yet it is also a center for artists and writers.

The town of Marfa, in the high-desert cattle country of West Texas, is about 4700 feet above sea level and 200 miles from the nearest airport. Although the town was founded as a railroad water stop, the train no longer stops here. In this semi-arid land, water is a critical commodity; Texas saw a record drought in 2013, with water storage at an all time low.

Marfa's current population of about 2000 is a mix of ranchers, cowboys, and an arts community that began to grow with Donald Judd's arrival in the 1970s. Judd, a renowned minimalist artist who formed a strong attachment to the local landscape, purchased hundreds of acres, including the decommissioned former Army base that now serves as an exhibition area for his work and that of contemporary artists. The Marfa community includes writers in residence and boasts its own public radio station, as well as a bookstore focusing on art and design, a gallery space that hosts films and concerts (Marfa Ballroom, housed in a former dance hall), and several active arts organizations. The starkness of the town has also attracted many filmmakers.

Cowboys lead cattle through the high desert landscape of Marfa, Texas.

CHRISTINE TEN EYCK

The entry to the Capri Lounge features a dramatic roof overhang. Ten Eyck created a planted bioswale here that carries the roof water toward the new ephemeral stream in the garden. Entry bridges create thresholds to the building.

Ten Eyck's site was a former parking lot.

In Marfa, the climate—both real and cultural—presented Ten Eyck with the kind of challenge she likes best: an arid place with enough local history to suggest the evocative use of indigenous materials. The site, as she found it, was an open treeless parking lot around the newly created Capri Lounge, developed as part of the Thunderbird Hotel across the street. The iconic Thunderbird, a one-story roadside motor court and a fixture here since the 1950s, had been renovated in 2005. A travel guide described its new style as "cowboy Zen."

The Capri Lounge, in a former Army storage hangar, was renovated by Lake|Flato Architects as an event space and a place for more casual gatherings. Both private and community events now take place here, including weddings at which the bride, her mother, and her bridesmaids all are likely to wear cowboy boots with their dresses. The large overhanging roof at the back of the Capri Lounge connects the indoor space to the outdoor areas architecturally.

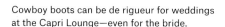

Cowboy boots can be de rigueur for weddings at the Capri Lounge—even for the bride.

An arroyo, also called a desert dry wash, is an intermittently dry creek or streambed that flows with water seasonally. The term *wadi* is used in the Middle East.

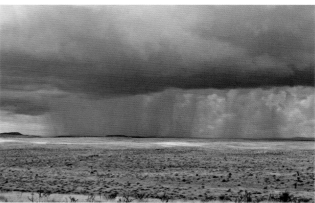

In the American Southwest, storms in the desert can fill the arroyos with water.

Ten Eyck's charge was to transform the barren parking lot into an inviting garden for relaxing and for celebratory occasions, and she drew planting inspiration from the high-desert landscape, materials inspiration from local recycled objects, and design ideas from the prospect of the happy events that would be held in the space. Although a thoughtful and environmentally responsible designer, Ten Eyck also exudes a great sense of fun, and the task of creating a party space drew on that side of her.

As in most of her work, water is a key element here. Ten Eyck often turns to a 1929 map by Omar Turney for inspiration. This map covers the extensive system of water canals created by prehistoric peoples in the American Southwest beginning in about 600 C.E. Titled *Prehistoric Irrigation Canals*, this map shows hundreds of miles of canals reaching out from the Salt River in the area of Phoenix and Tempe, Arizona, the largest irrigation system in the Americas. Engineered by the Hohokam people, the canals, some up to 15 feet deep and 45 feet across, irrigated more than 100,000 acres of land by the beginning of the fourteenth century, allowing the Hohokam to grow corn, beans, squash, and cotton and to lead settled lives in communities.

Knowledge of these canals—early examples of large-scale cooperative human intervention in the Southwestern landscape to sustain a community—was a revelation to Ten Eyck. She has also been inspired by arroyos, natural dry gulches that become intermittent streams and are catchments for the flash floods that can be a dangerous surprise, even in the most arid regions. Ten Eyck loves the idea of ephemeral water features and says she likes to "celebrate the path of water when it comes." She frequently uses constructed arroyos as a motif in her work. At the Capri Lounge, her designed arroyo curves through the garden, flanked by artfully placed trees to provide a landscape feature that is decorative and evocative while it also handles drainage.

As a container for water at the Capri Lounge, Ten Eyck designed a fountain that harvests rainwater from the rear half of the roof. This rectangular raised poured-concrete fountain recalls a cattle trough, while also seeming to refer to the multiple concrete sculptures by Donald Judd that are arranged on the land not far out of town. (Ten Eyck had used a similar fountain form in other projects, including one in her own Austin, Texas, garden.) When it rains, the fountain overflows into a channel that leads water to a community orchard.

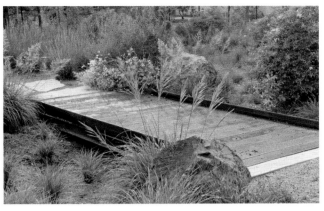

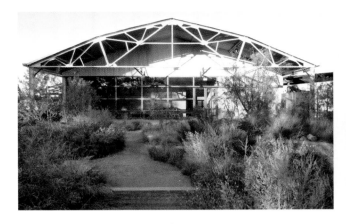

Replacing the former parking lot, native grasses and other indigenous plants soften the harsh landscape while evoking the surrounding high desert. A campfire area is half-hidden on the right, and a bridge over Ten Eyck's arroyo is in the foreground.

A closer view shows the bridge spanning Ten Eyck's arroyo.

An overhead pipe carries rainwater to the water trough, an example of the use of industrial materials at the Capri Lounge.

This campfire area, one of several, features flat-topped boulders as seats.

Lushly planted desert species surround the campfire areas. This space has chairs for seats, rather than boulders.

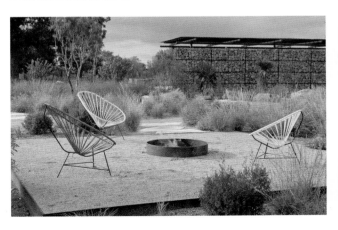

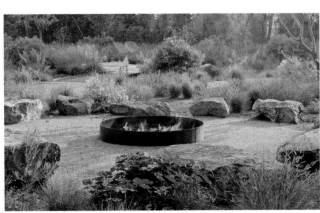

Ten Eyck's early sketch shows her preliminary thoughts. One note reads, "every once in a while use shrubby dogweed." The bike racks were in her plan from the beginning.

Ten Eyck's plan, in her signature hand-drawn and colored-pencil style, indicates the path of her constructed arroyo and shows multiple gathering places, including the fire pits. Her trough-like fountain is shown in the center.

With another garden feature, Ten Eyck recalls the archetypal image of cowboys sitting around a campfire. Her circular fire pits, formed with thick steel edging and stabilized decomposed granite, are constructed of local materials, and some include inviting boulders for seating.

The native rocks of the area around Marfa encouraged Ten Eyck to make tall gabion walls, building blocks of large rectangular wire cages filled with local stones in soft desert hues. These provide texture in the garden and a bit of indigenous context, as well as a sense of enclosure to her spaces.

"Harsh beauty" is Ten Eyck's expression for the places where tough native plants flourish and form a kind of landscape of survival. For her, the grasslands around Marfa, which stretch as far as the eye can see, are especially affecting, and she chose a selection of native grasses for her garden that tie it to the landscape beyond. She used sporobolus and muhlenbergia varieties as the main arroyo grasses, and blue grama in the drier areas. Other native plants here are yucca, bur oak, agarita, agave, and Texas mountain laurel.

It is the function of the garden, perhaps, that inspired Ten Eyck most of all. Gregarious herself, she learned that even the ancient and industrious Hohokam people were not always hard at work maintaining their extensive canals. They held large community gatherings where people of every age could get together and enjoy the festivities. In Ten Eyck's landscape at the Capri Lounge, the same spirit of community and celebration endures.

An island bed with rocks and plantings surround a small tree grove. Nearby there is ample room to dance.

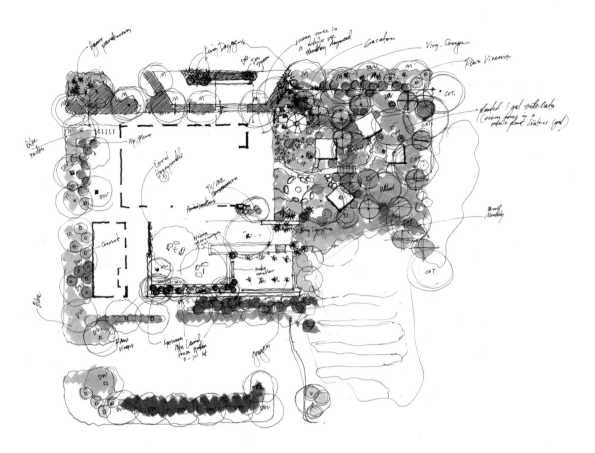

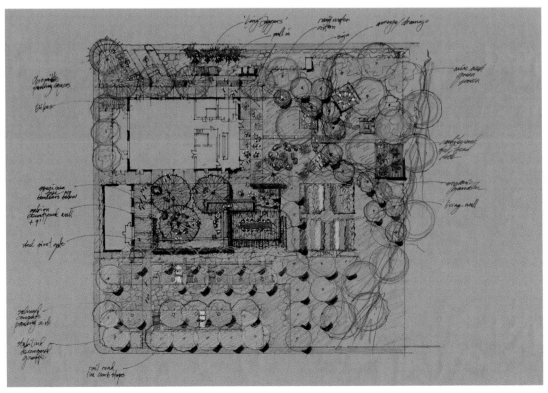

RYOKO UEYAMA

**KITAMACHI SHIMASHIMA PARK
SAITAMA, JAPAN
DESIGNED IN 2003**

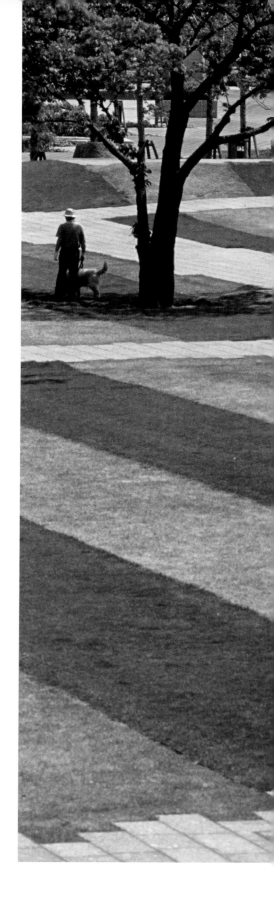

In looking for the "memories of the land," Ryoko Ueyama realized that her site for a proposed park was located exactly on a line connecting Japan's revered Mount Fuji with the local Mount Tsukuba. This unseen bond seemed almost mystical to Ueyama, and it inspired her design.

Japanese lawn grass and Kentucky blue grass were used to create the dominant stripe pattern that runs throughout Kitamachi Shimashima Park, and the stripes continue in the granite paving. *Shima-shima* means stripes.

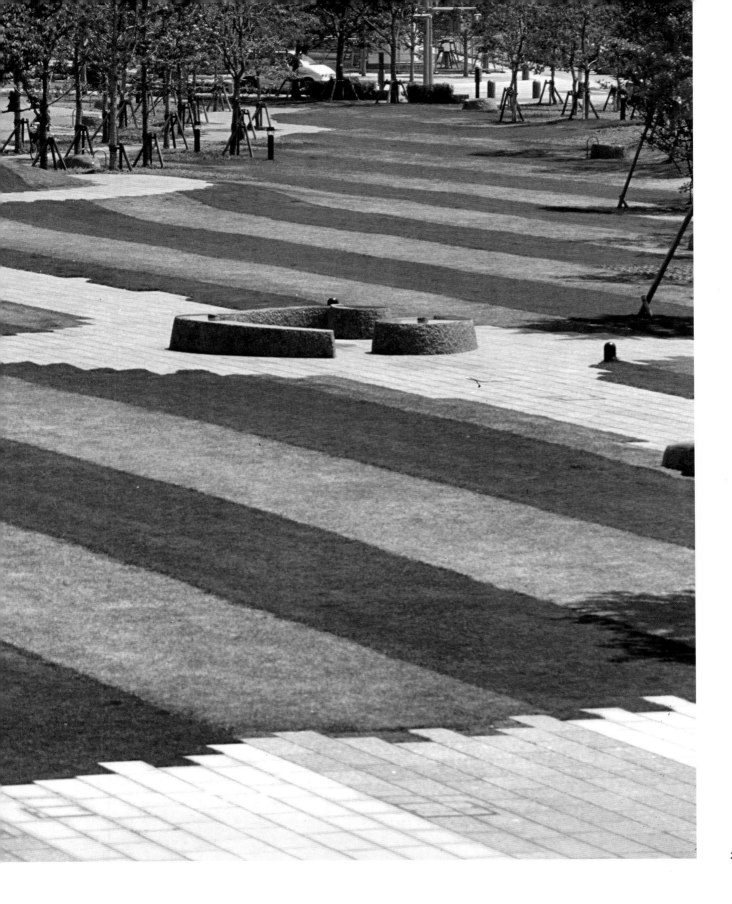

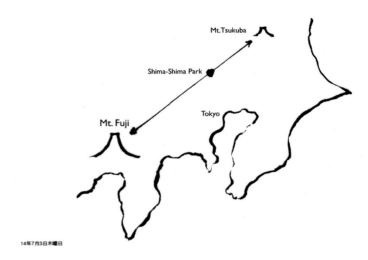

14年7月3日木曜日

Kitamachi Shimashima Park sits exactly on a line connecting Mount Fuji with the local Mount Tsukuba. This unseen bond seemed almost mystical to Ueyama, and it inspired her design and the name of the park.

I n 2003, Ryoko Ueyama was commissioned to design a neighborhood park in the suburbs of Saitama, on a long narrow site surrounded on three sides by roadways and bisected by another road. A multi-story shopping mall and a large complex of high-rise apartment buildings command the north side. Seeing the place for the first time, Ueyama said she felt keenly that the site was "spatially subjugated" to these tall buildings. She decided her goal was to overcome the limitations of the site and to make a "notable and unique" place, one that would become the core of the local community.

As she does for every project, Ueyama investigated the site and researched the area, looking for what she calls "memories of the land." What she discovered led to the unique design features of the new public park.

In her research, Ueyama discovered that her site is located precisely on the axis between Mount Fuji, Japan's tallest and most venerated mountain, and nearby Mount Tsukuba, sometimes called "local Mount Fuji." A source of legends and poetry, Mount Tsukuba is known for its double peaks and for its panoramic views of the surrounding lowlands and plateaus. On clear days, Mount Fuji is visible from Mount Tsukuba as well.

Majestic and venerated, Mount Fuji is an iconic image in Japan.

On clear days, one can view Mount Fuji from Mount Tsukuba. Ueyama feels her site's link to these two mountains is fortuitous and charmed.

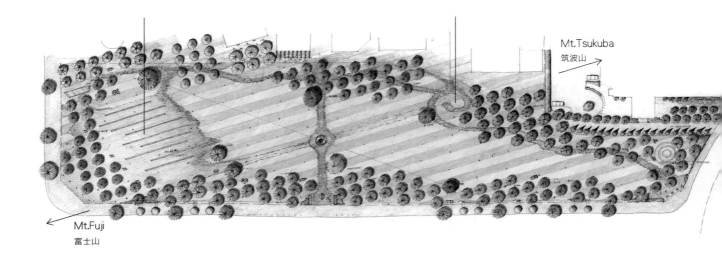

Mt.Tsukuba
筑波山 →

← Mt.Fuji
富士山

Ueyama's plan for Kitamachi Shimashima Park shows the striped lawns and the stripe pattern in the paved plaza, which also functions as a fountain. On her plan she indicated the directions of both Mount Fuji and Mount Tsukuba.

Reached in less than an hour by train from Tokyo Station, Saitama City is a major commercial and suburban center that spreads out within the greater Tokyo area. Though sprawling Saitama City is young—created in 2001 by the merger of three existing cities—this is an ancient place, mentioned in the oldest existing collection of Japanese poetry, from the eighth century.

As Ueyama began her work on the park, she searched for revelations to inform and inspire her design process. "It is one of my guiding principles," Ueyama said. "If you look deeply enough, every piece of land has thousands and thousands of memories. If you dig here a hole, you can see the layers, including the history of human beings."

She credits this insight to California landscape architect Lawrence Halprin, who taught a special course in landscape architecture at the University of California, Berkeley, where Ueyama earned her master's degree in 1978. During a week-long workshop with Halprin at the Sea Ranch in northern California, she came to understand how a seventy-year-old vernacular barn there could be "respected and treasured as an inspiration, to give a sense of time and place" to the landscape. Halprin taught her to notice such elements of the past and to consider their power to inspire design, which influenced all of Ueyama's work when she returned to Japan.

"The scales fell from my eyes," she said of her course with Halprin, "and I learned to listen to the voice of nature." She noted that it was her American teachers, rather than her life-long exposure to the traditional gardens of her native Japan, that provided her with her own voice as a landscape architect.

Now though, she said that she finds she is "coming home" and expressing the Japanese traditions and aesthetics that are part of what she calls her "cultural DNA." Certainly, this is evident in her work on Kitamachi Shimashima Park.

Ueyama said she considered the discovery of her site's axial relationship to Mount Fuji and Mount Tsukuba a "divine pronouncement," and as she looked for a way to express this connection in her plan, the answer she found became the defining feature of the new park: a pattern of stripes that covers the site and is aligned with the axis between the two mountains. For most of the park's acreage, these broad stripes, almost 10 feet wide, are planted with alternating swaths of Japanese lawn grass and Kentucky blue grass, creating a distinctive identity and sense of place.

Sea Ranch is a planned community in Sonoma County, California, where modest agricultural buildings inspired the architecture and Lawrence Halprin sought to integrate the buildings and the natural landscape into a whole vision.

The linear site is almost 4 acres, about 1600 feet long from east to west and varying in width between 80 and 160 feet from north to south. Within the park, Ueyama has planted many trees in groups along the Mount Fuji–Mount Tsukuba axis, augmenting the pattern but also softening the strict geometry of the ground plane. Because of these trees, the park feels like a park, not site art. At the plaza at the park's western entrance, the lawn stripes give way to stripes of alternating tones of granite paving. Ueyama noted that in addition to the striking effect, the pattern of stripes serves an important design function: the strong diagonal lines help to make the long narrow site appear broader.

Although the geometrically patterned ground in this park recalls the work of American landscape architects, including Dan Kiley and Peter Walker, Ueyama may have had a distinctly Japanese inspiration for this project: the striped patterns of the raked gravel in gardens that were first created as places of meditation hundreds of years ago and that are an important part of Japan's aesthetic heritage. The most famous of these dry gardens, Ryoan-ji, was created in the fifteenth century. To this day, a monk from the temple rakes the striped pattern.

Unlike the creators of Ryoan-ji and other dry gardens at Zen Buddhist temples, Ueyama's purpose was to make a place for lively human interaction. However, she has positioned her landscape features thoughtfully, much like the stones placed in the gravel of a temple garden. These features include a mound and several sculptural stone benches located throughout the site. These benches have a story to tell as well.

Peeling back the historic layers of the site in search of its memory, Ueyama knew that this park, located in the center of Japan's Kanto Plain, was the ancient home to the Jomon people, who hunted, fished, and gathered wild plants here about 10,000 years ago. They are known for their distinctive pottery—the oldest reliably dated on Earth—decorated with lines made by wrapping cords on wet clay to produce striped patterns on the surfaces.

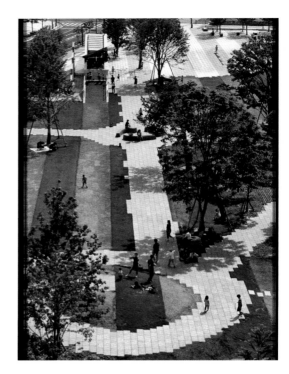

This aerial view shows the generous scale of the stripe patterns in the park.

A visit to a local museum provided a particular inspiration, when Ueyama came across a captivating Jomon artifact. Made of earthenware 5000 years ago, it was a musical instrument shaped like a turtle, which she describes as having "an E.T.-like face, with unique stripes on the back." This was a "messenger from the past," she said, and it told her how to create her landscape.

Ueyama was struck by the stripes, but she also thought the turtle was a "humorous and heartwarming" creature, and these were two qualities she wanted for her park design. She called on a colleague to design the amusing park signage that features a friendly cartoon-like Jomon-period turtle.

The dry gardens of Japan, such as Ryoan-ji, with their raked gravel, seem to be a subtle—and perhaps unintended—cultural influence on Ueyama's park.

This small Jomon-period musical instrument in the shape of a turtle especially intrigued Ueyama.

Inspired by a Jomon-period clay figure, the park's signage features images of the turtle.

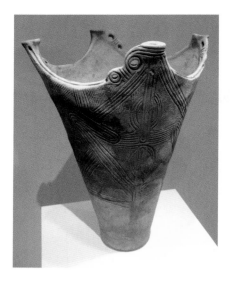

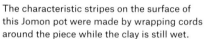

The characteristic stripes on the surface of this Jomon pot were made by wrapping cords around the piece while the clay is still wet.

After studying early Jomon pottery and jewelry in a local museum, Ueyama adapted some of these forms in her site furnishings for the park.

At the museum, the shape of a Jomon earring caught her eye, as did Jomon necklaces, and then other accessories. Entranced by these centuries-old objects, she modeled her benches on the shapes of Jomon artifacts. These benches, at once playful and useful, serve as inviting climbing objects for children as well as for seating. Their shapes are varied, but many have a soft, undulating character.

Near the western entrance to the park, on the plaza striped in granite, a fountain is programmed to arc in rows that follow the same diagonal pattern as that of the grass and paving. In Ueyama's fertile imagination, the thirty-five jets of arching water are a synchronized group of "leaping frogs," a thought that makes her laugh.

Kitamachi Shimashima Park literally means North Town Striped Park, and the name reflects Saitama's location north of Tokyo, the capital of Japan. But the Japanese word *machi* can also mean the center of a town, a place of activity and people: a place of connection. This name is most appropriate to the fulfillment of Ueyama's goal for this unprepossessing site: to be a unique, notable, and welcoming place. Perhaps it was no coincidence that on a visit to the park one bright fall day, when the waters leaped like frogs and the striped park was full of people, Ueyama wore a soft silk scarf around her neck, boldly striped in black and gold.

Children use the benches as places to play.

Children play in the water fountain on striped granite paving.

Ueyama described the fountain sprays, here seen at night, as "leaping frogs."

Ryoko Ueyama, in Kitamachi Shimashima Park, is wearing a striped scarf.

Playful site furnishings for sitting and climbing were inspired by the forms of Jomon pottery.

KIM WILKIE

**ORPHEUS AT BOUGHTON HOUSE
NORTHAMPTONSHIRE, ENGLAND
DESIGNED IN 2007**

The prehistoric earthworks of southern England were part of Kim Wilkie's initial inspiration at Boughton House. He then envisaged the two earthworks across a canal from each other in terms of the well-known Greek myth of Orpheus and Eurydice.

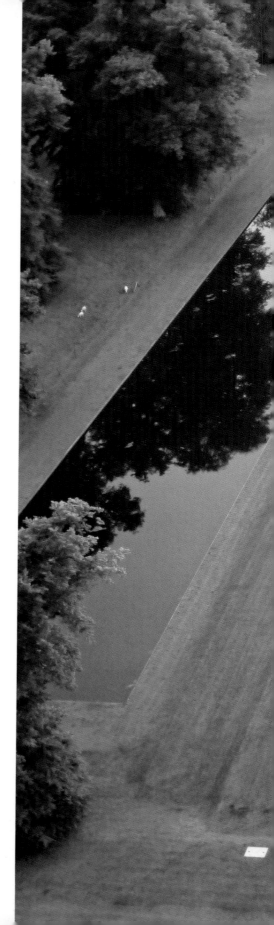

This view of Kim Wilkie's Orpheus shows his two-part landscape work, an excavated terraced landform and a sculptural feature that interprets the Golden Rectangle. His composition sits across a canal from the estate's 300-year-old existing mount.

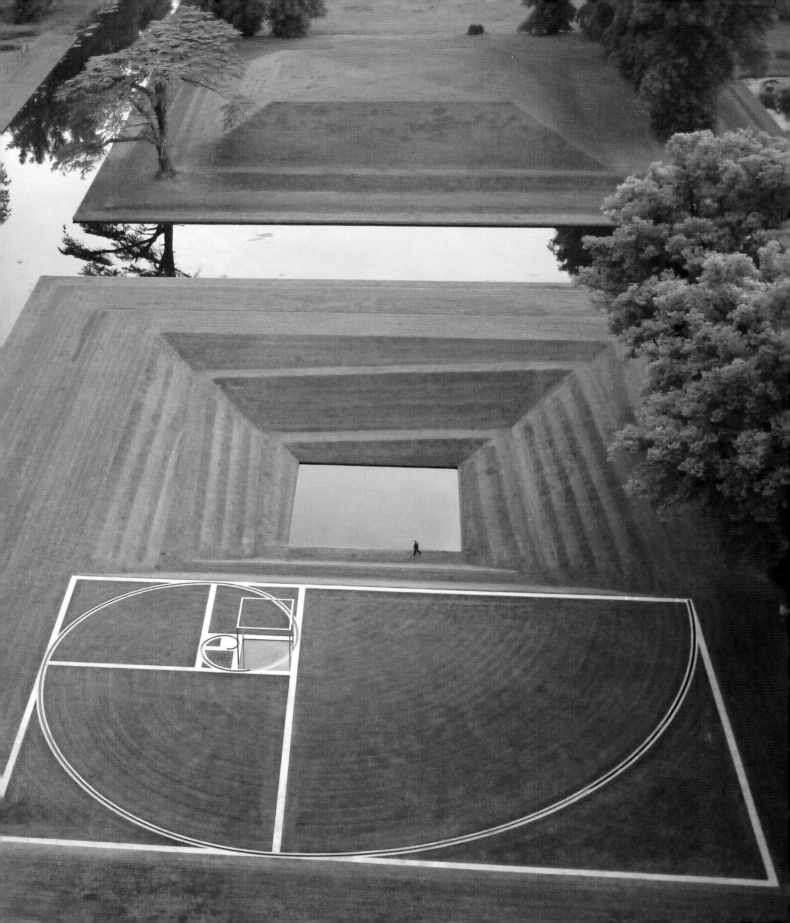

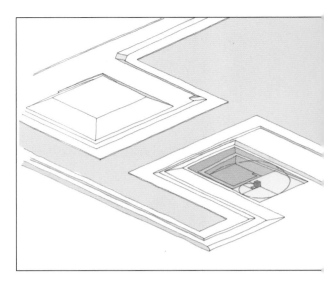

Wilkie's axonometric sketch illustrates his response to the request for a new landform to complement the old mount on the property.

In the spring of 2006, Kim Wilkie was invited to Boughton House in the East Midlands. There he found a gently rolling pastoral landscape and, on level land closer to the house, a vestigial garden of derelict canals and standing avenues of 250-year-old trees. His prospective client, Richard Scott, then Earl of Dalkeith, had an unusual project to discuss: creating a twenty-first-century landscape feature to complement a large mount that had existed on the property for 300 years.

Wilkie's background, experience, and sensibility uniquely prepared him to find inspiration at Boughton House that day. His childhood in Malaysia and Iraq had given him an open mind, an obsession with ziggurats and old Mesopotamian sites, and a fascination with all things sacred and mystical. Combined with his history degree from Oxford, Wilkie's graduate education in landscape architecture at the University of California, Berkeley, augmented his appreciation for historic landscapes, especially prehistoric earthworks: ancient forts and mounds, often built for protection or for a ritual purpose. For him, they evoke culture, memory, and the collective human spirit.

The question was what kind of earthwork should be built here that would relate to the mount? Standing with his client, Wilkie was under pressure to come up with an idea on the spot. As he recalled, "What is most thrilling is the first five minutes on a site, because your antennae are out and there is a real hope that something will electrify in that moment." In this case, it did. He told his client, "It would be interesting to go down rather than up." Instead of making a complementary mount, Wilkie proposed to create an inverted counterpart, with a path spiraling down into the earth.

Wilkie is intrigued by prehistoric earthworks such as this one, Silbury Hill, in Wiltshire, England, the largest man-made mound in Europe.

Wilkie's regard for ancient English mounts led him to create one on his own farm in Hampshire.

218

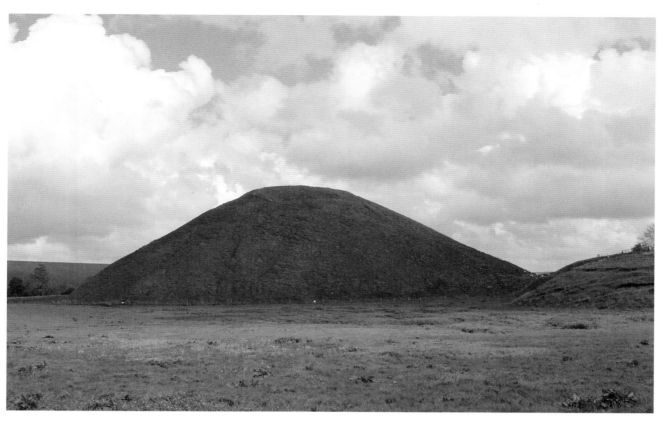

The rural Northamptonshire countryside beyond the garden is an agrarian foil to the sophisticated composition created by Wilkie.

Boughton House, a Northamptonshire estate 77 miles north of London with land enough to accommodate thousands of grazing sheep, has been home to the Montagu family and their descendants, the Dukes of Buccleuch and Queensberry, since 1528. The property was inherited in the seventeenth century by Ralph Montagu, who served as ambassador to Louis XIV. Montagu returned from the court of Versailles to refurbish Boughton in a way that would have made the French king feel at home. Alterations to the landscape followed, inspired by the formal allées of trees and axial symmetries in André Le Nôtre's gardens at Versailles.

In the following three centuries, Boughton House was seldom used and little altered. The owners departed, and the garden slept on, its simple, French-influenced geometry intact and ignored. From Kim Wilkie's point of view, this was all for the best. As he explained, the family left England and their estate at a "completely amazing moment" in the early decades of the eighteenth century, when the French-style parterres and flowers were being stripped out of English gardens, leaving only the framework and shapes of the seventeenth-century garden style: geometric planes of reflecting water, sculpted earth forms, and strong lines of trees, all opening up to the productive agricultural land beyond.

For Boughton House, this amazing moment lasted more than two centuries. Since the family was living elsewhere in the mid-eighteenth century, they were not present to engage the services of Capability Brown, as so many contemporary English estate owners had done. Brown would have removed all of Boughton's historic seventeenth-century landscape features in favor of a more informal landscape. So, at Boughton, the formal garden vestiges of the previous age were not eliminated, but remained into the twenty-first century, overgrown and softened by time.

221

The old canals at Boughton House were restored to their eighteenth-century contours after a long period of decline.

When Kim Wilkie first saw the property in 2006, the old mount was covered with trees.

It was in the middle of this landscape, where some restoration had already begun, that Kim Wilkie stood with the property's owner on a day in early spring to consider his commission. Miles of trees, planted in rows, had been lost, including those cut down for firewood during World War II, but the remaining avenues of lime trees were being well tended. Though compromised, the water channels were clearly visible, and much silt already had been removed. The Broad Water, a large rectangular lake, had been dug out and the sluice restored. Nearby, the impressive old mount, almost 200 feet square and nearly 26 feet high, was still completely covered by tall trees. But its distinctive shape—a low pyramid with a flat top—was discernable. The land adjacent to the mount and closer to the house was an empty canvas, waiting for a new landform.

It was not the first time that Wilkie had accepted such a challenge. He had created a dramatic earthwork, a sweeping terrace of lawn steps, at Heveningham Hall in Suffolk. But it was to more ancient forms that his mind turned that day at Boughton. Early man-made landforms, including the prehistoric earthworks of southern England, were part of Wilkie's initial inspiration. He has studied the mysterious Neolithic Avebury circles in Wiltshire and Maiden Castle, one of the many Iron Age forts in Dorset, and he understands the ways in which their makers shaped the earth into ramparts and ditches. He also can describe earthworks from more recent centuries that have a special resonance for him. One such, in Surrey, is the eighteenth-century amphitheater in Claremont Landscape Garden. Shaped of earth and clothed in grass, it is best viewed from across a small lake. Like the work he was beginning to imagine for Boughton House, the terraces of the Claremont amphitheater can be reached from the top, and it terraces down. Claremont, which combines crisp angular landforms with a reflecting body of water, was in his mind that first day at Boughton House.

Looking up at the existing mount at Boughton and then picturing a winding path down into his proposed earthwork, Wilkie suddenly envisaged the two earthworks across a canal from each other in terms of the Greek myth of Orpheus and Eurydice. Orpheus, through the incomparable music of his lyre and his songs, was able to rescue his wife Eurydice from Hades, only to lose her when he looked back. In terms of the myth, the old mount could be imagined as Mount Olympus, the new earthwork would be the Underworld of Hades, and the canal between them would be the River Styx.

The amphitheater at Claremont Landscape Garden, seen in this old engraving, was an inspiration for Wilkie's earthwork at Boughton House.

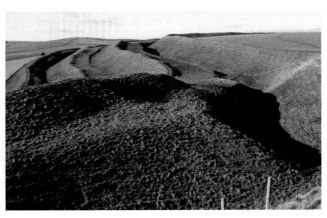

Maiden Castle, in Dorset, England, is an Iron Age hill fort with ramparts and ditches that were added in the fifth century B.C.E.

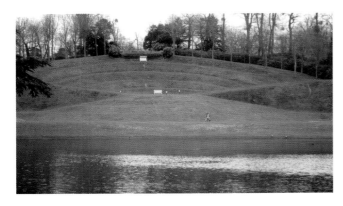

The eighteenth-century turfed amphitheater at Claremont overlooks a lake. The ramps of Wilkie's Orpheus resemble the amphitheater's terraces.

The form of Wilkie's earthwork was inspired by the legend of Orpheus and Eurydice. Visitors may use the terraced ramp to descend and ascend this earthwork.

Kim Wilkie's diagram shows his concept of the proposed earthwork in terms of Greek myths. Mount Olympus is the home of the gods, the River Styx is the boundary between Earth and the Underworld of Hades, and Hades is the abode of the dead.

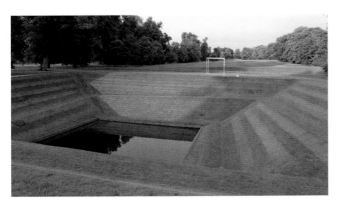

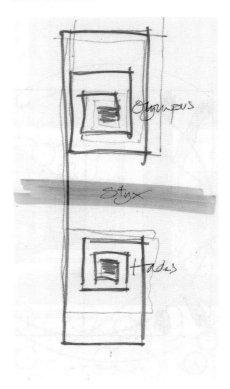

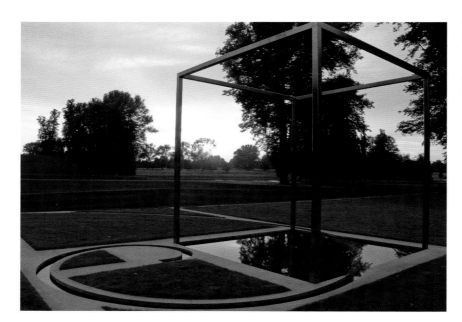

To Wilkie, this depiction of the Golden Rectangle represents life on Earth.

OPPOSITE Artist James Turrell's works, such as his 2010 *Roden Crater, East Portal Entryway* in Arizona, inspired Wilkie.

Although the tale of Orpheus and Eurydice is a gloomy story, Wilkie chose to focus on some positive elements. For example, Orpheus' mythically enchanting music is recognized here. In the summer, a platform is placed at the bottom of the earthwork, creating a stage for musical performances. Wilkie also mentioned that light is important to his composition. When the concert floor is not in use, the water reflects the light of the sky and the English clouds in which Wilkie finds ineffable beauty. In creating this mirror of the sky, Wilkie was inspired by James Turrell's Skyspaces, which play with the viewer's perceptions of space, light, and the surrounding environment.

The crisp geometry of Orpheus is made possible by two natural factors in this area. First, the characteristically mild English weather means that short grass can thrive, allowing the crisp lines of earthworks to remain so. Second, the local blue clay soil allows the steep banks to hold. In addition, the quality of the English light—determined by the country's northern latitude—allows for the lovely shadows that enhance Wilkie's work, especially in the morning and late afternoon. And frequent, but gentle, frosts provide stunning effects.

For Wilkie, the bilateral composition of Mount Olympus and the Underworld was not complete without the creation of an additional built landscape that represented the place of man in the world, and, by extension, civilization. Adjacent to Orpheus he created a work based on the Golden Rectangle. His inspiration came from an old map that showed the garden as it was in the early eighteenth century. Wilkie realized that the garden layout conformed to the golden ratio, considered to be an exceptionally harmonic proportion. In geometry, this is a rectangle whose side lengths are in the ratio of 1 to approximately 1.618. To express the harmony that recently has returned to Boughton House and to celebrate the role of geometry in the work of garden designers past and present, Wilkie depicted this geometric figure in three dimensions directly next to Orpheus.

Wilkie's original design instinct—going down into the earth, rather than building up the land—led to a work rich in narrative and geometry. Out of soil, mud, light, myth, and music, Kim Wilkie has drawn from his own interests and fascinations to make an intriguing contribution to a historic English landscape.

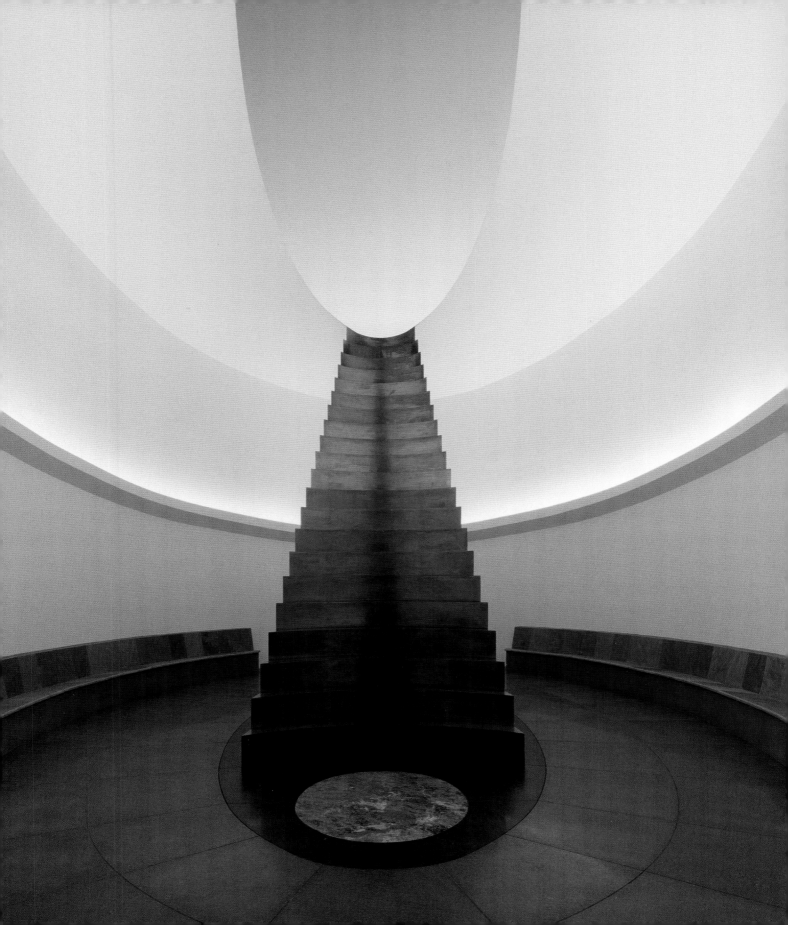

THOMAS WOLTZ

**HITHER HILL GARDEN
MONTAUK, NEW YORK
COMPLETED IN 2009**

Tom Woltz's site plan for a Montauk residence was inspired by the hinged composition of buildings in the sixteenth-century Cortile di Belvedere in Rome. Woltz also adapted a pergola by Edwin Lutyens and studied Gertrude Jekyll's plant lists for inspiration for several garden beds.

This view shows the pool complex, including Woltz's walls with benches, the stone and wood pergola, and some of the Jekyll-inspired country garden plantings. The hinge for the project's change of axis is seen at bottom right.

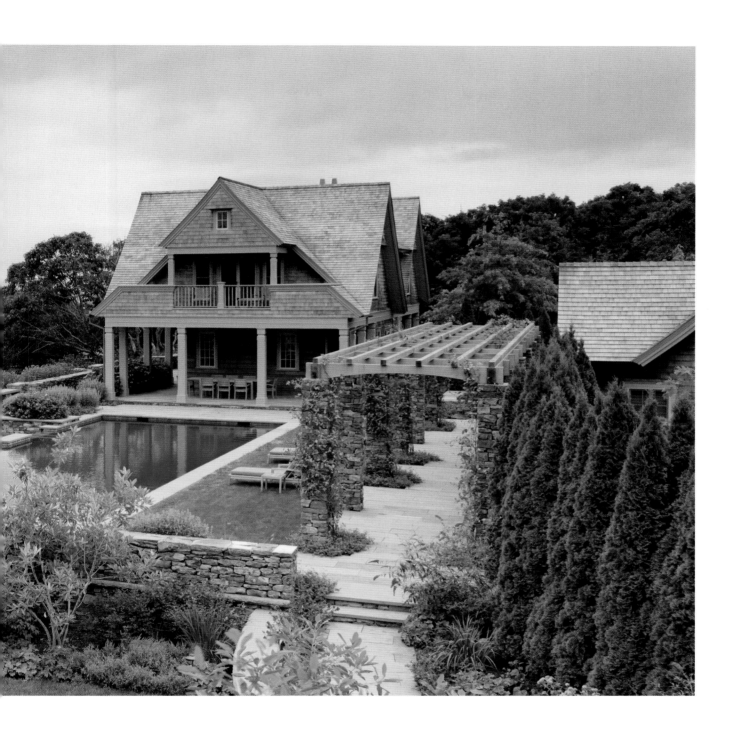

At their first meeting at the Montauk site, the owners and their design team sought to determine the location of a house, a pool, and a pool house, a complicated issue, as this seaside property had several challenges. Its southern boundary was at an angle to the ocean's edge, with an odd topography of slopes and ridges. The question of how to make the project's elements fit on the site was a tricky one, and Thomas Woltz was asked to work it out. His Eureka moment came with the image of a hinge.

Having trained as an architect before turning to landscape architecture, Woltz was acquainted with hinges at every scale, from interior hardware to site plans for buildings. He was familiar with Donato Bramante's influential sixteenth-century Cortile di Belvedere in Rome, which linked two existing buildings, the Vatican Palace and the Villa Belvedere. Bramante designed two long narrow columned corridors, not quite parallel to each other, that formed a courtyard, and he created the architectural hinge that joined these buildings with a series of dramatic terraces and monumental stairs.

With Bramante in mind, Woltz sketched a rough site plan that showed how garden architecture could be used to create a pivot point, or hinge, between the main house in Montauk and the pool and pool house complex. The two buildings would be set apart at a wide angle, conforming to the two angled ridges that ran through the property.

Woltz's proposal put the gardens and lawn in the middle of the site, rather than the more typical plan of a house surrounded by gardens. His final site plan, on which the architect based his designs, placed the buildings on the property's two ridges, while the garden terraces, retaining walls, steps, and walks became the linking device between the main house and the pool complex.

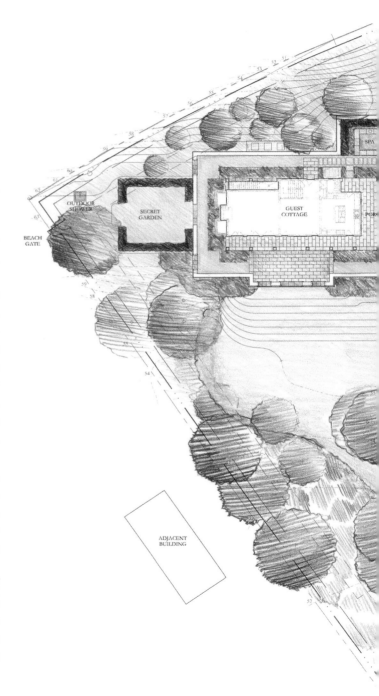

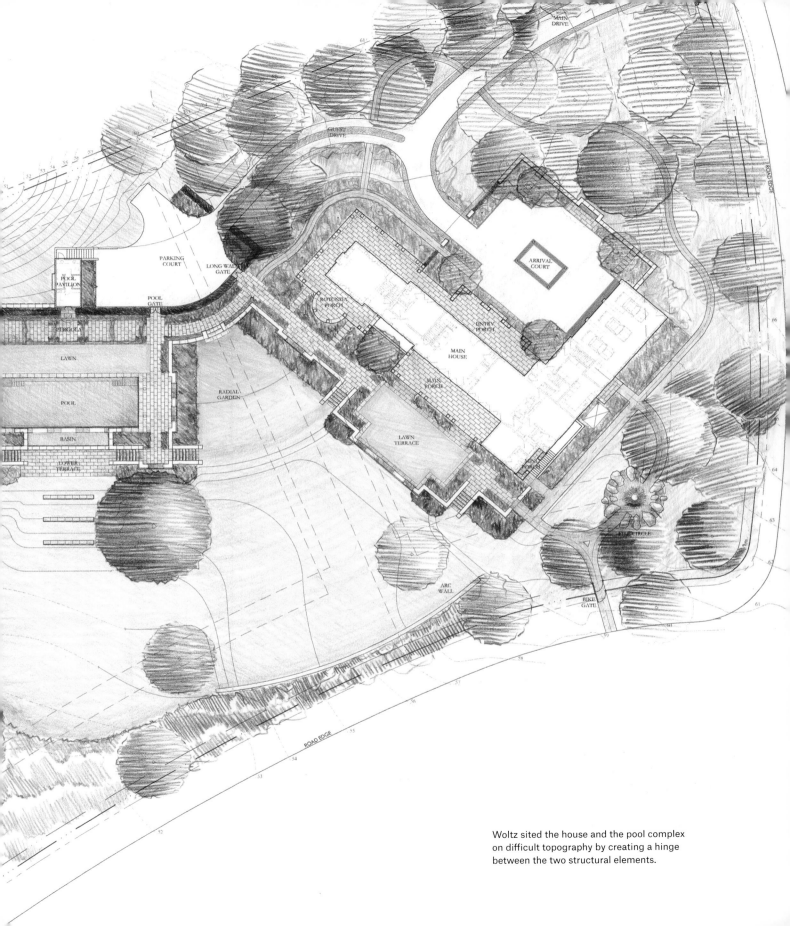

MAIN DRIVE

ROAD EDGE

GUEST DRIVE

ARRIVAL COURT

POOL PAVILION

PARKING COURT

LONG WALL GATE

POOL GATE

ROTUNDA PORCH

ENTRY PORCH

PERGOLA

MAIN HOUSE

LAWN

RADIAL GARDEN

MAIN PORCH

POOL

BASIN

LAWN TERRACE

LOWER TERRACE

FIRE CIRCLE

ARC WALL

BIKE GATE

ROAD EDGE

Woltz sited the house and the pool complex
on difficult topography by creating a hinge
between the two structural elements.

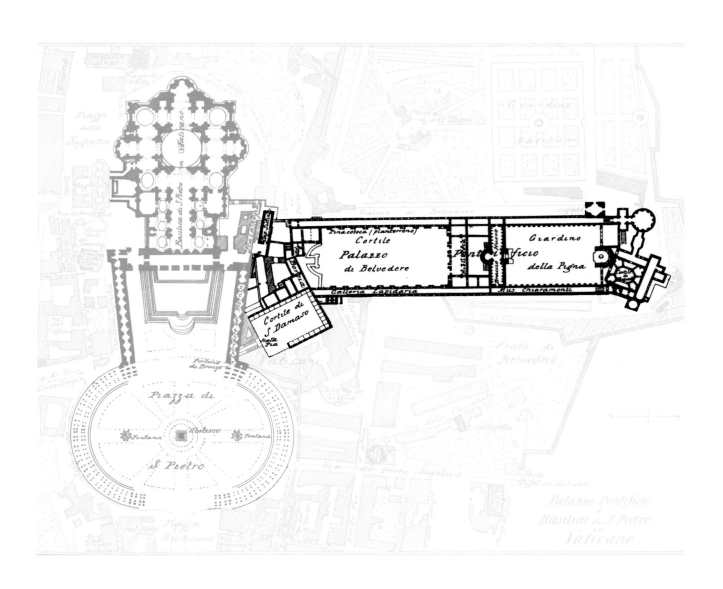

Bramante's hinged composition of buildings in
the sixteenth-century Cortile di Belevedere in
Rome was well known to Thomas Woltz, who
lived and worked in Italy for over a year.

As these two sketches show, Woltz explored
the options for locating the buildings and pool
on the site.

231

Artist Dwight William Tryon painted *Montauk, Long Island, New York* in 1874. This view is close to the site of Woltz's client's home.

The hamlet of Montauk, on the eastern tip of the southern fork of Long Island, is nearly surrounded by the sea. Once a strategic location for World War II military bases monitoring the Atlantic coast, Montauk, with its long line of sandy beaches, is now a vacation destination for fishing, biking, hiking, horseback riding, and surfing. In 2005, a young family purchased land to build a home on a south-facing bluff above the Atlantic Ocean. They hired East Hampton architect Francis Fleetwood to design the house. Then, after seeing his work at a friend's house, they also engaged landscape architect Thomas Woltz.

The team decided that Woltz would develop a plan for the property, locating the buildings and features. There is a strong precedent for taking this lead in Woltz's own practice. His clients often hire his firm, Nelson Byrd Woltz, to create a site plan first and then ask Woltz to suggest appropriate architects for the buildings. This arrangement has been followed historically as well. As an example, Gertrude Jekyll created her extensive garden at Munstead Wood in Surrey, England, beginning in 1883, leaving an open area for her future home. Years later, she invited British architect Edwin Lutyens to design the house.

There is a local precedent, too, on a nearby bluff overlooking the ocean. In 1891, the celebrated landscape architect Frederick Law Olmsted was commissioned to create the plans for a private summer community, and the then-young architectural firm of McKim, Mead & White was chosen to design the houses. Olmsted created a site plan for seven cottages that are widely spaced and asymmetrically arranged to take advantage of existing topography, native vegetation, views, and breezes. Using Olmsted's plan, McKim, Mead & White designed wood-framed houses with generous gable roofs, wide verandas, balustrades, and shingle covering, later identified by art historian Vincent Scully as the Shingle Style. Perhaps it is not a coincidence that Francis Fleetwood has restored two of the houses in recent years. Certainly, there are echoes of these charming cottages in his design for the young family. For Thomas Woltz, the historic Montauk Association site, with its seven houses placed at seemingly random angles to each other, was a helpful image to hold in his mind.

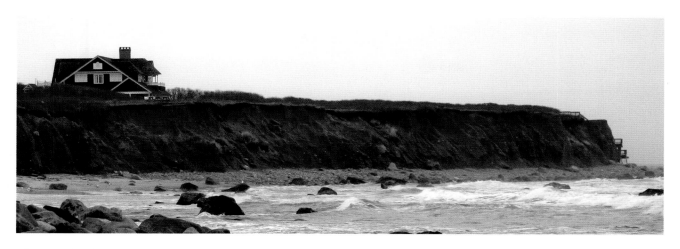

A house on the cliff overlooking the Atlantic Ocean is part of the Montauk Association development laid out by Frederick Law Olmsted.

Woltz created simple slopes and terraces as landscaped platforms for the house and this pool complex.

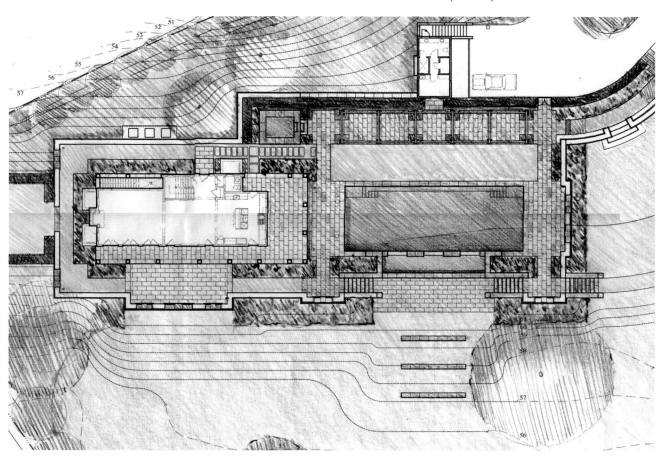

Edwin Lutyens designed Hestercombe's pergola, shown here with garden flowers in full bloom.

The pergola relates to the curving hinge that joins the two parts of the Montauk residence.

As part of his plan, Woltz suggested a pergola as a shaded passageway and sitting area behind the swimming pool. For this structure he found inspiration in the pergola designed in the early twentieth century by Edwin Lutyens for the garden of Hestercombe House in Somerset. Woltz, who much admires Lutyens' work, thought the Arts and Crafts style of the Hestercombe pergola, with its arched beams, suited Fleetwood's design for the Montauk house. But, Woltz noted, "We made it crisp and modern."

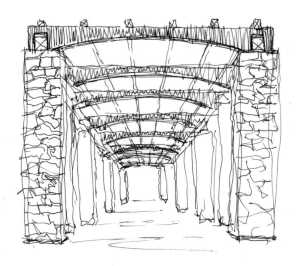

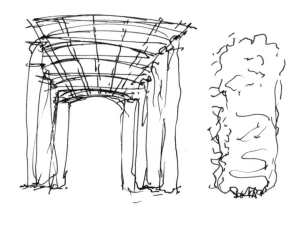

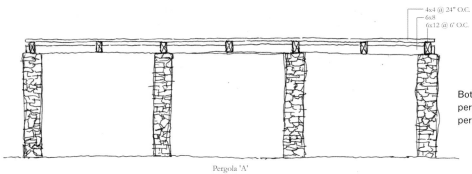

4x4 @ 24" O.C.
6x8
6x12 @ 6' O.C.

Both the rough and final sketches of Woltz's pergola reveal the influence of Lutyens' pergola at Hestercombe House.

Pergola 'A'

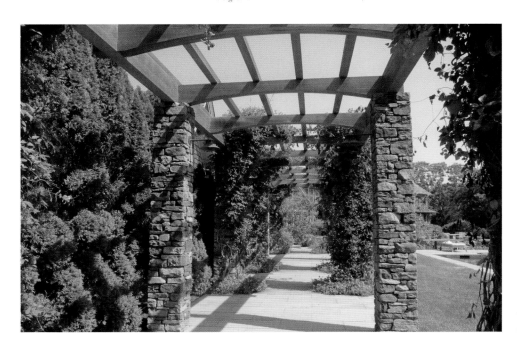

Woltz's pergola runs along the side of the pool.

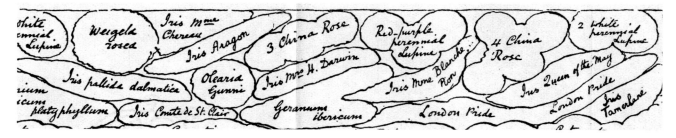

This garden plan by Gertrude Jekyll, the eminent English garden designer and author, appeared in her book *Colour Schemes for the Flower Garden*.

Woltz designed a terraced walkway with plantings inspired by the color schemes used by English garden designer Gertrude Jekyll.

In a famous decades-long design partnership, Lutyens, the celebrated architect of English country houses, collaborated in the early twentieth century with horticulturist and garden writer Gertrude Jekyll, who created planting schemes renowned for their brilliant use of color and texture. So it was appropriate that Woltz studied Jekyll's plant lists for inspiration for the garden beds in this country house project. After considering the possibilities, he chose a color scheme of purple, pink, and chartreuse, and the result is a happy combination of old-fashioned flowers that billow over his modern composition of walls and walks.

For Woltz, these gardens do more than soften the stonework and provide a colorful, breeze-blown, joyous summer atmosphere to the home. Woltz wanted his gardens to mediate between the traditional architecture of the house and the "more modernist" landscape he created in stone. In keeping with his way of working—for each project Woltz creates a kit of parts that is rooted in the place—he wanted the built landscape here to have its own unique character.

"We wanted the sensibility of furniture built into the walls and a craftsmanship that was contemporary and belonged only to this project," Woltz said. He and his colleagues "sketched and sketched and came up with the idea of imbedding the benches into the stonework." The walls around the pool, which also serve as retaining walls, contain slabs of bluestone that are toothed into the fieldstone walls, transparent below so, as he said, "you really see out." As part of this distinctive poolside composition, three waterfalls spill over the walls into a small wading pool for the children, who are able to paddle about and play under the spray.

For these wall and waterfall elements, Woltz had no specific inspiration: just pencil and paper and an artist's eye. Once he made the connections to Bramante's hinge and to the work of Lutyens and Jekyll, he made the rest seem easy.

In July, the flowering border adds color and charm to the view across the swimming pool to the pergola.

The poolside elements of walls, walks, and plantings are carried to the rear of the house as well. Woltz also designed this wood entrance gate from the parking area.

Woltz lightened the feeling of his stone walls with these distinctive bench elements.

KONGJIAN YU

**RICE CAMPUS, SHENYANG JIANZHU UNIVERSITY
SHENYANG, CHINA
COMPLETED IN 2004**

**RED RIBBON PARK
QINHUANGDOA, CHINA
COMPLETED IN 2007**

Kongjian Yu's inspiration for the rice campus came from years of working the communal rice fields with his father during the Cultural Revolution. Memories of searching wetlands for good forage for the village's water buffalo inspired the meandering path at Red Ribbon Park.

Kongjian Yu's rice field campus for the new Shenyang Jianzhu University provides a generous annual crop as well as a landscape that is rich in historical associations.

A welcoming red fiberglass bench weaves among the native grasses at Red Ribbon Park. Yu incorporated lighting and planting into the structure, sometimes to humorous effect.

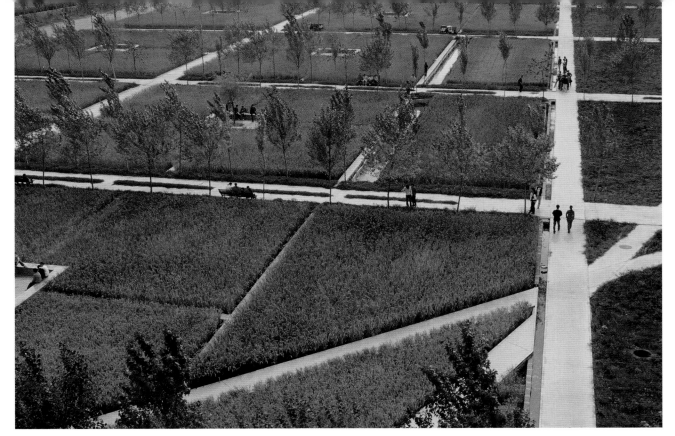

RICE CAMPUS

I t was the arduous life of Kongjian Yu's boyhood and the farming knowledge that he gained from his father that inspired the designs for two of his most successful landscapes. Each project draws on his rural roots in a different way. Yu's inspiration for a campus landscape of productive rice fields came to him as he viewed an open, flat expanse. Though the land was degraded, he could see it had once been used for agriculture. "This place is good for rice," he recalled thinking. "I can see it. I know it. I immediately thought, this could be a rice field."

In an instant, he imagined how the students might bond as a community by planting and harvesting the campus rice each year, and how this experience would help them understand their own agrarian heritage. Yu also imagined the geometry of the rice fields, with square sitting areas, shaded by poplar trees that would draw students into the rice landscape to socialize and to study.

University students plant and harvest the campus's crop of rice.

Students use the gathering areas Yu created within the grids of his rice fields.

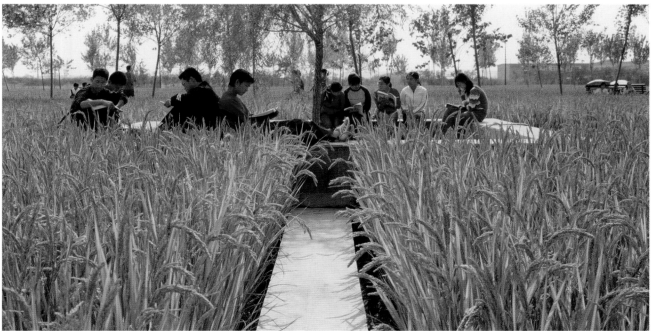

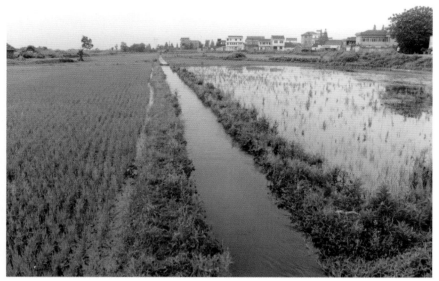

The logo for Kongjian Yu's firm, Turenscape, is composed of the Chinese characters for earth and farmer.

Kongjian Yu's home village in the countryside has many rice fields.

The logo design for Kongjian Yu's firm, Turenscape, represents a "pumpkin-man," or a farmer, standing next to the Chinese character for the earth. This earth symbol is composed of two calligraphic strokes: a baseline for the earth, and an upright line to signify the way in which the ancient Chinese people used shadows to measure land. As Yu points out, the humble farmer figure's head seems to bow toward the earth.

This respectful figure could be a stand-in for Kongjian Yu, who has been close to the earth from his earliest years, when he took measure of the ground daily, with his eyes and with his feet. Born into a rural farming family, far from urban life, Yu spent his childhood shadowing his father and doing hard work on the land during the Cultural Revolution. Most of the village land—the best land—was planted with rice.

It was not an easy life. Once the villagers made their required contribution to the government, there was seldom enough rice for them to eat. Everyone worked, and each morning all the members of the community assembled to learn their assigned tasks. Children might be required to weed or to trim branches. Women would plant. Men did the plowing, with the help of the one water buffalo shared by the village. In those days, before the use of selective herbicides, the rice fields were weeded laboriously by hand. Long hours of rice harvesting might continue from day through the night.

In late 2001, Yu was invited to discuss a possible landscape plan for the new suburban campus of the architectural university in Shenyang, the largest city in northeastern China's Liaoning Province. Yu arrived in winter, when the buildings were nearing completion and the site was filled with construction debris. The president of the university explained that they had only a minimal budget and very little time. The new landscape had to be finished when the university opened the following fall.

A vintage print owned by Yu shows how rice
has been harvested in China for generations.

Yu returned to his family land for a visit in
2003 with his wife and children.

The construction site was filled with debris when Yu made
his first consulting visit to the new university campus.

As Yu's sketches suggest, he designed a roadway system through the rice fields that has a center median with plantings to accommodate both pedestrians and the wheels of heavy tractors.

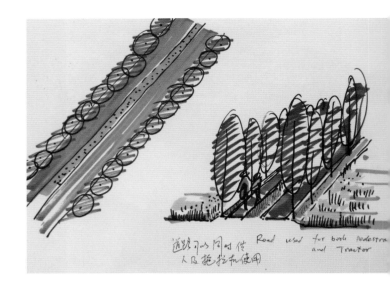

Still, Yu had a design idea for the extensive campus landscape that he believed could satisfy the goals of the university leadership and meet the time constraints. At the brainstorming session with the university president and a faculty committee, Yu asked tentatively, "Could this campus be rice, for example?" The immediate reaction was positive. As Yu explained, he was lucky, because the university president was a romantic man who loved the idea, and the dean of the School of Architecture wanted something new and unique for the new institution.

Yu then asked himself several questions. Is it messy rice? Or is it designed rice? And, how can rice become a modern contemporary design? One answer came from his historical knowledge of Chinese urban planning: a grid of nine squares, according to Yu, has been the traditional building block for Chinese cities for hundreds of years.

In addition, grids and simple squares were an established design motif during the time Yu studied at Harvard. He recalls the modern approach to landscape design to which he was exposed. Simplicity and minimalism, he said, were key concepts in his design education with great professors like Peter Walker. In Yu's design for the rectilinear rice fields of the campus, he acknowledges with a laugh, "Peter Walker is here." But then Yu brought the story back to his own life as a boy. He believes that simple and minimal schemes are intuitive concepts to him, "because I am a farmer. A farmer is straight ahead, real, useful and functional." Here at Shenyang, he said, "Harvard and my farmer background come together."

An early sketch shows how Yu organized the paths between the squares, with planting strips, so that they could accommodate both the large wheels of tractors and the students and visitors who chose to enter the landscape.

Imagining rice fields in a moment of inspiration was one thing, but creating them required an irrigation system, something Yu understood, thanks to his father. Yu's father was respected in their village as a "water man," and he was entrusted with the irrigation of all the rice paddies in the community. Throughout his childhood, Yu walked behind his father as the older man adjusted the flow of water from one field to another, using a shovel and simple earthen dikes. What he learned most, Yu said, is how subtle it all was. He noted that his father might calculate that the right time to change the course of the water in the fields would be in the middle of the night, and he would wake to do it, with his son following behind. For the university's fields, Yu designed a large reflecting pond that retains all the stormwater on site and irrigates the rice fields.

The type of rice grown here—in one long growing season rather than two short ones—is known as North China rice, considered to be the finest in the country, according to Yu. The university has branded rice from its fields with a special name, "Golden Rice." It is sold to support the university, served in the campus cafeteria, and the bright red packages are given to campus visitors as souvenirs.

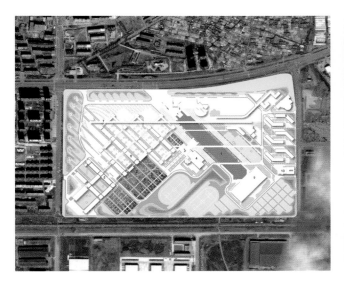

This schematic plan shows the rice campus in the context of its neighborhood.

Red bags containing the rice grown in the campus fields are given as gifts to visitors. This North China rice is highly prized.

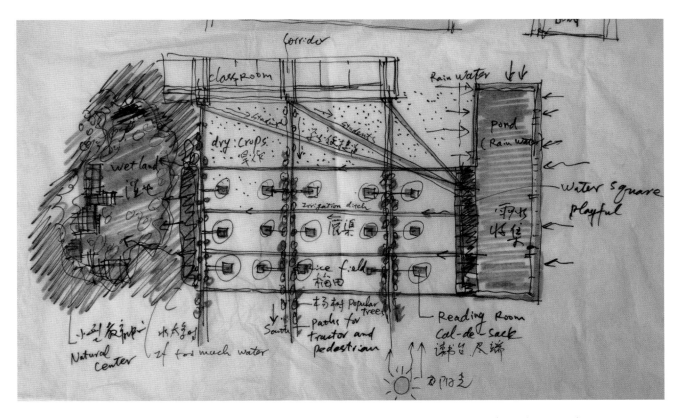

Kongjian Yu's concept sketch shows how he organized the elements of his plan. The rice fields, square areas for students to gather, rows of poplar trees on a north–south axis, a rainwater pond, and diagonal paths were all in his plans from the beginning.

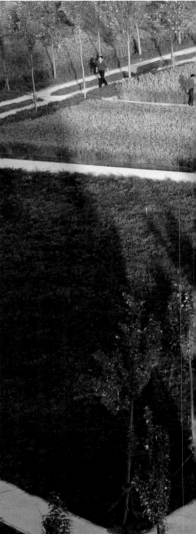

A university student's room overlooks the rice field campus.

One design feature within the rice field grid is worth noting: diagonal paths cut through the squares of rice paddies to provide for the circulation of students across the campus. As Yu noted, the paths are purely functional. But they are beautiful as well, and one can imagine the designer's hand drawing the strong diagonal lines over the pattern of squares. "This line," said Yu, pointing to the plan, "means we are not agricultural anymore. We are urban. We are post-agriculture. Suddenly, we become modern, or we find a modern contemporary use for agriculture. So this diagonal line is for pleasure, plus function."

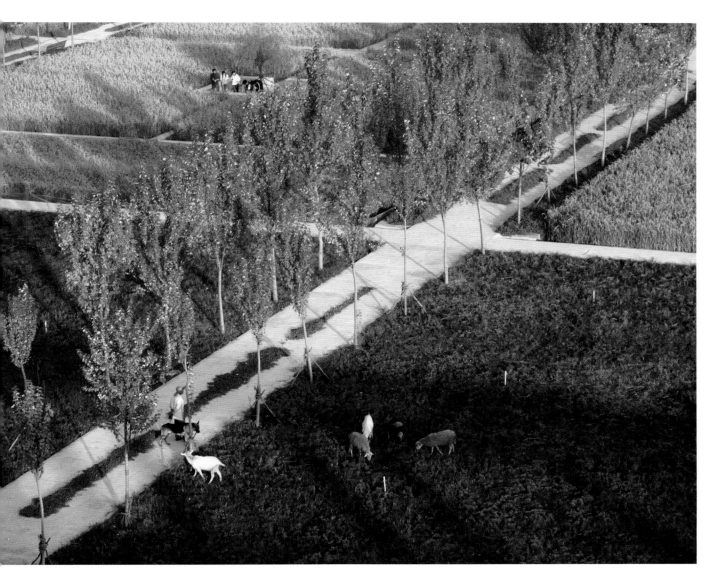

An aerial view of the ripening rice fields with poplar trees and the square areas for students to study and gather outdoors. The path for pedestrians and tractors has a planted median. In the foreground, goats are allowed to graze.

RED RIBBON PARK

Visitors find a restful spot within the dense vegetation of Red Ribbon Park.

n the coastal resort city of Qinhuangdoa, Kongjian Yu created a very different pedestrian path. In this case, the line defines the project, called Red Ribbon Park. As irregular and ungeometric as the university rice fields are linear, the path made by Yu in Qinhuangdoa and the continuous wave of red fiberglass benches along this path make an inviting place for people to walk and to linger within a previously inaccessible environment of native plants along the floodplain of the Tanghe River.

A presentation sketch illustrates Yu's first idea for the park, a red ribbon path. When this proved inadvisable based on available materials, Yu instead reimagined the red ribbon as a bench with lighting.

The site of the future park was derelict and littered with debris when Yu arrived for his first site visit.

This view shows the debris and deteriorating condition of the site before it was transformed by Yu's park plan.

Yu's concept for Red Ribbon Park was based on his observation of the lush natural growth on the 50-acre site and his desire to retain the rich vegetation by keeping disturbance to a minimum. Creating a narrow linear park and leaving most of the land in its natural state was his solution, and his initial concept was to provide a wide red-colored walkway along the river and through the woods. He envisioned this path raised above the ground, an idea based, he admitted, on his own fear of snakes. Along this path, which would vary in width, would be pavilions to provide gathering places.

As he searched for appropriate building materials and refined his design, Yu had to relinquish his plan to make a red path. Instead, he created a boardwalk of wood, and he used red fiberglass, produced by a local factory, for a continuously winding bench, which is lit from within. The illumination provides safety for users and makes the entire 1600-foot length of the structure glow.

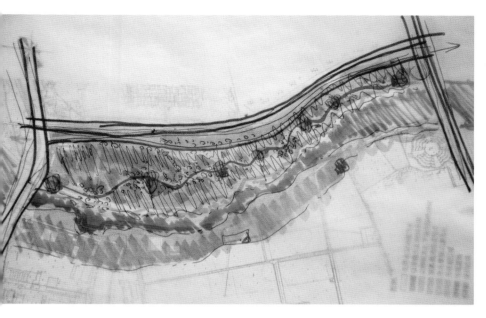

This early concept sketch shows the red ribbon as a squiggly line running the length of the park not far from the river's edge.

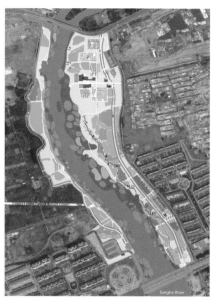

In this plan view, the Red Ribbon Park is shown in the context of the highly developed surrounding area. The red ribbon is shown, as is the gently curving bike path along the park's eastern edge.

Because there were no invasive plants in the park area, Yu was able to retain all of the existing native vegetation, including the grasses.

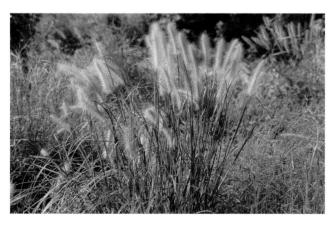

Yu's sketch locates several pavilions that serve as gathering and viewing areas along the red bench. They have poetic names, such as Pavilion of Reed and Pavilion of Silvergrass.

Chinese calligraphy in Mao Zedong's loose style is one inspiration for Yu's wiggly line at Red Ribbon Park.

One inspiration for the curving line of the red path may have been the distinctively loose calligraphy of Chairman Mao, often printed in red ink. Yu does not dispute that inspiration, and he noted that, in fact, his original sketches for the park show a wiggly, red calligraphic line. Although the red color relates to Mao and the Cultural Revolution that caused much pain to Yu's family, he uses this color in his work as a positive symbol of a revolutionary way of designing landscapes, a way that means working with nature, responding to the ecology, undoing the channelization of rivers, finding simple and functional solutions, and lowering maintenance costs.

But the true inspiration for this park, according to Yu, came from his experiences in his native farming village. For many of the seventeen years he spent working on the farm, Yu was in charge of the village's only water buffalo, which he sometimes referred to as "the cow." It was his job to lead the animal every day to find a good place to graze. "You have to find a place with lush vegetation," Yu said, "and then the cow is happy. When he is happy, I am happy, so I always try to find this kind of wetland, with rich tall grass that the cow likes very much."

The terrain along the Tanghe River reminded Yu of the places where the water buffalo was most happy. As in his childhood home, the key in Qinhuangdoa was finding a path through the dense vegetation. Referring to his time with the water buffalo, Yu said, "To find a path is so important. To get through the dense vegetation, you want a nice path." Often the path was winding and long. But, Yu added, "to pass through the dense forest, or vegetation, I always feel good." This time he is talking not only about his young farming self. He is also talking about his Red Ribbon Park.

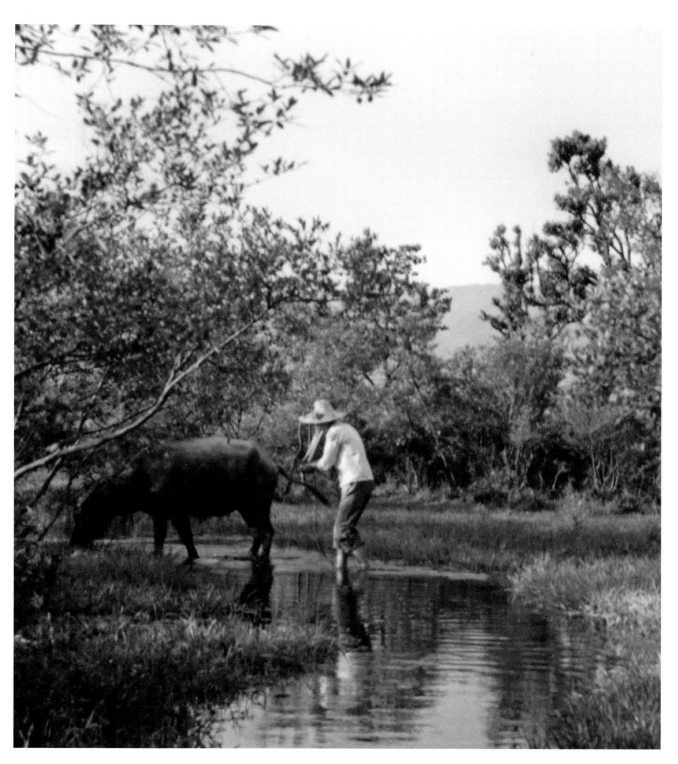

In this 1985 photograph, the village's water buffalo is seen grazing along White Sand Creek. Yu's years of caring for the water buffalo inspired his design of the path at Red Ribbon Park.

METRIC
CONVERSIONS

feet	m
1	0.3
5	1.5
10	3
100	30
500	150
1000	300

miles	km
1	1.6
5	8.0
10	16
50	80
100	160

acres	ha
1	0.405
100	40.5

ton	kg
1	910

SUGGESTED READING

Czerniak, Julia, and George Hargreaves, eds. *Large Parks*. New York: Princeton Architectural Press, 2007.

Deford, Deborah, ed. *Flesh and Stone, Stony Creek and the Age of Granite*. Stony Creek, Connecticut: Stony Creek Granite Quarry Workers Celebration, 2001.

Halprin, Lawrence. *A Life Spent Changing Places*. Philadelphia: University of Pennsylvania Press, 2011.

Harrison, Robert. *Visible | Invisible: Landscape Works of Reed Hilderbrand*. New York: Metropolis Books, 2013.

Herrington, Susan. *Cornelia Hahn Oberlander: Making the Modern Landscape*. Charlottesville: University of Virginia Press, 2013.

Jacobs, Peter. *Shlomo Aronson: Making Peace with the Land: Designing Israel's Landscape*. Washington, D.C.: Spacemaker Press, 1998.

Jencks, Charles, and Edwin Heathcote. *The Architecture of Hope, Maggie's Cancer Caring Centres*. London: Frances Lincoln Ltd, 2010.

Justice, Clive L. *Mr. Menzies' Garden Legacy: Plant Collecting on the Northwest Coast*. Vancouver, Cavendish Books, 2000.

Locher, Mira. *Zen Gardens: The Complete Works of Shunmyo Masuno, Japan's Leading Garden Designer*. Tokyo: Tuttle Publishing, 2012.

Rocca, Alessandro, ed. *Planetary Gardens: The Landscape Architecture of Gilles Clément*. Basel: Birkhäuser, 2008.

Rose, James C. *Gardens Make Me Laugh*. London: The Johns Hopkins University Press, 1990.

Saito, Katsuo, and Sadaji Wada. *Magic of Trees and Stones: Secrets of Japanese Gardening*. Translated by Richard L. Gage. New York: Japan Publications Trading Company, 1964.

Saunders, William S., ed. *Designed Ecologies: The Landscape Architecture of Kongjian Yu*. Basel: Birkhäuser, 2012.

Smith, Ken. *Ken Smith: Landscape Architect*. New York: The Monacelli Press, 2009.

Takei, Jirō, and Marc P. Keane. *Sakuteiki, Visions of the Japanese Garden: A Modern Translation of Japan's Gardening Classic*. North Clarendon, Vermont: Tuttle Publishing, 2008.

Trulove, James Grayson. *Ten Landscapes, Stephen Stimson Associates*. Gloucester, Massachusetts: Rockport Publishers, 2002.

Ueyama, Ryoko. *Landscape Design*. Tokyo: Azur Corporation, 2008.

Walker, Peter, and Melanie Simo. *Invisible Gardens: The Search for Modernism in the American Landscape*. Cambridge: The MIT Press, 1994.

Wilde, Jurgen. *Karl Blossfeldt: The Alphabet of Plants*. Munich: Schirmer Art Books, 2007.

ACKNOWLEDGMENTS

Without the generosity of spirit of the landscape architects who shared their work and their stories with me, this book would not have been possible. I thank them all. I am also grateful to the members of their firms who were part of the conversation, especially Barbara Aronson, Kuroush Davis, Anneliese Latz, Yoshi Masuno, and Lauren Stimson,

I am indebted as well to all those who allowed me access to their properties. In addition, I was fortunate to have several kind and knowledgeable guides during my visits: Lance Goffort-Hall and David Cullum at Boughton House, Andrew Woodall at Broughton Grange, Tina Cancemi at the American Academy in Rome, and Reverend Masafumi Nakanishi at Samukawa Shrine. And I would like to thank all the artists who graciously permitted their work to appear on these pages.

Thank you to everyone at Timber Press, beginning with Juree Sondker, who invited me to write this book and then offered advice, support, and the gift of friendship. Leah Erickson worked tirelessly on the images, and Lisa D. Brousseau and Eve Goodman provided skillful editing. It was a great pleasure to work with these accomplished and dedicated professionals.

Many friends and colleagues were of immeasurable help, providing timely and much-appreciated assistance: Steve Beimel, Florence Boogaerts, Abigail Carlson, Amy Katoh, Mira Locher, Maureen Repaci, Kristin Schleiter, Dick Solomon, Anne von Stuelpnagel, Peter Walker, Sandra Weber, and Martha Zoubek. Most of all, I thank my husband, Bruce, who traveled with me to many landscapes and provided constant humor-filled support and encouragement.

PHOTO AND
ILLUSTRATION CREDITS

PAGE 52 (LEFT) Creative Commons License image courtesy
 Greg Varinot on Flickr
 (RIGHT) Creative Commons License image courtesy
 TijsB on Flickr

PAGE 53 (BOTTOM) courtesy Gilles Clement

PAGE 54 courtesy Gilles Clement

PAGES 56–57 courtesy of Millicent Harvey

PAGE 59 courtesy Ken Castellucci and Stony Creek Museum

PAGE 60 (LEFT) Creative Commons License image courtesy Severin
 St. Martin on Flickr
 (RIGHT) courtesy of Millicent Harvey

PAGE 61 (TOP) courtesy Charles Mayer
 (LOWER LEFT) courtesy Reed Hilderbrand
 Landscape Architects

PAGE 62 (TOP CENTER) Creative Commons License image courtesy
 Wilson Bilkovich on Flickr

PAGE 63 (TOP RIGHT) courtesy Charles Mayer

PAGES 64–65 (CENTER) courtesy Reed Hilderbrand Landscape Architects

PAGE 64 (LEFT) courtesy of Millicent Harvey

PAGE 65 (RIGHT) courtesy of Millicent Harvey

PAGES 66–67 (CENTER) Creative Commons License image courtesy
 Aphrodite in NY on Flickr

PAGE 67 (TOP AND BOTTOM RIGHT) courtesy Reed Hilderbrand
 Landscape Architecture

PAGE 69 courtesy Charles Jencks

PAGES 70–71 courtesy Charles Jencks

PAGE 73 courtesy Charles Jencks

PAGE 74 courtesy Charles Jencks

PAGE 75 (TOP) courtesy Charles Jencks
 (BOTTOM) courtesy Charles Jencks/Page Park Architects

PAGE 76 courtesy Charles Jencks/Page Park Architects

PAGE 77 (TOP) courtesy Charles Jencks/Maggie's Centre
 (BOTTOM) courtesy Charles Jencks/Page Park Architects

PAGE 78 courtesy Charles Jencks

PAGE 79 (TOP) courtesy Chris Young
 (BOTTOM) Chloe Bliss/courtesy Maggie's Centre

PAGES 80–81 Lauren Griffith/courtesy Hargreaves Associates

PAGE 83 (TOP LEFT) MS21-068, *Ima Hogg with Azaleas*. 1970. Ima
 Hogg Papers, Museum of Fine Arts, Houston Archives
 (TOP RIGHT AND BOTTOM LEFT) courtesy
 Hargreaves Associates

PAGE 84 courtesy Hargreaves Associates

PAGE 85 (TOP) courtesy Hargreaves Associates
 (BOTTOM) John Gollings/courtesy Hargreaves Associates

PAGE 86 (LEFT) John Gollings/courtesy Hargreaves Associates

PAGES 86–87 courtesy Hargreaves Associates

PAGE 88 Paul Hester/courtesy Hargreaves Associates

PAGE 89 (TOP) John Gollings/courtesy Hargreaves Associates
 (BOTTOM) Paul Hester/courtesy Hargreaves Associates

PAGE 90 (TOP) Paul Hester/courtesy Hargreaves Associates
 (BOTTOM) courtesy Mary Margaret Jones

PAGE 91 (TOP) John Gollings/courtesy Hargreaves Associates
 (BOTTOM) courtesy Hargreaves Associates

PAGE 93 Hedrich Blessing/courtesy Mikyoung Kim Design

PAGE 94 courtesy Mikyoung Kim

PAGE 95 (TOP) courtesy Mikyoung Kim Design
 (BOTTOM) Hedrich Blessing/courtesy Mikyoung
 Kim Design

PAGE 96 (TOP LEFT AND RIGHT) courtesy Mikyoung Kim
 (BOTTOM RIGHT) Eva Hesse, *Repetition Nineteen III*. 1968.
 Fiberglass, polyester resin, installation variable, 19 units;
 Museum of Modern Art, New York; Gift of Charles and
 Anita Blatt; photo: Abby Robinson, New York. © The
 Estate of Eva Hesse/courtesy Hauser & Wirth

PAGE 97 (TOP) courtesy Mikyoung Kim Design
 (BOTTOM) Karen Moylan/courtesy Mikyoung Kim Design

PAGE 98 (LEFT) George Heinrich/courtesy Mikyoung Kim Design
 (RIGHT) courtesy Mikyoung Kim Design

PAGE 99 (TOP LEFT) George Heinrich/courtesy Mikyoung
 Kim Design
 (TOP AND BOTTOM RIGHT, BOTTOM LEFT) courtesy
 Mikyoung Kim Design

PAGES 100–101 George Heinrich/courtesy Mikyoung Kim Design

PAGES 102–103 Michael Latz/courtesy Latz + Partner

PAGE 105 Detroit Publishing Company, Kyffhauser Denkmal.
 Barbarossa. 1905. Courtesy Library of Congress,
 LC-DIG-ppmsca-01118

PAGE 107 (TOP) courtesy Latz + Partner
 (BOTTOM) Creative Commons License image courtesy
 Myrabella on Wikimedia Commons

PAGES 108–109 (TOP) courtesy Latz + Partner

PAGE 108 (BOTTOM) courtesy Latz + Partner

PAGE 109 (TOP AND BOTTOM RIGHT) Michael Latz/courtesy
Latz + Partner

PAGE 111 (TOP) courtesy Latz + Partner

PAGE 112 (BOTTOM RIGHT) courtesy Latz + Partner

PAGE 114 courtesy Latz + Partner

PAGE 115 Michael Latz/courtesy Latz + Partner

PAGE 116 (LEFT AND RIGHT) Michael Latz/courtesy Latz + Partner
(CENTER) courtesy Latz + Partner

PAGE 117 Creative Commons License image courtesy Lukashed
on Flickr

PAGE 119 (TOP) courtesy Shunmyo Masuno
(BOTTOM) Creative Commons License image courtesy
663Highland on Wikimedia Commons

PAGES 121–122 (ALL) courtesy Shunmyo Masuno

PAGE 123 (TOP) courtesy Shunmyo Masuno
(BOTTOM RIGHT) Joe McAuliffe, *Carp Leaping Over Dragon's
Gate*. 2007. Ink and watercolor on paper, 37 × 25 in.
© Joe McAuliffe/Zen Gyotaku

PAGES 124 author unknown, public domain image courtesy
Wikimedia Commons

PAGES 125–127 courtesy Shunmyo Masuno

PAGES 128–129 courtesy Matthews Nielsen

PAGE 131 (TOP) Signe Nielsen/courtesy Matthews Nielsen

PAGES 132–133 courtesy Matthews Nielsen

PAGE 134 (LEFT) courtesy Matthews Nielsen

PAGES 134–135 (CENTER) Bernard Ratzer, Map of Brooklyn. 1766.
Courtesy Wikimedia Commons

PAGE 135 (TOP RIGHT) courtesy Matthews Nielsen
(BOTTOM RIGHT) Walt Whitman, Three-quarter length
portrait, facing front, as a young man, dressed in rural
attire for frontispiece of *Leaves of Grass*, 1854, courtesy
Library of Congress, LC-DIG-ppmsca-07143

PAGE 137 (TOP) *The Fulton Ferry Boat*, [Brooklyn, N.Y.]. 1890.
Courtesy Library of Congress, LC-DIG-ppmsca-07542
(BOTTOM) courtesy Matthews Nielsen

PAGE 138 (TOP LEFT) Creative Commons License image courtesy
Rob Young on Wikimedia Commons

PAGES 138–139 (BOTTOM CENTER) Creative Commons License image
courtesy BigPinkCookie on Flickr

PAGE 139 (TOP LEFT AND RIGHT, BOTTOM RIGHT) courtesy
Matthews Nielsen Landscape Architects

PAGES 140–141 courtesy Busby Perkins + Will Architects

PAGES 142–143 © Michael Elkan Photography

PAGE 144 courtesy Busby Perkins + Will Architects

PAGE 145 (TOP) courtesy Cornelia Hahn Oberlander and Sharp
and Diamond Landscape Architecture Inc.
(BOTTOM) Creative Commons License image courtesy
ColinK on Flickr

PAGE 147 (LEFT) Karl Blossfeldt/courtesy Stiftung Ann und Jurgen
Wilde, Pinakothek der Mondernephoto
(RIGHT) Archibald Menzies in L. Hitchcock and
A. Cronquist. *Flora of the PacificNorthwest*. Seattle,
WA: University of Washington Press, 2009/
courtesy University of Washington Press

PAGE 148 (BOTTOM LEFT) Sharp and Diamond Landscape
Architecture Inc./courtesy Cornelia Hahn Oberlander

PAGES 148–149 (TOP) courtesy Busby Perkins + Will Architects

PAGE 149 (BOTTOM) Nic Lehoux/courtesy Busby Perkins + Will

PAGE 150 Nic Lehoux/courtesy Busby Perkins + Will

PAGE 151 Brett Hitchins/courtesy Cornelia Hahn Oberlander and
Sharp and Diamond Landscape Architecture Inc.

PAGE 155 (BOTTOM) courtesy Olin Studio

INDEX

SUSAN COHEN is a licensed landscape architect and fellow of the American Society of Landscape Architects in private practice in Greenwich, Connecticut. She also teaches and lectures on landscape design and history. Her talks for civic groups, garden clubs, museums, and The New York Botanical Garden have included lectures on her own work and on garden history, including Japanese gardens, Monet's garden, Italian gardens, and English gardens. She has traveled extensively to visit and study gardens old and new and for several recent years has led garden study trips to Japan.

A graduate of Smith College, where she has served as a trustee, Susan received her professional degree in landscape architecture from the City College of New York. In addition to her award-winning design practice, she has taught courses at The New York Botanical Garden, where she is also the coordinator of the Landscape Design Program. Active as a volunteer at the garden, she also serves as a member of the Board of Advisors. She has also taught in the MLA program at the City College of New York.

Since 1998, when she founded The New York Botanical Garden's celebrated Landscape Design Portfolio Series, she has introduced outstanding landscape architects from around the world to an enthusiastic New York audience.

As a designer, educator, and writer, **PETER WALKER** is a major presence in the field of landscape architecture. Among his many honors are Harvard's Centennial Medal, the University of Virginia's Thomas Jefferson Medal, the ASLA Medal, and the IFLA Sir Geoffrey Jellicoe Gold Medal. He is codesigner, with Michael Arad, of the National September 11th Memorial in New York City.